THE MOST BEAUTIFUL

OPERA HOUSES

IN THE WORLD

THE MOST BEAUTIFUL
OPERA HOUSES
IN THE WORLD

PHOTOGRAPHS BY GUILLAUME DE LAUBIER

TEXT BY ANTOINE PECQUEUR

FOREWORD BY JAMES LEVINE, MUSIC DIRECTOR, THE METROPOLITAN OPERA

TRANSLATED FROM THE FRENCH BY NICHOLAS ELLIOTT

ABRAMS NEW YORK

CONTENTS

The vantage point from which I define "beauty" and "a beautiful opera house" is perhaps somewhat different from that of an audience member. As a conductor, I walk into an opera house seeking the conditions that can lead to great opera performances. At the top of the list are two things: superior acoustics in order to achieve the musical expression, and the atmosphere and facilities necessary to fulfill the composer's and librettist's theatrical vision.

Even with those fundamental elements in place, creating an extraordinary performance is a feat of tremendous complexity. The singers, orchestra, and I are always aware that, night after night, people walk through the doors hoping for a remarkable experience in the theater. We feel the pressure of that expectation, we welcome it, and we constantly strive to fulfill it.

I feel fortunate to have spent more than four decades working in a house where it has been possible to do some excellent work—perhaps surprising for such a large theater. The Metropolitan Opera House, which opened at Lincoln Center in 1966, has tremendous personality, especially for a hall that holds nearly 4,000 people. It has a particularly live and vital acoustic and a sense of presence for each individual listener. The interior of the house is made of a beautiful African rosewood, burgundy furnishings, and a kind of dark, burnished gold that does not glare or reflect a lot of light. As a result, once the chandeliers go up and the house lights go down, it is possible to focus on dramatic things, rather than on the audience or on the auditorium.

That is also my experience at the Bayreuth Festspielhaus, which seats a little more than 1,900 people. This theater, imagined and built by Richard Wagner, is unique. He composed *Parsifal*, his final work, with the sightlines and acoustics of the theater clearly in mind. The fact that you cannot see the orchestra or

conductor produces a lot of non-metrical, syncopated musical ideas and floating layers of sound, which surround you in the hall with a truly present, warm depth of tone all the way through. It is an interesting contrast to its neighbor, the intimate Markgräfliches Opernhaus, a gem of a rococo theater, where I have recorded a couple of times during the summers while conducting at the Bayreuth Festival. Good acoustics are obviously easier to obtain in a room that is smaller, but small theaters do not always have them.

In theaters like the Bayreuth Festspielhaus, the Wiener Staatsoper, or Teatro alla Scala, artists and audience members bring memories of performances into the theater with them. The more history an opera house has, the more it is part of people's consciousness. The old Metropolitan Opera House, which sadly was torn down in 1967, was a great old theater. Whenever you walked in, you knew Caruso, Flagstad, Melchior, Ponselle, Chaliapin, Mahler, and Toscanini (to name just a few) had all performed there. I am still nostalgic about the old Met, but since I started to conduct professionally in 1964, more and more people have grown up—and a tremendous amount of history has been made—in this glorious new house. Perhaps the most exciting thing is that each generation adds its own history in different ways.

So when we leaf through the photographs in this elegant book, we bring with us our own memories of music heard, images seen, and emotions felt in the great opera houses pictured in its pages. And we bring our hopes for what we long to encounter in any theater: something truly extraordinary.

—JAMES LEVINE, Music Director, The Metropolitan Opera

OPERA HOUSE ARCHITECTURE THROUGH THE CENTURIES

The first opera in history is considered to be *Euridice*, written by Jacopo Peri in 1600. The form rapidly evolved in the hands of Claudio Monteverdi, the composer of *L'Orfeo* (1607), *The Return of Ulysses* (1640), and *The Coronation of Poppea* (1642). Naturally, during this same period, Italy saw the construction of the first theaters designed for opera performances. Architects from Palladio to Aleotti drew their inspiration from the forms of antiquity, including both the amphitheater and the Olympic Stadium. Yet significant differences emerged: Contrary to the open-air structures of the Greco-Roman period, these were covered edifices built inside palaces. The theaters were initially private, most often reserved for the court. The first public theater, the San Cassiano, was opened in the democratic Republic of Venice in 1637.

Designing opera houses in a horseshoe shape, to aid acoustics, was a major architectural innovation. The first was the Teatro Santi Giovanni e Paolo (1654), also in Venice. Geographic specificities also began to emerge: In Italy, theaters were built with private boxes, while in France, theaters such as the Grand Théâtre de Bordeaux (1780) had open balconies. The Italian model allowed for political and romantic intrigue by isolating certain theatergoers together and sheltering them from prying eyes. In the French model, the performance was a social event, at which one was to see and be seen by one's neighbors. Theaters also grew larger and larger in size, particularly the San Carlo in Naples, which by 1737 could seat an audience of 2,400.

In the eighteenth century, opera house architecture adopted the neoclassical style, with its requisite pediments and colonnades. This trend brought an increasing aesthetic standardization of new opera houses. But some daring persisted, as witnessed in Claude-Nicolas Ledoux's theater in Besançon (1784), which was built as an amphitheater with a covered orchestra pit—a concept Wagner later borrowed in Bayreuth. Sadly, the Besançon theater's interior has since been modified.

Other structures reached extremes, from the most extravagant, such as the Palais Garnier (1875) with its majestic staircase and neo-baroque flourishes, to the most understated, such as the Festspielhaus in Bayreuth (1876). In the late nineteenth century, safety came first: Following the destruction of countless European theaters by fire, architects improved crowd circulation by installing multiple staircases.

In the twentieth century, great names in architecture brought an innovative spirit to opera house construction. In Paris, Auguste Perret built the first performance hall made of concrete, the Théâtre des Champs-Élysées (1913). In 1958, Finnish architect Alvar Aalto won the competition to design an opera house in Essen, an unusual project with fluid, asymmetrical lines that would be built after his death.

Outside Europe, spectacular, unconventional edifices were erected. In Manaus, in the middle of the Amazon, the rubber trade funded the 1896 construction of a theater using Carrara marble and Murano glass. In Buenos Aires, the Teatro Colón (1908) had close to 2,500 seats and some of the best acoustics in the world. And Sydney, Australia, became home to one of the most emblematic but also controversial opera houses in the world, built from 1963 to 1973. The extremely costly design by Danish architect Jørn Utzon was eventually only half completed. Because the stage house was never built, the main hall originally intended for operas can be used only for symphony concerts. Operas are staged in a second, smaller hall with terrible acoustics. But the Sydney Opera House remains a global icon, which continues to inspire cities to build their own theaters in the unspoken hope that they will become as famous as the one on the Australian harbor. In recent years, Beijing treated itself to a dome-shaped titanium-and-glass opera house by Paul Andreu, while Guangzhou opted for Zaha Hadid's deconstructivist lines.

But today the crucial issue is acoustics. After having revolutionized symphony concert halls, notably by seating the audience all around the orchestra, acousticians are exploring new leads. The challenge is to obtain a sound that is neither too reverberant, so the lyrics can be intelligible, nor too dry, to support the vocal and orchestral tones. And of course proximity between the stage and audience, a token of theatrical credibility, must be maintained. Opera is a total art, some would say a utopian art, which leaves no room for mistakes.

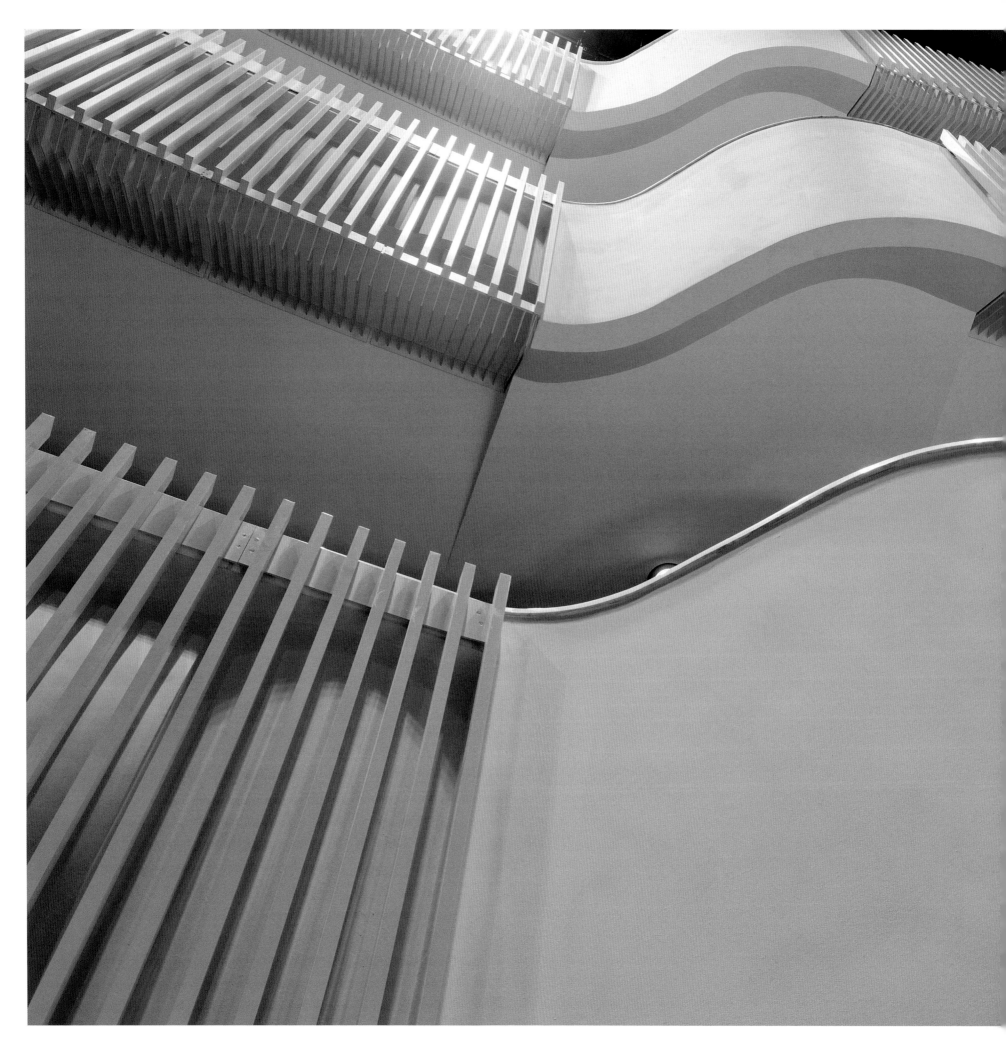

AALTO-MUSIKTHEATER

ESSEN

GERMANY

T

he Alvar Aalto style is recognizable at first glance: from its fluid outlines and asymmetrical shapes. The choice of materials and treatment of light reminds spectators of the "architectural humanism" that is probably the Finnish architect's most essential quality. And yet Alvar Aalto did not personally carry out his design for the Essen Opera House.

Located in the Ruhr, Germany's industrial stronghold, the city of Essen was severely damaged during the Second World War. After the war, it had to rebuild fast and as cheaply as possible: Austere, monotonous concrete buildings rose out of the earth. Once the housing challenge was met, it was time for culture. In 1958, the city held an architecture competition for the construction of a new opera house. The lucky winner was none other than Alvar Aalto, whose aesthetic approach centered on an organic dimension, a far cry from the pure functionalism of the post-war years. Expectations were tremendously high: This would be the Finnish architect's first opera house. Unfortunately, the project had a long and twisted road ahead. For one thing, Aalto had to constantly revise his design to reduce construction costs. He died in 1976 before a single stone had been laid. There was every indication that this opera house would join a long list of abandoned projects.

But in 1983, the city of Essen finally decided to see Aalto's opera house through to completion without him. His widow would supervise the building's construction. Aalto's plans and initial sketches were closely examined, and in 1988 a new vessel for opera was inaugurated just a few steps from the Essen train station. As always with Aalto's work, the relationship to nature is crucial: The opera house is located in the middle of a park in the heart of downtown. The stage house is completely integrated into the roof, which makes the structure impossible to recognize as an opera house from the outside. Its musicality is to be found in its outlines. The gray granite façade provides the entire edifice with a dynamic rhythm through its curves and the placement of its windows.

Inside, the architect used his favorite materials, wood and marble. In Aalto's designs, the use of marble—which he particularly appreciated for its durability—is never ostentatious but creates a sensation of purity and poetry. The auditorium is fan-shaped, with an amphitheater orchestra and three balconies. The fan shape provides the entire audience of 1,025 with a feeling of intimacy, particularly since the upper balconies remain very close to the stage. The harmonious blend of blue walls and white balcony partitions is undoubtedly surprising. Yet this floor plan is not exceptional from an acoustic point of view, though reflectors have been installed to improve the room's acoustics. Thankfully the Essen Opera House is not the acoustic disaster of the Finlandia Hall that Alvar Aalto built in Helsinki, also fan-shaped but with an abundance of marble, hence the mediocre sound. Aalto placed so much importance on the spectators' physical comfort that he sometimes overlooked the acoustic factor. The shortcomings of his performance spaces may also have to do with the fact that he spent very little time in theaters and concert halls.

One is occasionally surprised to note a lack of attention to detail in the Essen Opera's public areas, which Aalto would likely not have stood for. But let's not spoil our fun: Though built posthumously, the opera house remains a thrilling testament to the Finnish architect's art. The opera house and its neighbor, the Philharmonie, which was renovated in 2003–2004, have given this Essen neighborhood a musical identity.

OPPOSITE, TOP *The glass openings provide the façade with a dynamic rhythm.*
OPPOSITE, BOTTOM *The balconies are pure white.*
PAGES 14–15 *Blue and white alternate in the fan-shaped auditorium.*

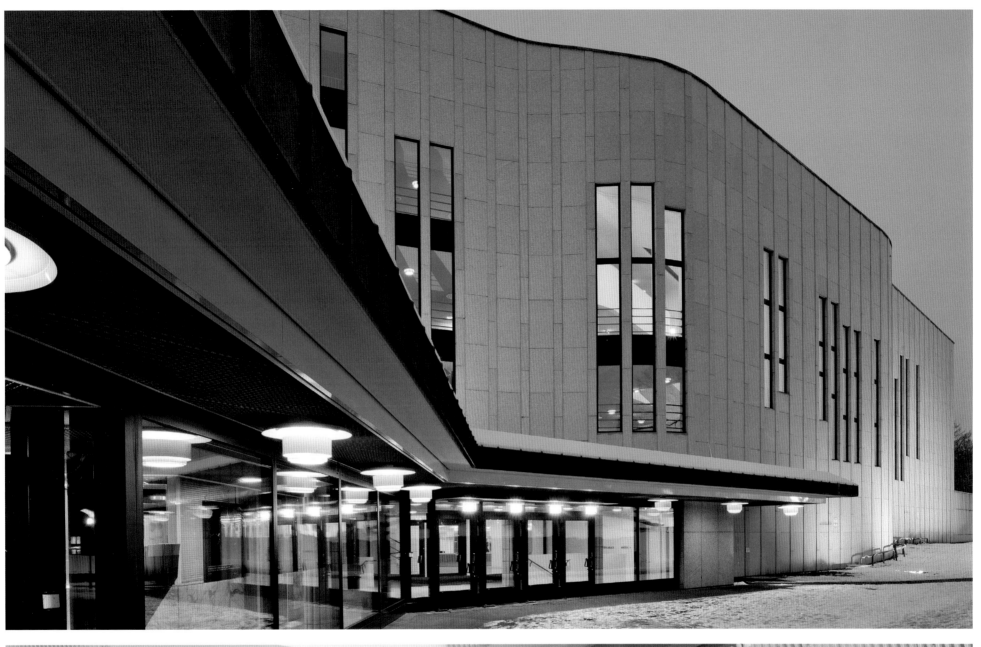
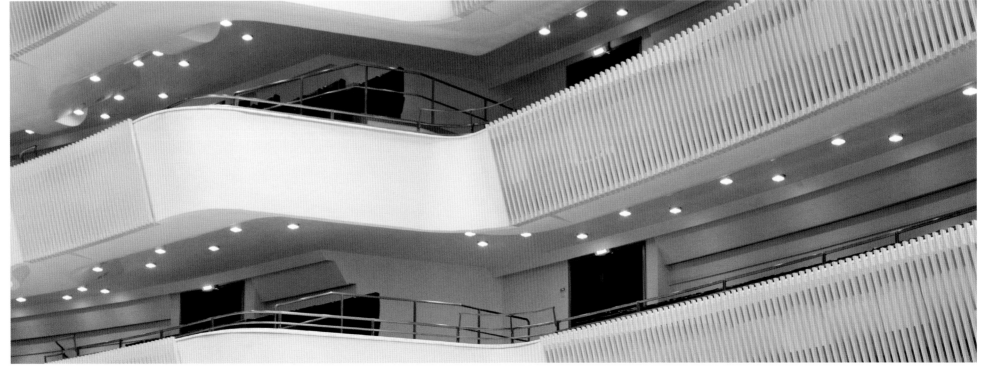

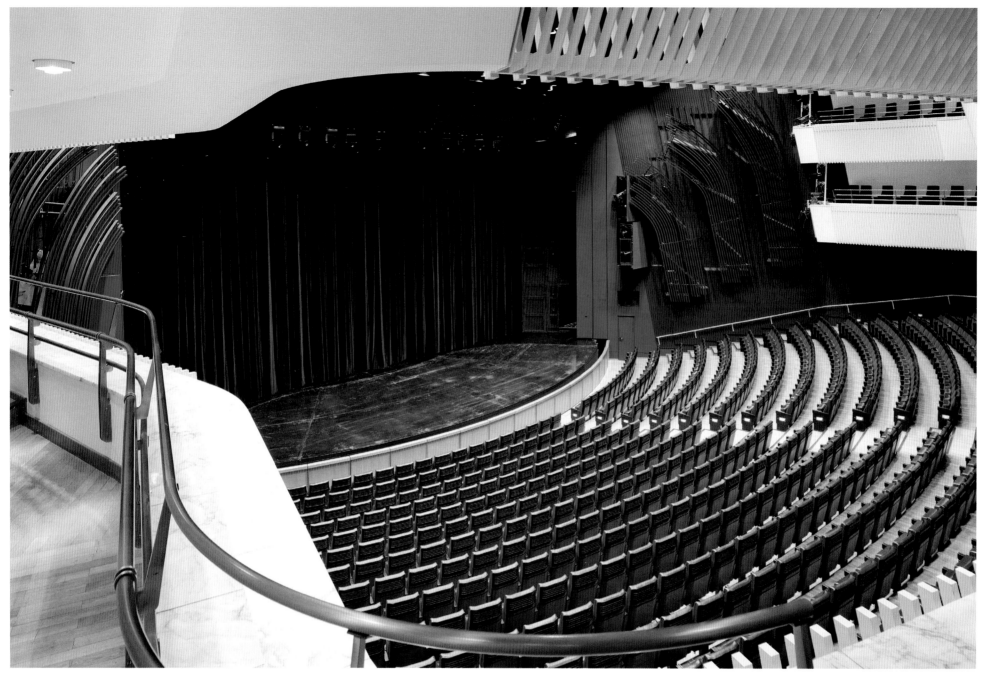

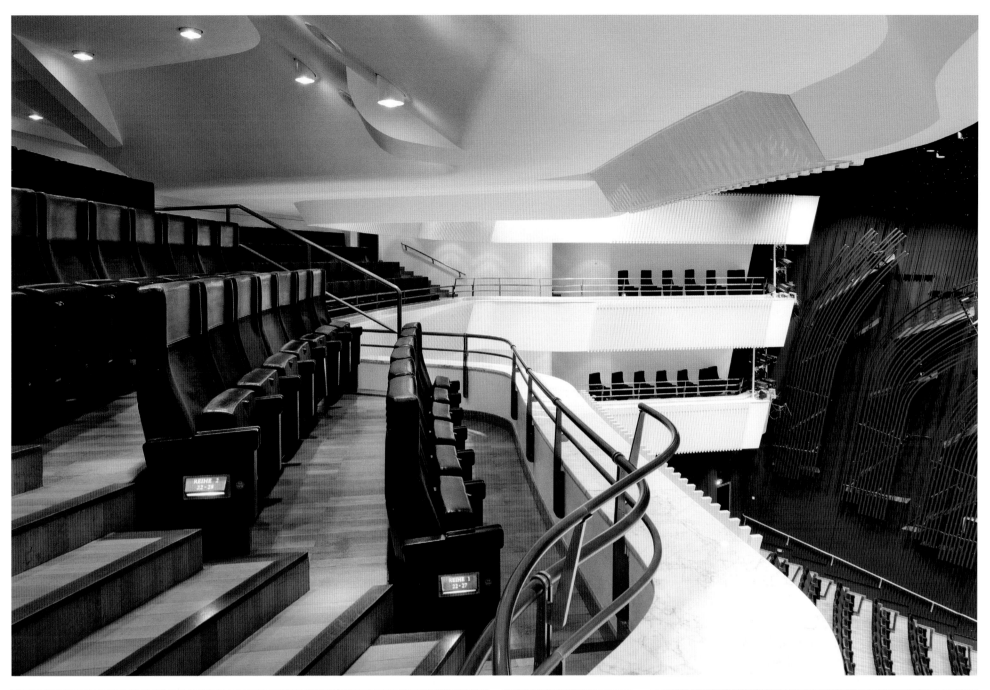
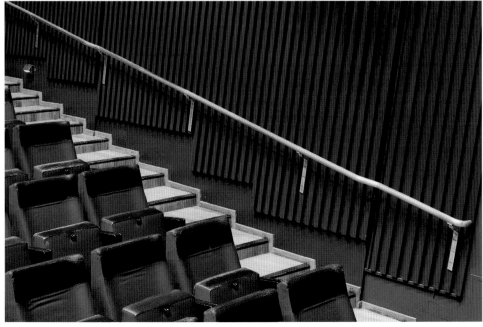
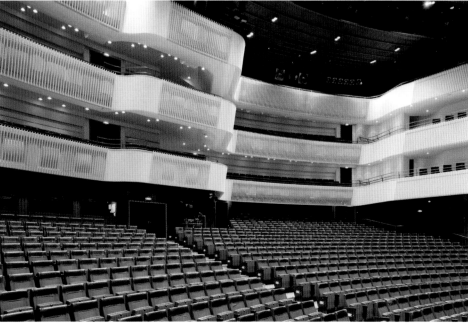

PARKETT >
BALKONE

The dazzlingly bright foyer also has some marble detailing.

BOLSHOI THEATER

MOSCOW

RUSSIA

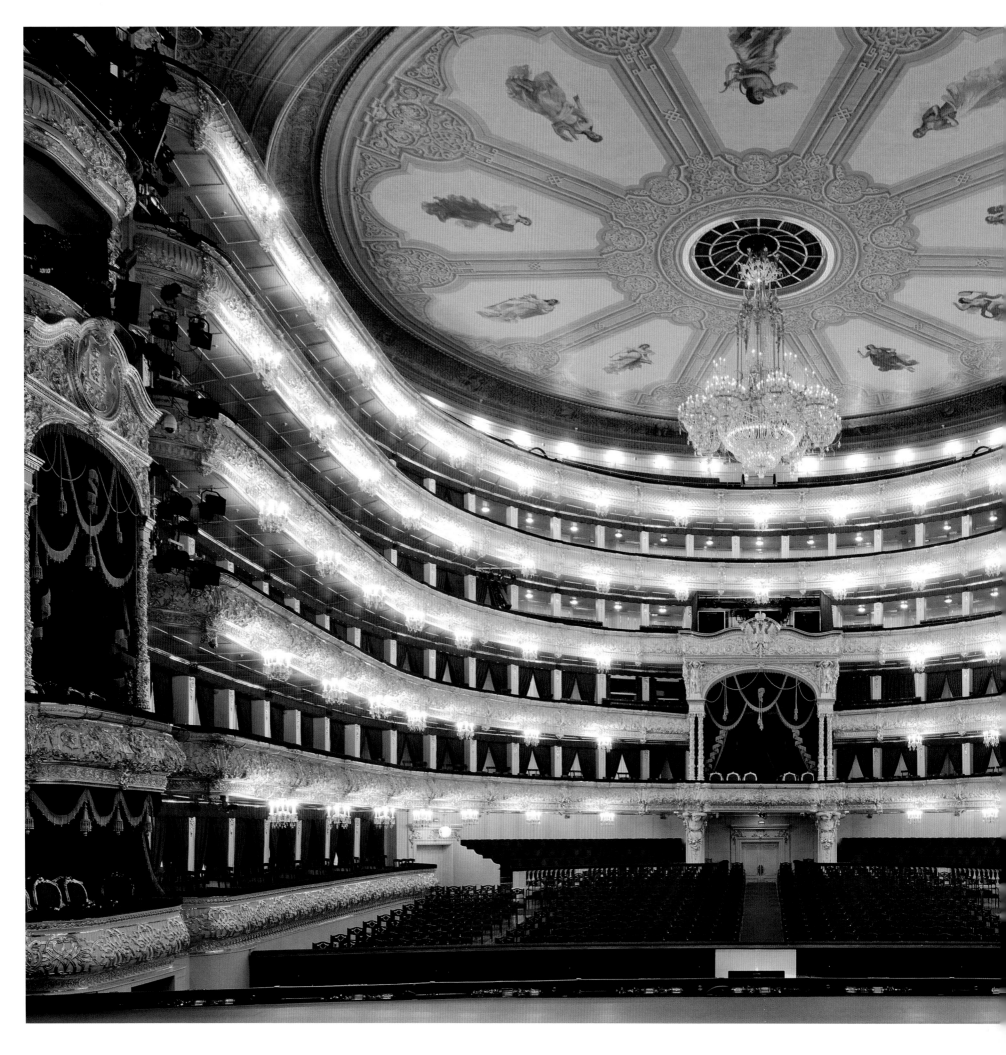

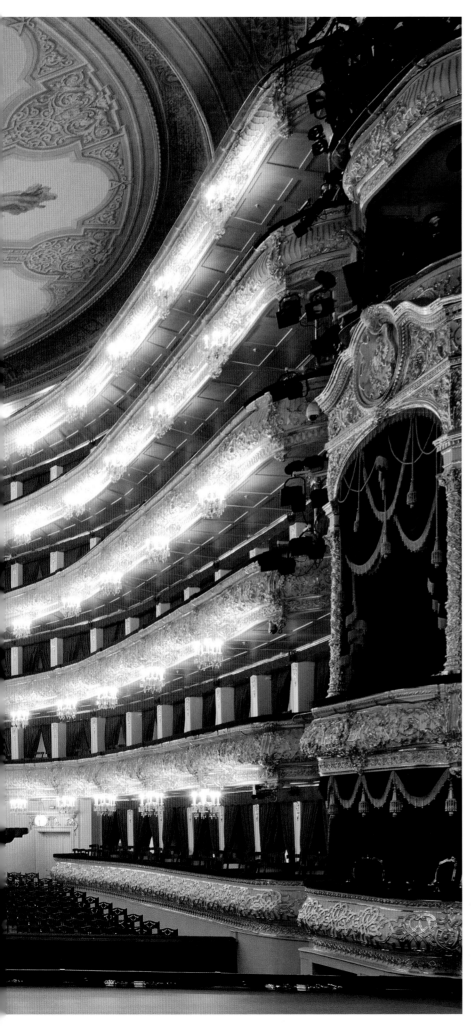
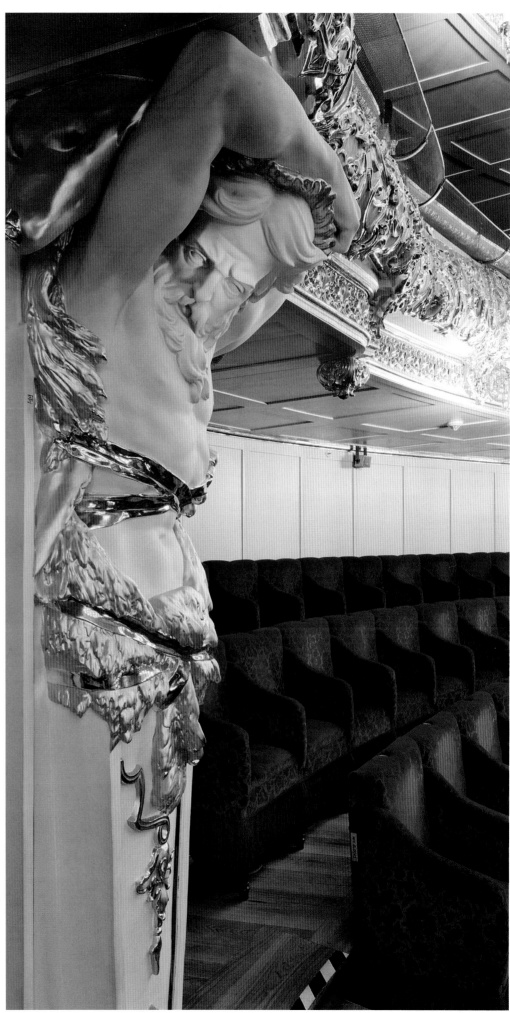

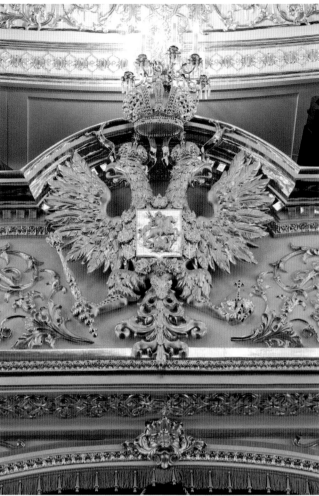
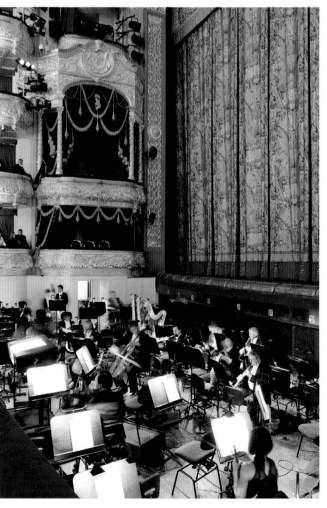

fter six years of work by some 3,000 workers at a total cost of €580 million, the Bolshoi Theater reopened on October 28, 2011. The occasion was celebrated with a gala featuring singers from all over the world, including Natalie Dessay, Angela Gheorghiu, and Plácido Domingo, and was broadcast live on television and in hundreds of movie theaters. This sumptuous event served as a reminder of the importance of this Moscow theater, whose name means "grand."

This was not the Bolshoi's first restoration. The first theater on this site in the center of Moscow was built in 1776. The goal at the time was to compete with the artistic riches of Saint Petersburg. But a few years later the edifice was engulfed by flames. Construction of a new opera house was entrusted to architect Joseph Bové, who had participated in the reconstruction of Moscow after the fire of 1812, and his colleague Andreï Mikhailov. Unfortunately, history was to repeat itself: The theater burned, and only the exterior walls and portico were saved.

The Bolshoi Theater we know today dates from the reconstruction of 1856, which was completed by Alberto Cavos, who also built the Mariinsky Theater in Saint Petersburg—the Bolshoi's eternal rival. It is an imposing structure of grandiose proportions, with no less than eight columns lining its façade. A typically neoclassical pediment is topped by a statue of Apollo in his horse-drawn chariot, which has come to symbolize the building. The interior is equally over-the-top. The red and gold main

PAGES 20–21 *The crimson and gold auditorium has 1,700 seats.*
OPPOSITE AND RIGHT *Completed in 2011, the theater's renovation restored the gilding to its original glory.*

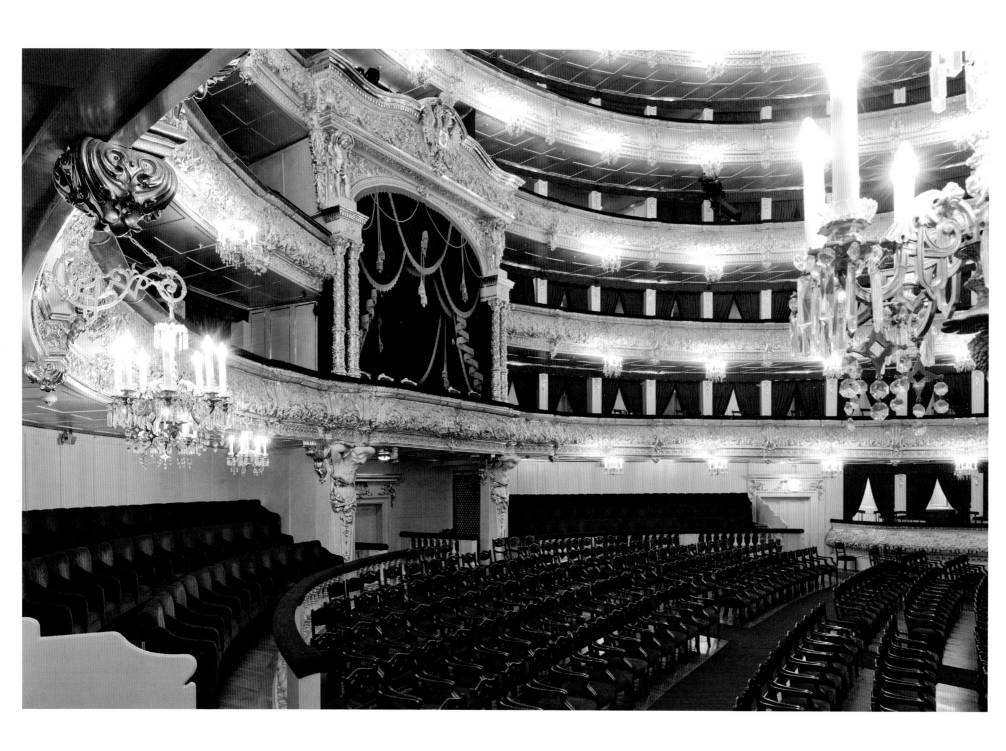

More than opera, dance has always been given pride of place at the Bolshoi.

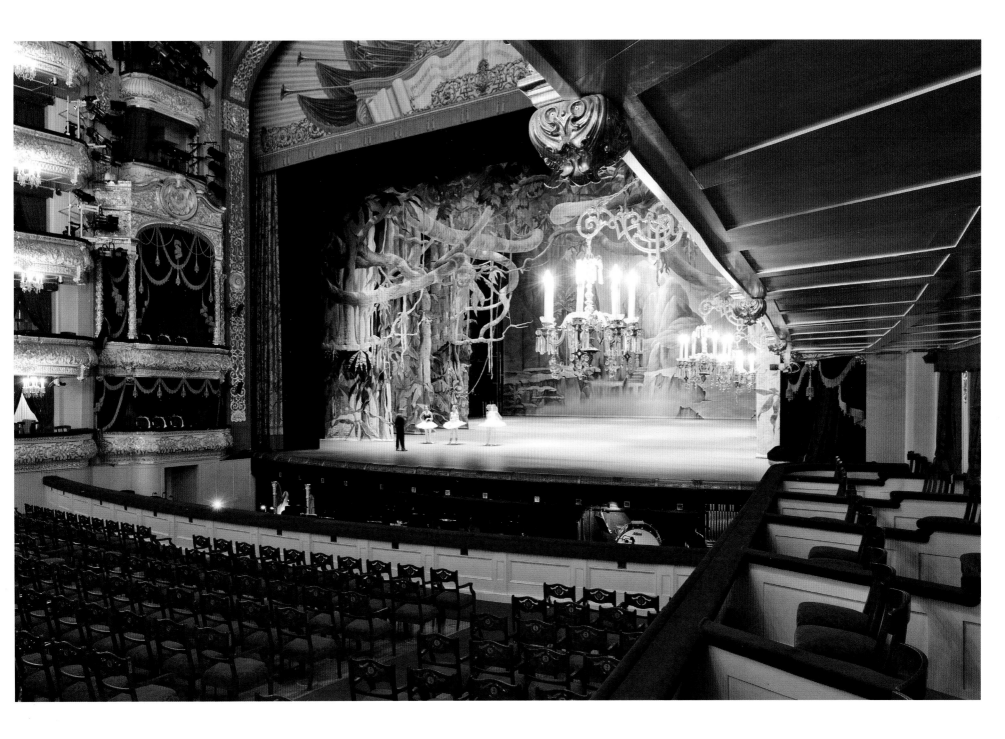

auditorium has four balconies and a gallery and was intended to hold more than 2,000 seats, though today's safety standards have limited the number to 1,700. The floor plan is a hybrid of a horseshoe and a U shape. The main foyer is equally majestic; only the staircase is slightly more modest, unlike the extravagant staircase at the Palais Garnier (see page 137).

Aside from returning the theater to its original state, the most recent renovation improved the auditorium's acoustics (the concrete under the orchestra seats was removed) and the artists' working conditions. A modular theater with 300 seats has also been built on basement level six.

Throughout its history, the Bolshoi has produced the leading operas of the Russian repertoire: Tchaikovsky's *The Voyevoda* in 1869, Rachmaninoff's *Aleko* in 1893, and Prokofiev's *War and Peace* in 1959. But more than opera, the Bolshoi is known for its commitment to dance, notably with the premiere of Tchaikovsky's *Swan Lake* in 1877. In fact, tickets for dance performances are still more expensive than opera tickets.

Yet the Bolshoi is not just a place for art. Due to its position a few steps from the Kremlin and Red Square, the theater was a major site for political gatherings in the Communist era. It was here that the Union of Soviet Socialist Republics was proclaimed in December 1922 and that the congresses of the Communist International were held under Lenin. As for Stalin, he never missed the opening of a new production.

Today the Bolshoi is under the direct authority of the president of Russia and has close to 3,000 employees, including 1,000 dancers, singers, and musicians. It remains one of the most famous stages in the world.

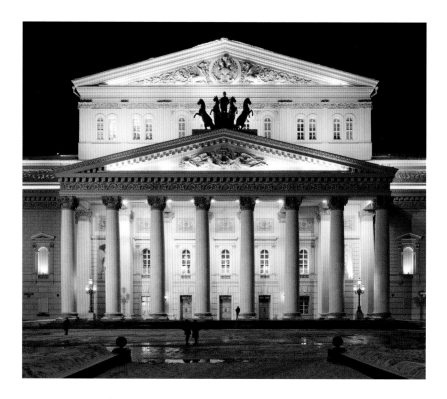

ABOVE *The statue of Apollo's chariot atop the façade has become the building's symbol.*

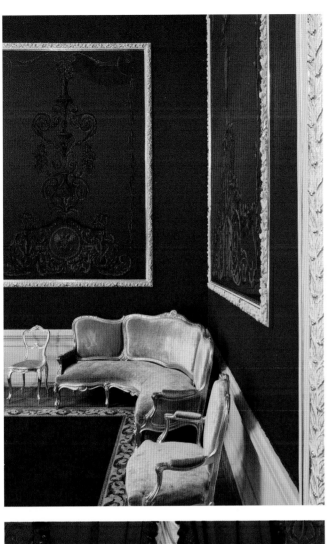

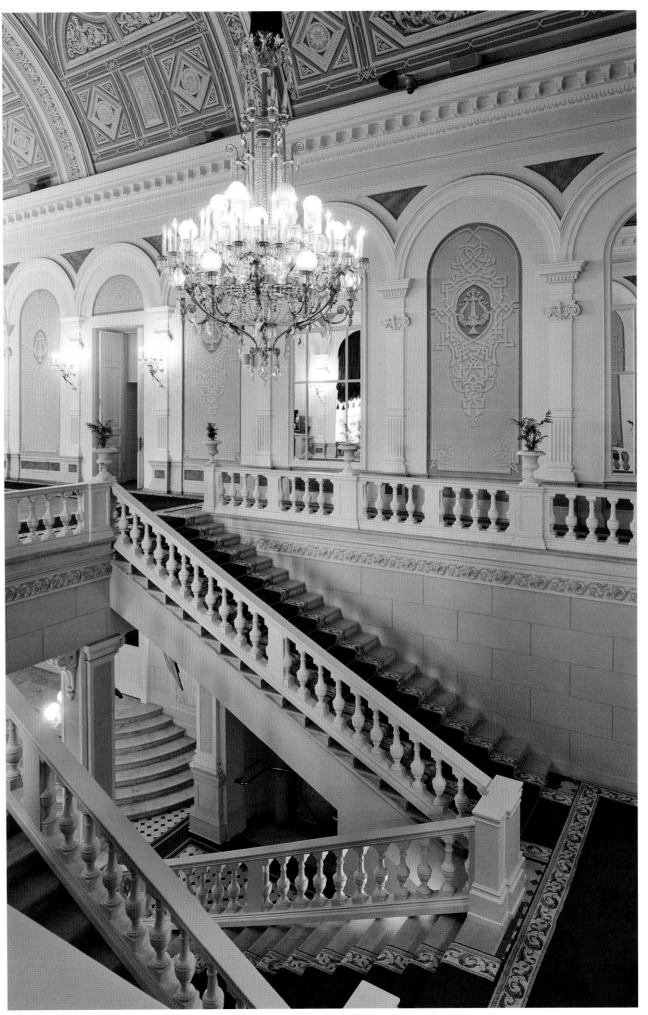

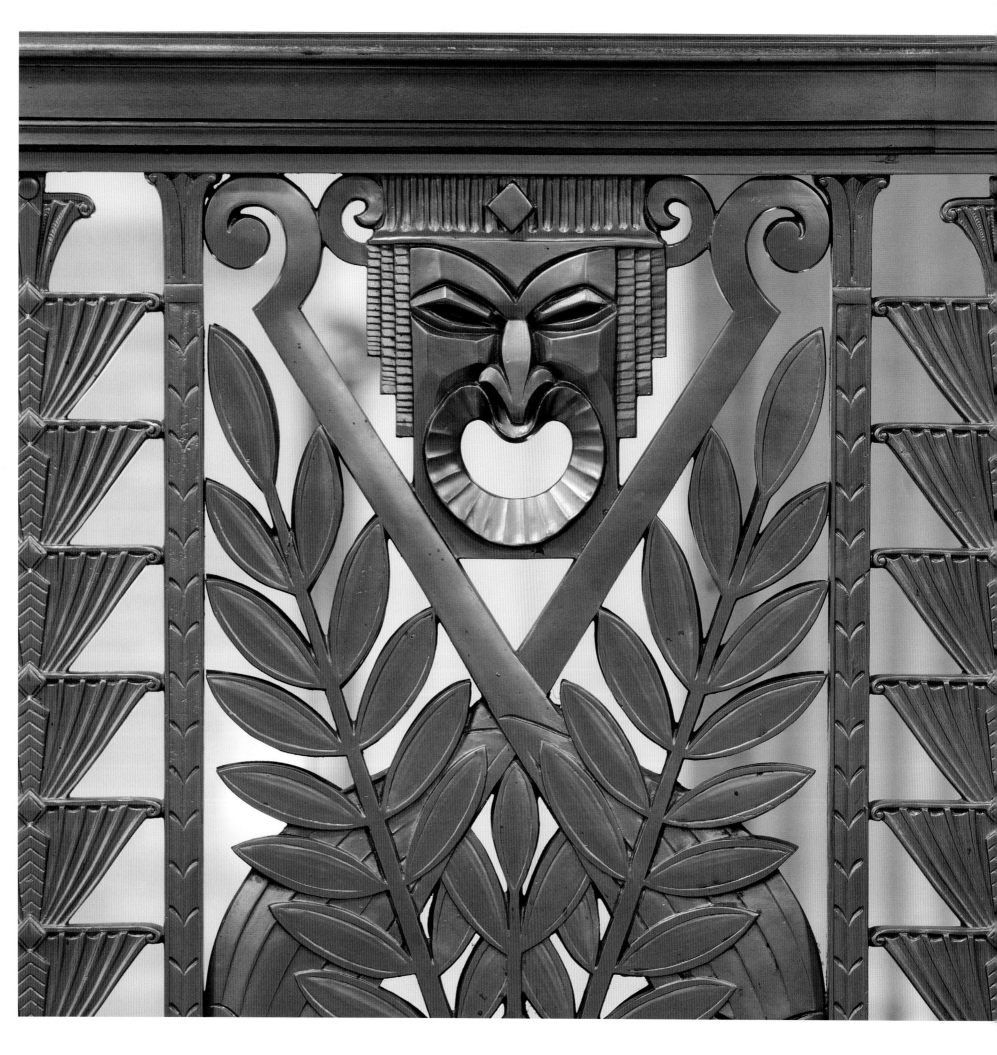

CIVIC
OPERA
HOUSE

CHICAGO

UNITED STATES

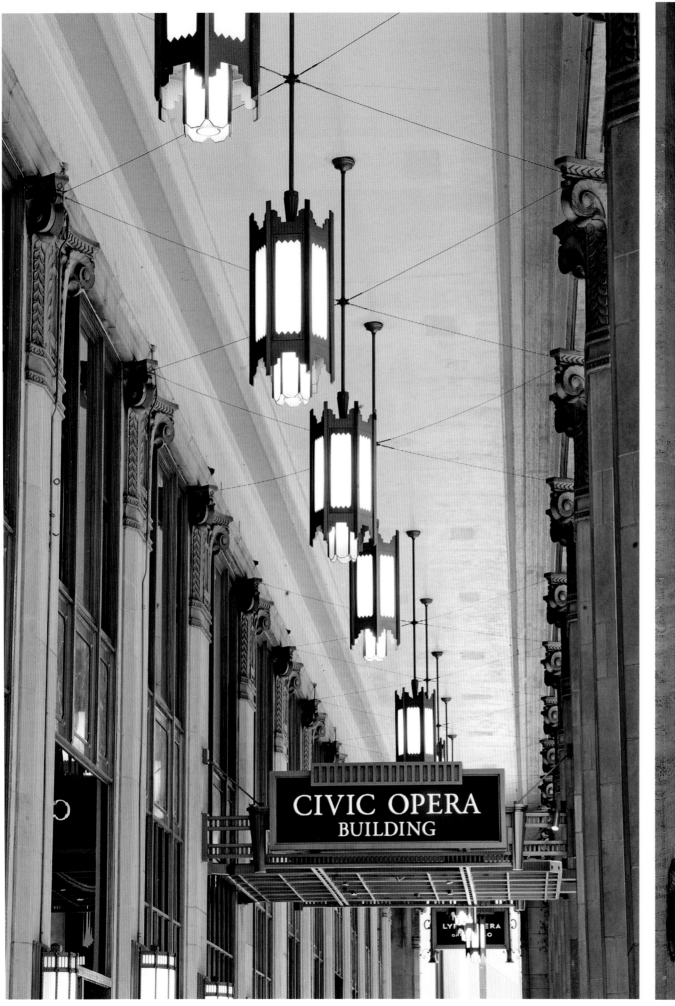

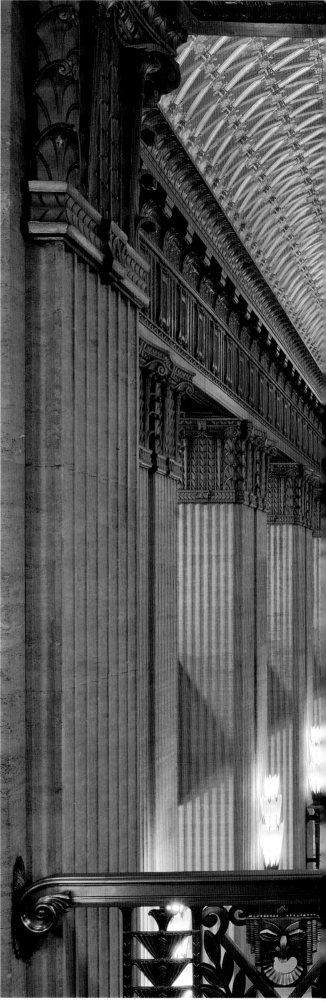

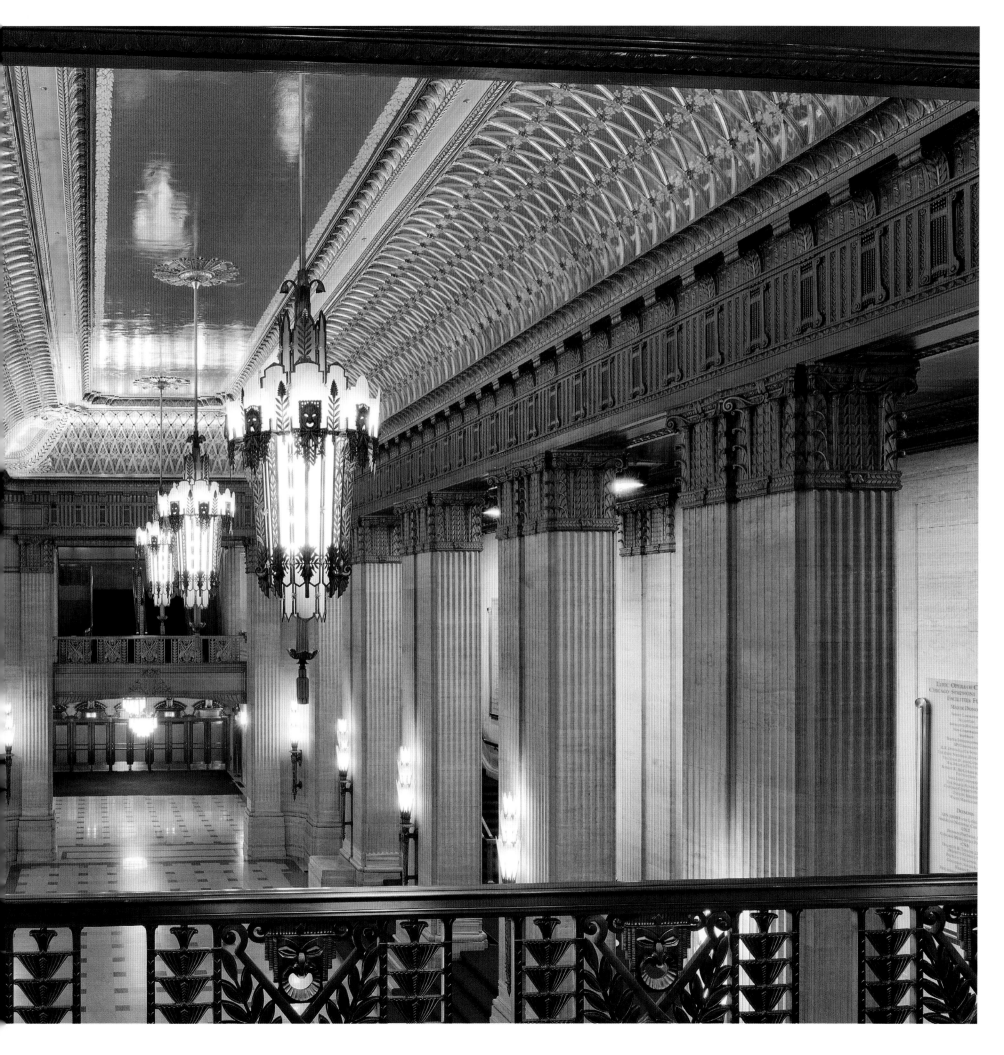

hicago is heaven for architecture lovers, who travel there to admire some of the most beautiful skyscrapers in North America. The city's opera facilities are no exception. The Civic Opera House is inside a building that was erected between North Wacker Drive and the banks of the Chicago River in 1929. The art deco edifice consists of a forty-five-story tower with a pair of twenty-two-story wings. Locals traditionally compare it to a throne, with a seatback and two armrests. Most of the building consists of office space, but in an original twist it has an opera hall on its lower floors. The building was commissioned by the investor Samuel Insull, former secretary to Thomas Edison, who handed over the vast project to the architects Graham, Anderson, Probst & White. Their Chicago firm was responsible for several notable structures in the city, including the Field Museum of Natural History and the Wrigley Building.

To enter the opera house, theatergoers pass under a façade by Henry Hering, an American sculptor educated at the École des Beaux-Arts in Paris. Intriguing sculptures are scattered among the traditional columns and pediments: naked women, commedia masks . . . Welcome to the fantasy world of opera!

The auditorium is typical of the excess often found in American performance spaces. With 3,565 seats, the Civic Opera is just a hair smaller than the Metropolitan Opera in New York, which has some 3,800 seats (see page 108). The fan-shaped hall includes an orchestra and two wavy balconies. The rich and colorful interior decoration by Jules Guérin shifts from red to gold to pink. The stage curtain boldly depicts scenes from famous operas, including the triumphant march in Verdi's *Aida*.

For many years, this opera house struggled financially. The theater was inaugurated six days after the stock market crash of October 1929, which drove the initial opera company to bankruptcy. The venue was then shared by three opera companies

The interior spaces are filled with art deco–style detailing.

in the 1930s and 1940s, but none survived. The Lyric Theatre (now called the Lyric Opera of Chicago) began renting the facility in 1954, then bought it in 1993 and undertook a major renovation. The company also acquired neighboring structures, including several movie theaters, to expand its rehearsal spaces. The bill came to $100 million. In 2012, a New York real estate holding company bought the rest of the Civic Opera Building for $126 million and now rents out the office floors at top dollar.

The idea of putting an opera house in a skyscraper caught on in Japan: The New National Theatre, inaugurated in 1997, is located on the ground floor of a Tokyo building (see page 116). In the early 2000s, the New York City Opera commissioned architect Christian de Portzamparc to design a similar project, but it was later canceled for financial reasons.

The Civic Opera House's auditorium is known for its fan-shaped floor plan.

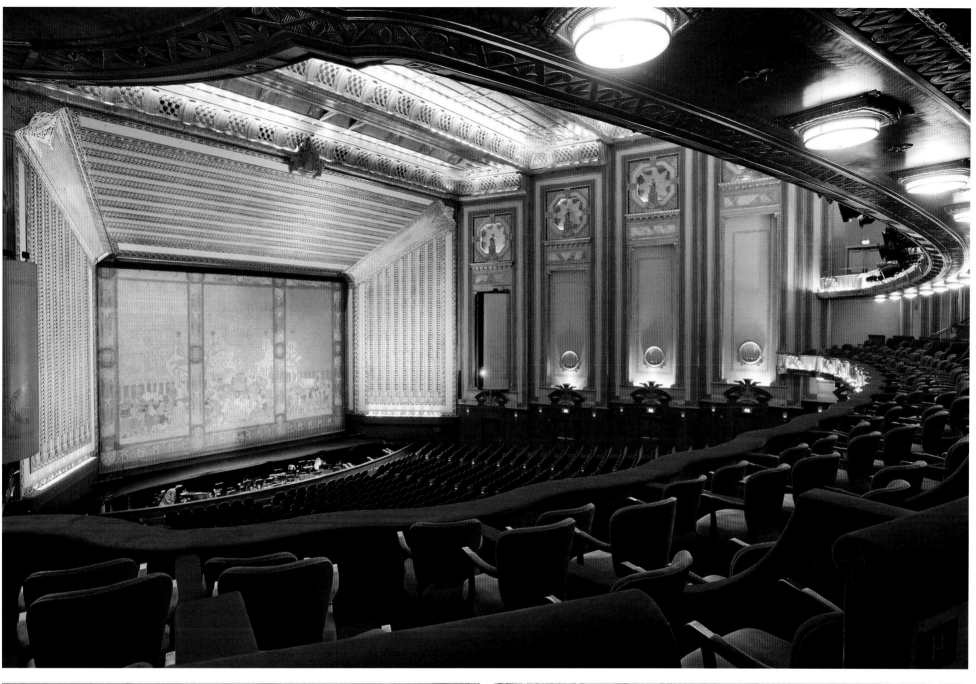

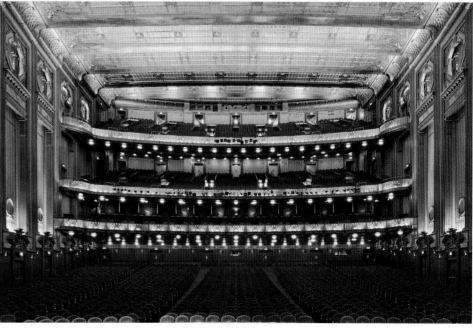

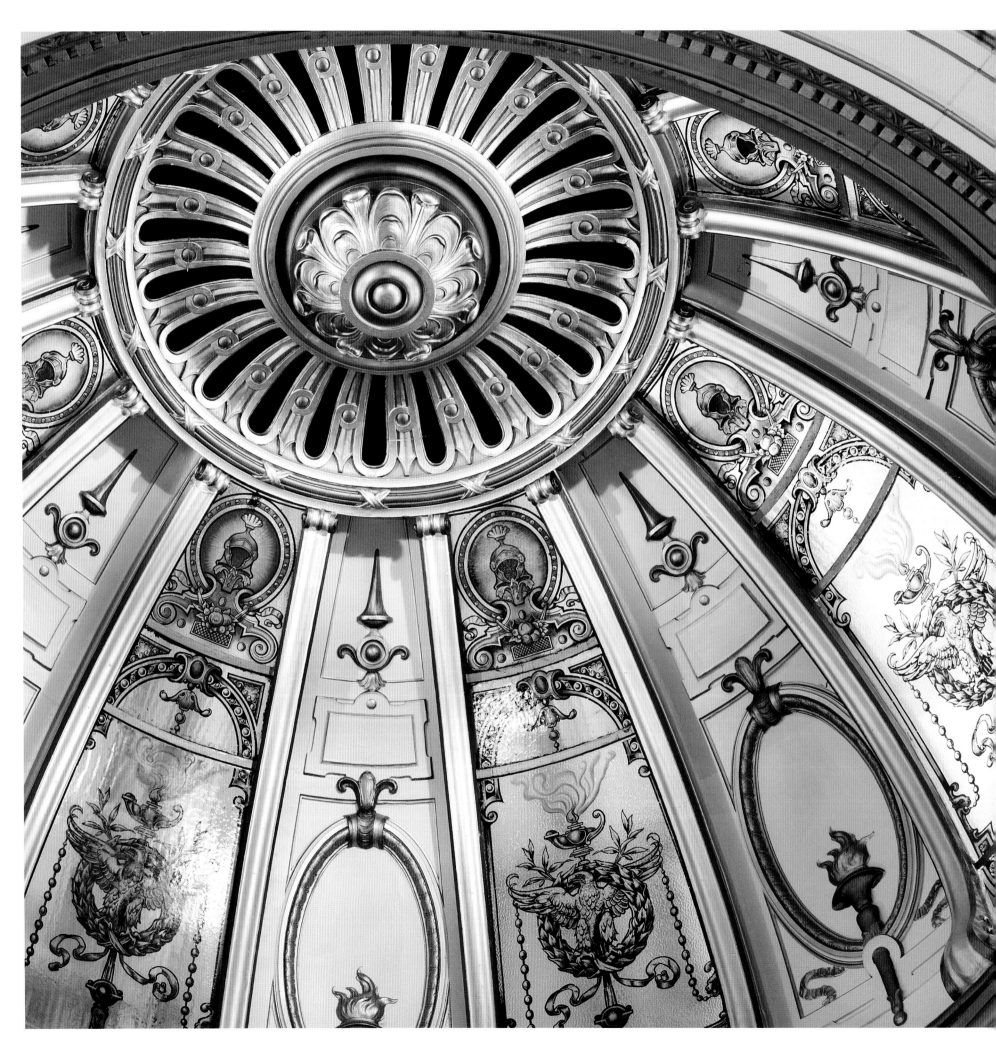

COLISEUM

LONDON

GREAT BRITAIN

T hough London's two opera houses, the Royal Opera House and the Coliseum, are both located near Leicester Square, they have little else in common. While the Royal Opera House (see page 152) is famous the world over, the Coliseum is mostly known to English audiences. And for good reason: At the Coliseum, all the operas are performed in the language of Shakespeare. *Die Zauberflöte* becomes *The Magic Flute*; *Il barbiere di Seviglia*, *The Barber of Seville* ... But artistic quality is not sacrificed—far from it. Great conductors such as Colin Davis, Edward Gardner, and Charles Mackerras have succeeded one another at the head of the English National Opera, the Coliseum's resident company. The atmosphere in the two houses is also completely different: The Royal Opera House is the chic place to see and be seen, while the Coliseum has a far more relaxed family atmosphere.

The two buildings are architectural opposites as well. Inaugurated in 1904, the Coliseum was built by the architect Frank Matcham, who also designed the Palladium Theatre in London. His style is joyously eclectic, a far cry from neoclassical theaters such as Covent Garden. The edifice stands out on St. Martin's Lane because of its belfry-like tower surmounted by a luminous globe. Thanks to the tower, the theater is visible from a great distance and can even be identified in aerial photographs of London. Its proportions are colossal: With 2,359 seats divided among an orchestra and three balconies, the Coliseum is the biggest theater in London. Its revolving stage long made it one of the most technically advanced theaters, and it was one of the first in London to be lit electrically. The foyers offer audiences a perfect opportunity to admire typically Edwardian decor.

Originally, the Coliseum did not stage operas: It was built for producer Oswald Stoll, who used it to present variety and music-hall shows. The Ballets Russes performed here in 1917. During the Second World War, the theater was requisitioned

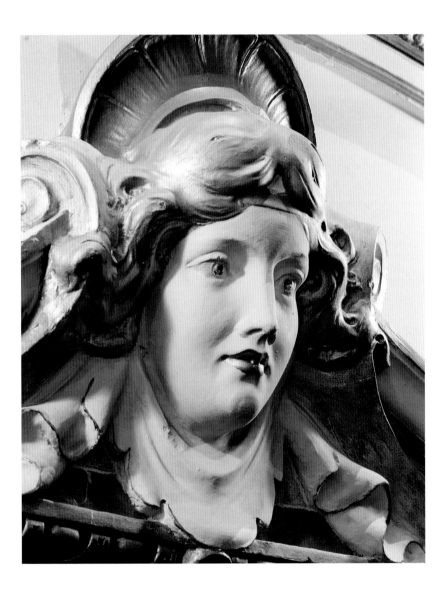

With 2,359 seats, the Coliseum is the biggest theater in London.

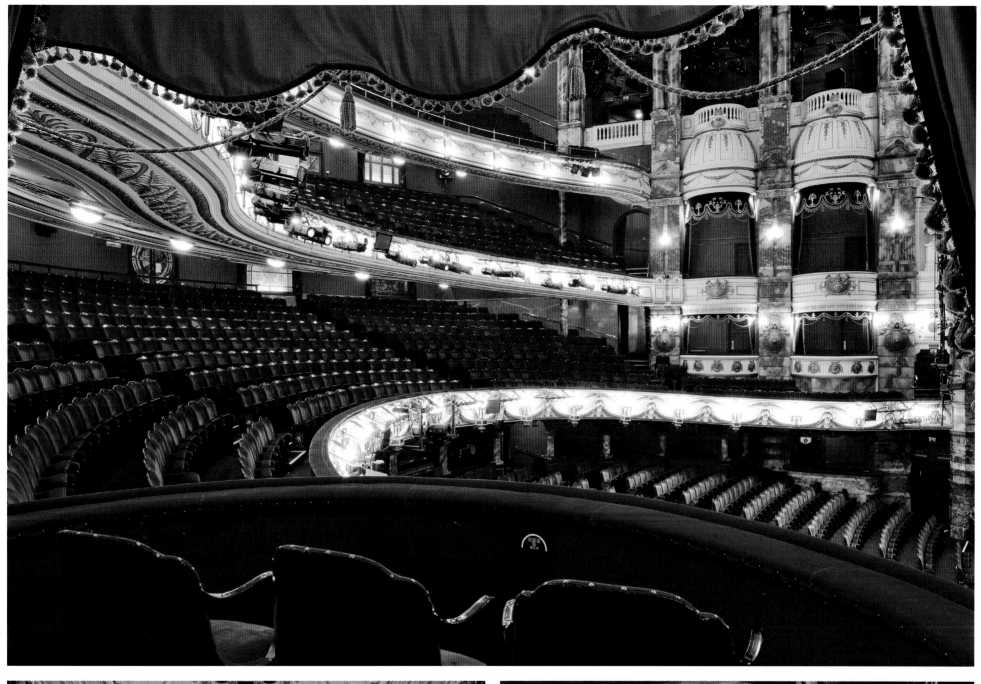

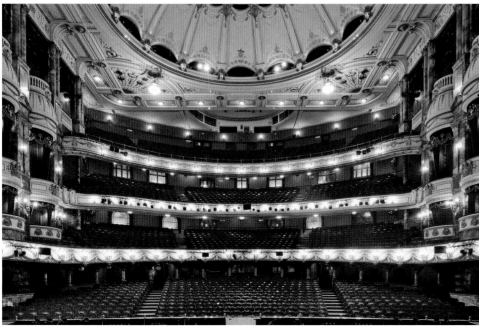

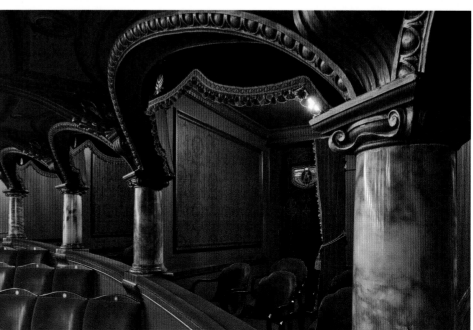

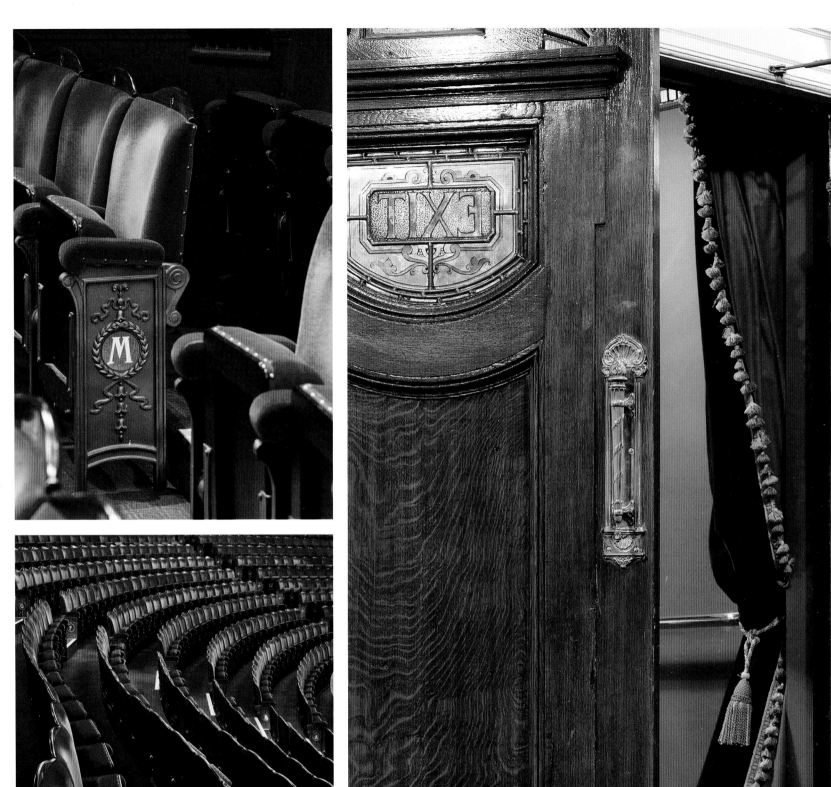

for use as a mess hall for patrols assigned to civilian air raid protection. After the war, American musicals were on the marquee, but not for long: In 1961, the theater was repurposed and turned into a movie house by MGM. For seven years, London's crème de la crème packed the screenings of movies, such as *Gone with the Wind*. Then the Hollywood studio relinquished the theater to the Sadler's Wells Opera Company, which changed its name to the English National Opera in 1974.

The opera company had been feeling cramped in its theater in the north of London and successfully made the transition to the Coliseum, despite its daunting audience capacity. Aside from the major titles of the opera repertoire, contemporary operas were also brought to the fore, notably with the premiere of Harrison Birtwistle's *The Mask of Orpheus* in 1986. In 1992, the English National Opera acquired the Coliseum for £12.8 million. Following an extensive renovation from 2000 to 2004, the theater was returned to its former glory, and new public areas were created. Sadly, the English National Opera is currently facing tremendous financial challenges: In 2012 the company lost close to £2.2 million and the 2011–2012 season drew only 188,000 spectators, for an attendance level of seventy-one percent. The economic and financial crisis has not spared the biggest London theater, which is currently trying to diversify its financing.

The renovation carried out from 2000 to 2004 restored the grandeur of the Coliseum, down to the details of its Edwardian decoration.
PAGES 42–43 *The seating is divided among an orchestra and three balconies.*

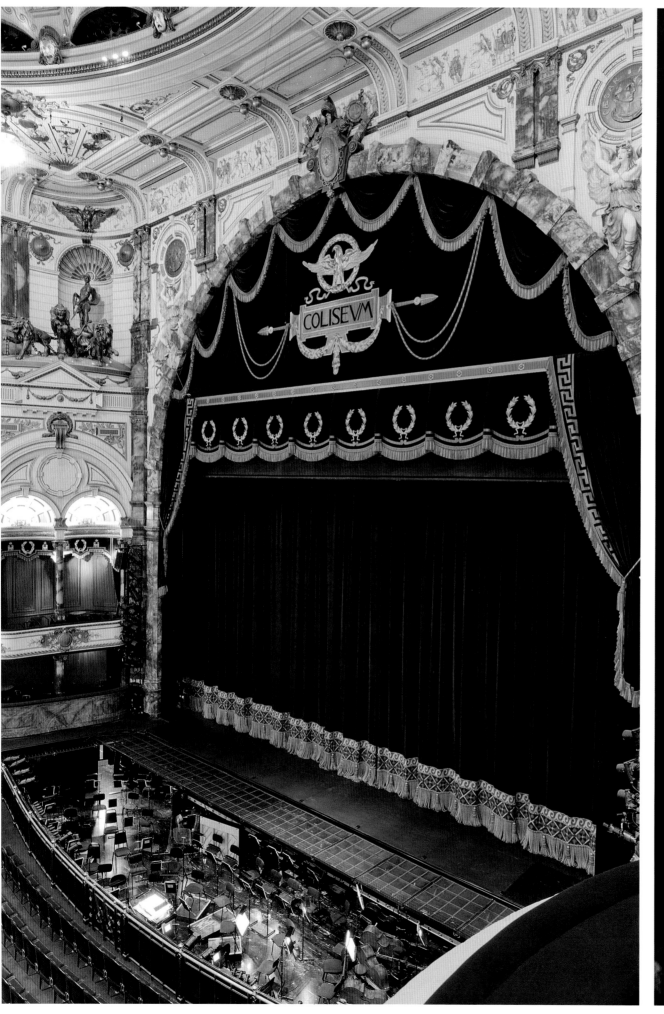

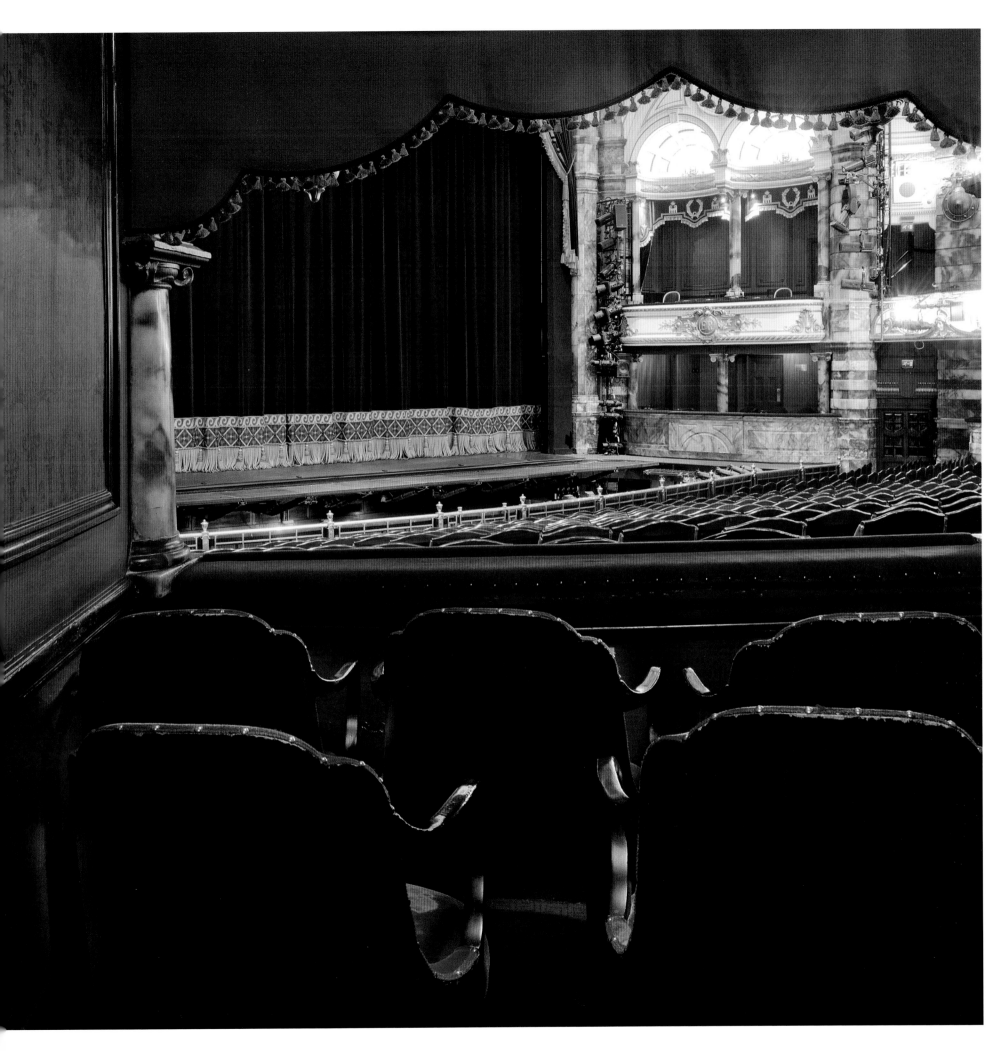

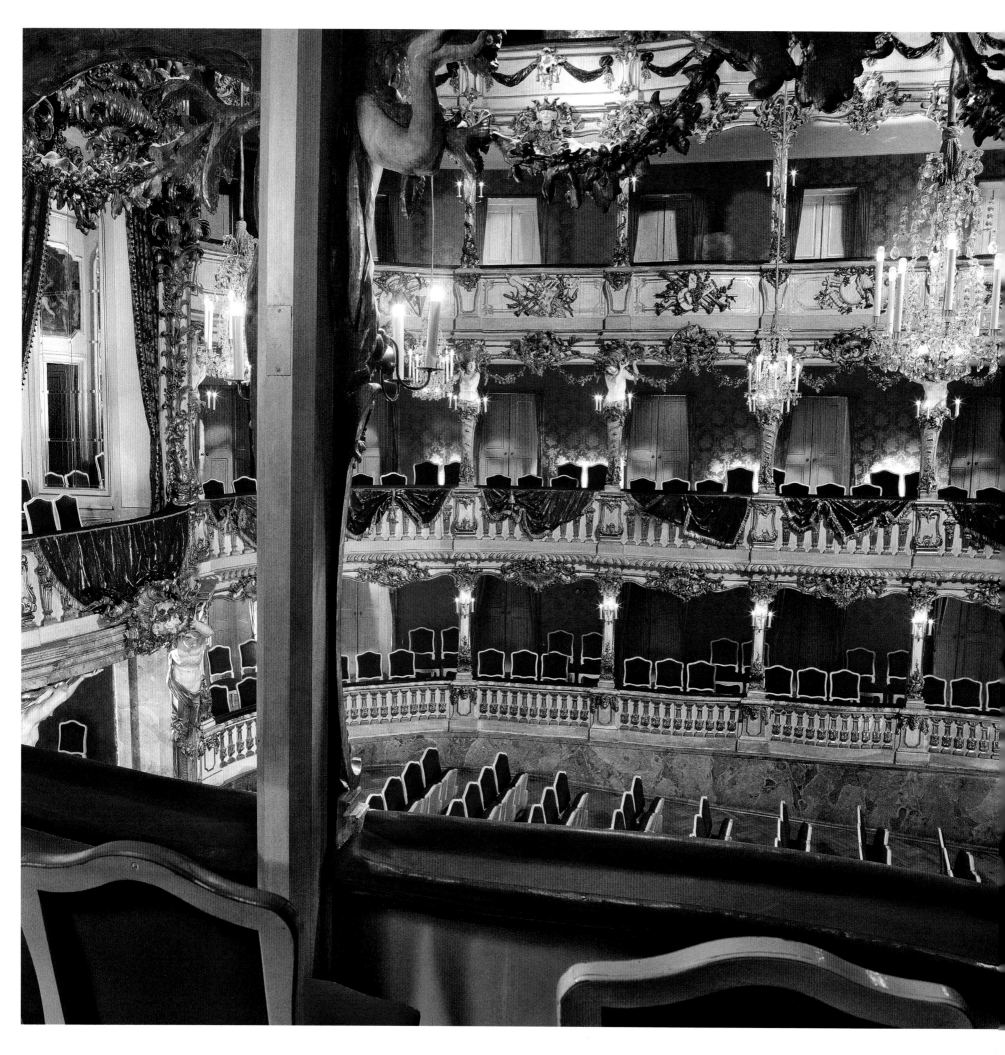

CUVILLIÉS THEATER

MUNICH GERMANY

In 2008, after four years of renovation, the Cuvilliés Theater celebrated its reopening with a series of performances of Mozart's *Idomeneo*—a highly symbolic choice, for Mozart's opera premiered in this very theater on January 29, 1781. A commission of Charles Theodore, Prince-Elector of Palatinate and Bavaria, this triumph of *opera seria* was performed three times, in the presence of the entire Mozart family. At the time, the Cuvilliés Theater had been in business a little under thirty years.

Built inside the Residenz, the prince-elector's palace in the heart of Munich, the theater took its name from its architect. Originally from Hainaut, a Belgian province then under the control of Bavaria, François de Cuvilliés spent most of his life working at the court of Munich, where he became one of the masters of the Bavarian rococo style. After designing the Residenz's interior, he was asked by Prince-Elector Maximilian III Joseph to build a theater inside its walls. Inaugurated in 1753 with Giovanni Battista Ferrandini's *Catone in Utica*, the auditorium is one of the most beautiful baroque opera houses in the world. It is an intimate space with only 523 seats, all in sumptuous red and gold. The decor depicts a variety of plant forms (flowers, palm trees, fruits) with rare precision. The four balconies are divided into boxes in the Italian style. After taking in the stage boxes, one is irresistibly drawn to the monumental center box supported by two Atlases and reserved for the prince-elector.

This fabulous auditorium could have disappeared during the bombing of Munich in the Second World War if some wise individual hadn't taken the initiative to disassemble the theater entirely and store the pieces in a safe place. The Residenz was indeed severely damaged by bombs, and after the war the theater was relocated to the former pharmacy, in another part of the palace. A few modifications were made: The stage was expanded, a revolving plate was added, and the dividers between the boxes were removed to create balconies in the French style. In 1958, Mozart's *The Marriage of Figaro* inaugurated the theater's new location. Today the Cuvilliés Theater is home to productions by the Bavarian State Opera, particularly small-scale operas and chamber music concerts. Like the theater's architecture and decor, the acoustics, which are both precise and enveloping, are stunning.

Built by François de Cuvilliés, the theater in the Munich Residenz is a masterpiece of rococo architecture.

DEN NORSKE OPERA OG BALLETT

OSLO

NORWAY

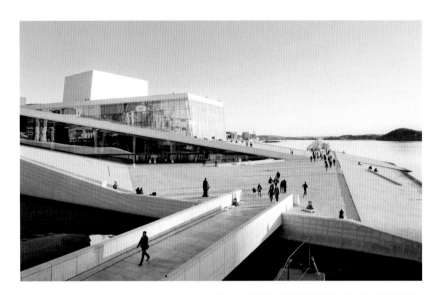

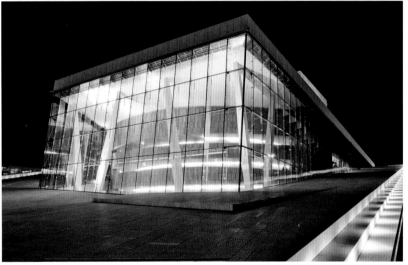

orway's oil revenue has allowed it to invest in culture. The Oslo Opera, inaugurated in 2008, cost a colossal €500 million. The payoff was immediate: This is the only opera house in the world to have won the prestigious Mies van der Rohe Award for contemporary architecture from the European Union.

The award was not bestowed upon a large architecture firm but the boutique Norwegian firm, Snøhetta, which had previously specialized in the construction of public buildings in Scandinavia and the Arab countries. With the Oslo Opera, this team did more than provide the Norwegian capital with remarkably functional equipment—it gave it a symbol.

The location was crucial: Built on the harbor, the opera house faces the fjords, creating a direct link between the city and nature. One can even access the building's roof to best enjoy the view. This architectural innovation has met with widespread success: Even in the dead of winter, you can find entire families on the building's snowy slope.

The opera house's other key asset is its materials. The exterior façade largely consists of dazzling white Carrara marble (more than 215,000 square feet of it), which blends with the snow in winter—and goes a long way toward explaining the building's cost . . . Snøhetta's architects also opted for large glass façades, revealing not only the auditorium's shape from the exterior but also the costume and set designers' studios in the wings—an unusual example of the principle of transparency so important in Scandinavia.

Wood dominates the interior. The acoustics of the main hall, whose floor plan is inspired by the Semperoper in Dresden (see page 156), were supervised by the Arup agency. Its sound has incredible depth, notably thanks to a particularly sonorous orchestra pit, typical of the Scandinavian conception of opera houses. The

LEFT *In Oslo, you can walk on the roof of the opera house.*
OPPOSITE *Inside the building is a successful alliance of glass and wood.*

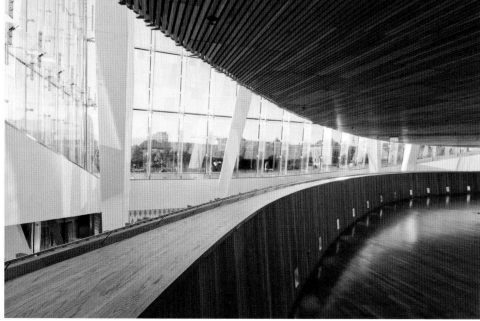

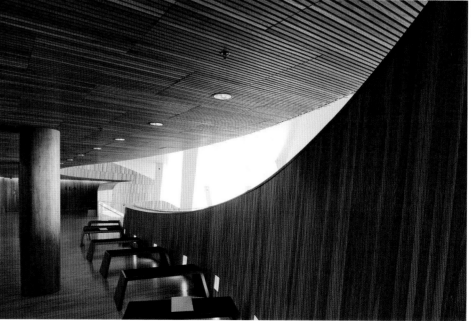

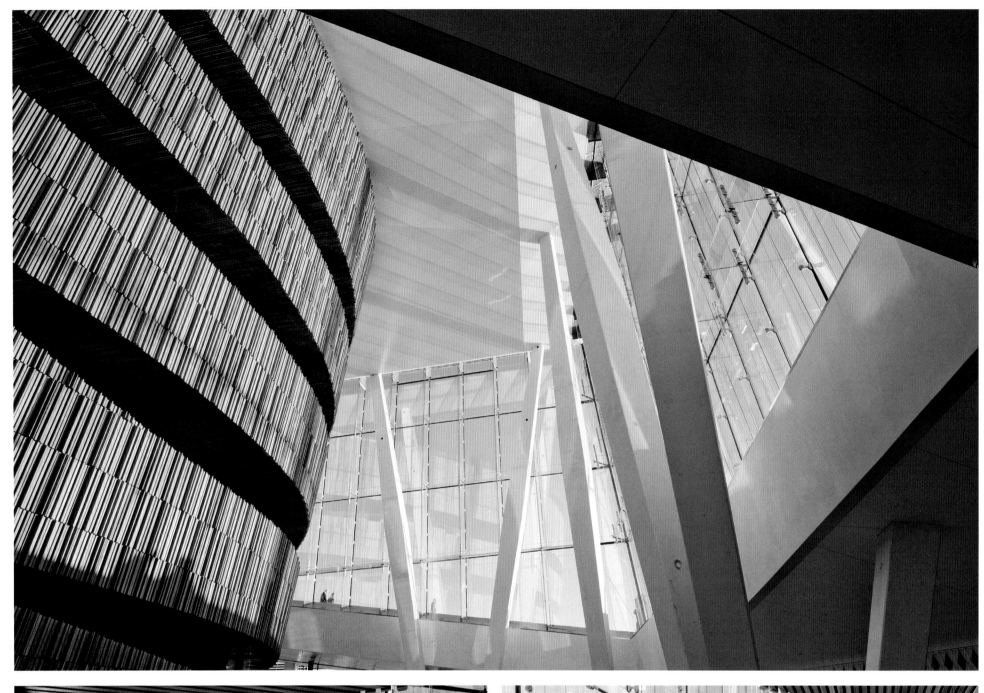
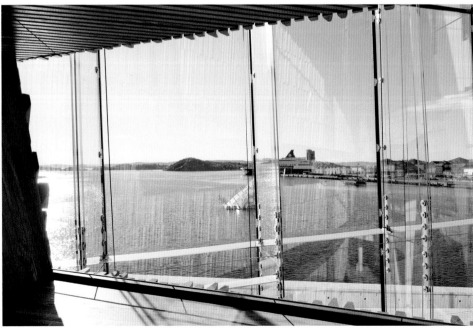
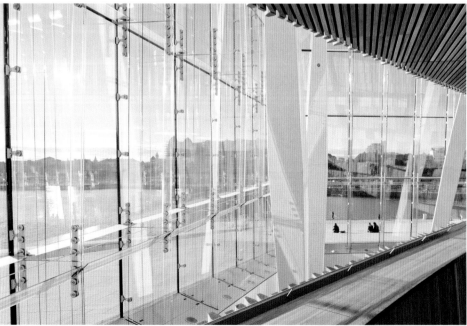

reverberation period is 1.7 seconds, a period halfway between opera theaters and symphonic halls. Unfortunately, some of the 1,364 seats have limited visibility, a tradeoff for a floor plan inspired by classical architecture. However, the audience enjoys the most high-tech equipment available, including screens on each seatback showing subtitling in eight languages.

A black box with metal panels serves as another concert hall dedicated to contemporary music. This dark experimental space contrasts with the rest of the building, which is stunningly bright.

The public areas were carefully thought out. The architects collaborated with famous designers such as Icelandic artist Olafur Eliasson, who designed the wall panels in the lobby. The complex also features restaurants, and even the arty restrooms are worth a visit!

The building's luxury is not limited to its public areas. All the working spaces, both artistic and administrative, are bathed in light, an essential quality for the inhabitants of Scandinavian countries, where sunlight is particularly rare in winter. The 600 employees gather at lunchtime to eat their *matpakke* (packed snack) in a canteen with a balcony overlooking the Oslo harbor.

Since the opera house's inauguration, the harbor neighborhood has been changing at a fast pace. New projects are constantly cropping up: a library, the Edvard Munch museum . . . In terms of contemporary architecture, Oslo will be generating buzz for some time to come.

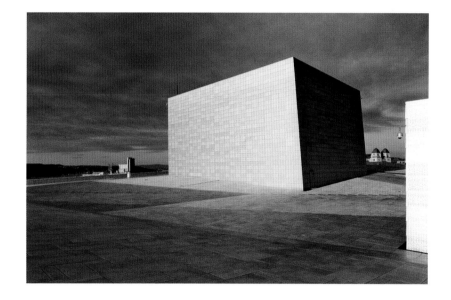

PAGE 52, TOP *The floor plan is inspired by the Semperoper in Dresden.*
PAGE 52, BOTTOM LEFT *The stage curtain in layers of crumpled aluminum was designed by American artist Pae White.*
PAGE 53 *Aside from opera performances, the Oslo Opera House also holds symphony concerts.*

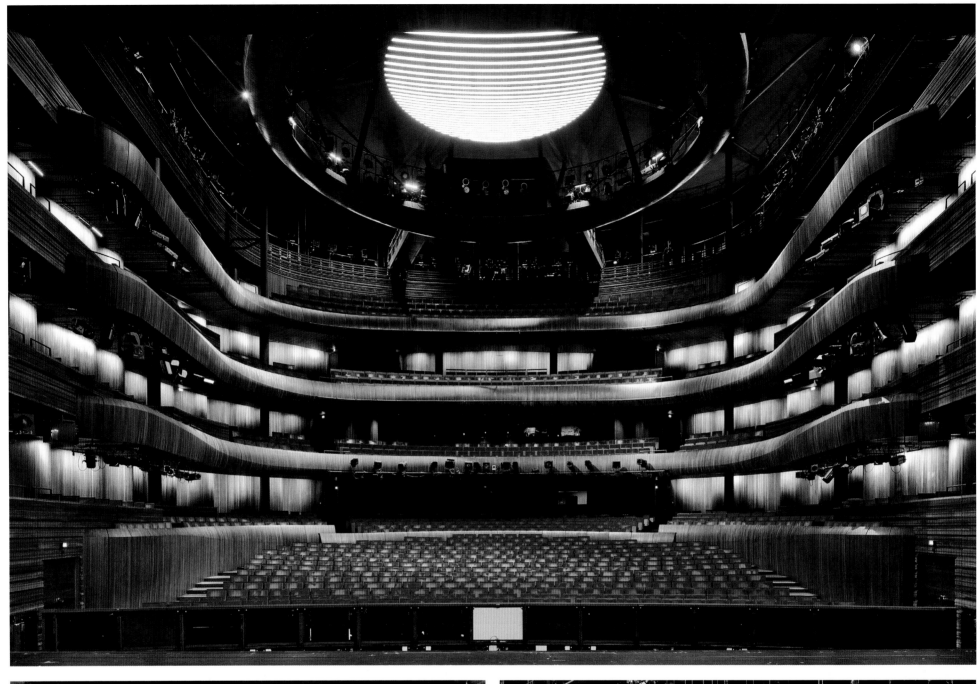

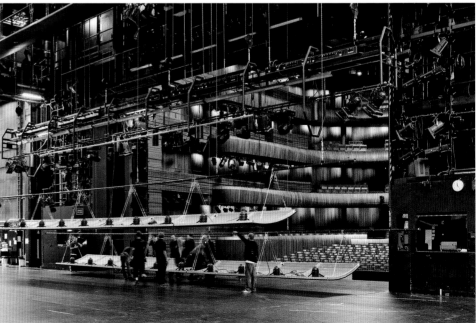

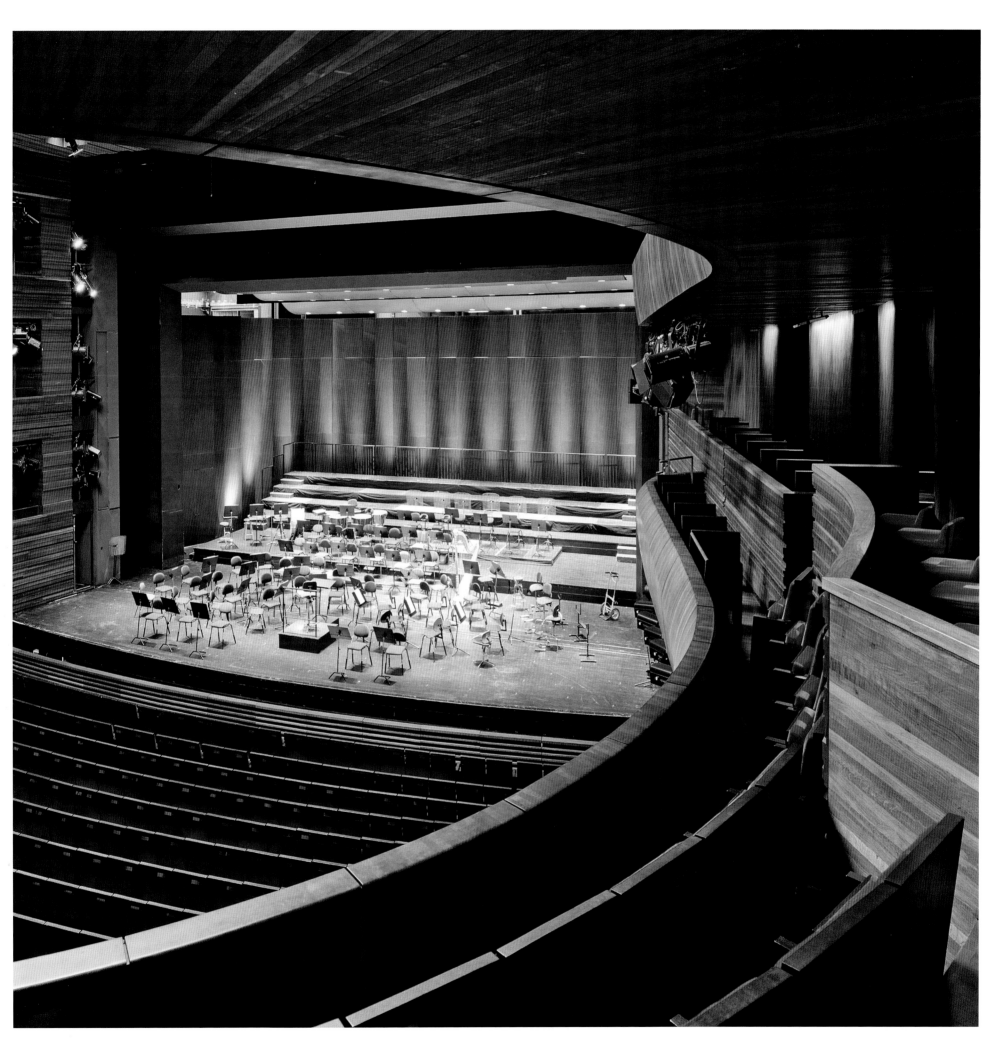

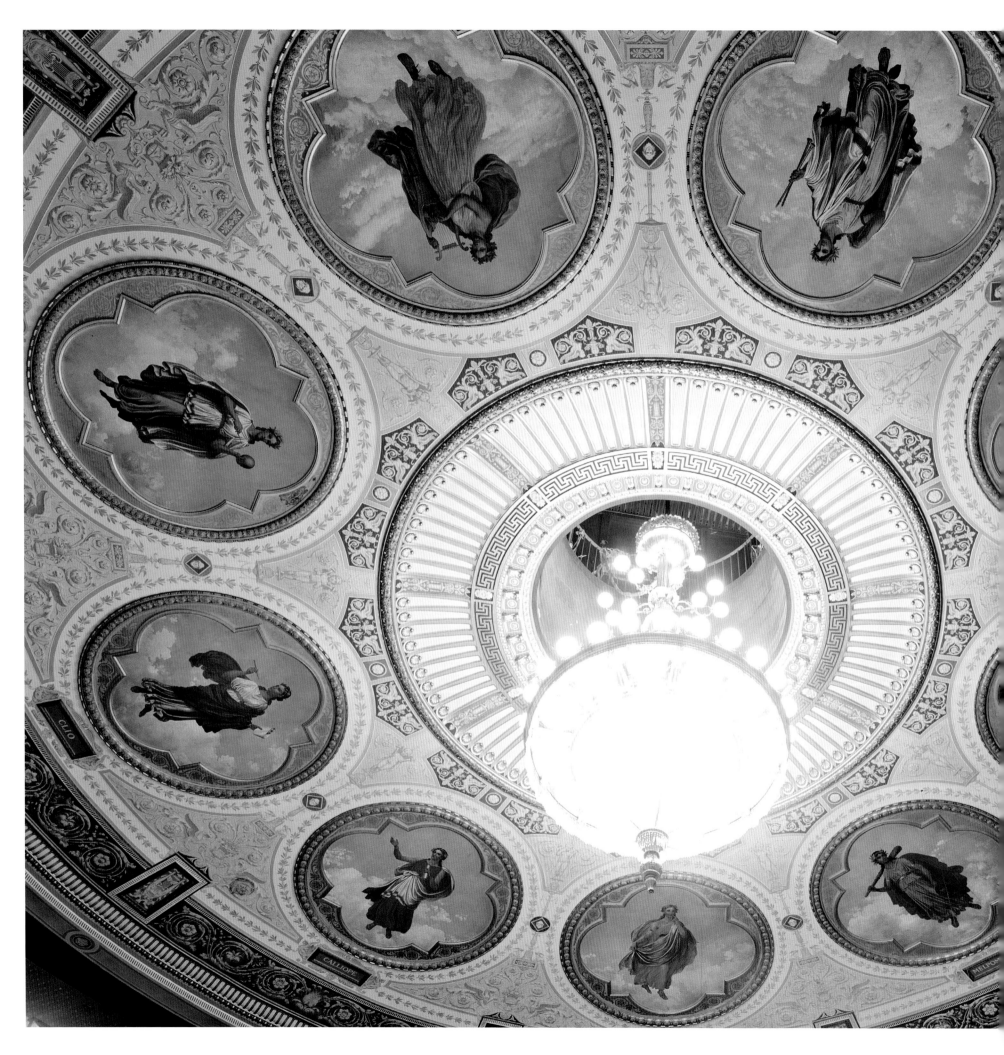

DET KONGELIGE TEATER,

Gamle Scene

COPENHAGEN

DENMARK

*L*ike the Paris National Opera, which includes both the Palais Gar-nier and the Opéra Bastille, the Copenhagen Opera divides its programming between two stages, one historical (*gamle scene*, the old stage), the other contemporary (*operaen store scene*, the new stage). While the latter hosts large-scale productions requiring a big symphony (for operas by Richard Strauss or Wagner), the former is an ideal setting for the music of Handel or Mozart.

The *gamle scene* in the Kongelige Teater (royal theater) is located on the Kongens Nytorv, one of Copenhagen's central squares. The first theater on this site was erected in 1748. Built by the architect Nicolai Eigtved, it was revolutionary at the time for its policy of welcoming both the aristocracy and the bourgeoisie. Less than thirty years later, the edifice was rebuilt by the architect Caspar Frederik Harsdorff, who favored a neoclassical aesthetic. The reconstruction was also spurred by the practical objective of significantly increasing the theater's capacity to 1,370 seats.

But that still wasn't enough! In 1874, the new royal opera house was inaugurated next to the old theater. Built by architects Vilhelm Dahlerup and Ove Petersen, it was designed in the neo-Renaissance style of the Vienna and Budapest opera houses. The façade is intended to be solemn, with columns and a loggia, and the entire structure is capped by a large dome. The building's two lateral wings are set back, like those of the Palais Garnier (see page 134). The interior is equally grandiose, with an eye-catching elegant coffered ceiling in the foyer. The auditorium holds 1,600 seats on a U-shaped floor plan, dominated by the massive honor boxes located on the forestage: In Copen-hagen, royalty did not hide the fact that they were in the building!

The old theater was demolished a few years later as part of a large urban renewal project. The new opera house continued to undergo significant changes. In 1931, the architect Holger Jacobsen built an edifice nearby intended to house both Danmarks Radio (DR) and a performance space for theater. The opera house was connected to this new building by an arcade. Far from being purely functional, this passageway is a fanciful, dreamlike jewel of Danish art deco. Beneath the archway, colorful mosaics by Ejnar Nielsen represent personalities of the art and radio worlds (notably the Danish composer Carl Nielsen). Yet the new building had a major drawback: The recording studios and performance space were very poorly soundproofed. In 1940, DR moved to a new building designed by Vilhelm Lauritzen. As for the theater, it was occupied by the Royal Theater Company until 2008, when a new theater was inaugurated on the harbor front.

The *gamle scene* was under construction from 1983 to 1985 so that workshops and rehearsal rooms could be added and the stage opening and orchestra pit expanded. One might have worried that the inauguration of Henning Larsen's new opera house in 2005 would slow activity in this older building. Luckily, the *gamle scene* is still thriving: Aside from "chamber" operas, the theater hosts many performances by the Royal Danish Ballet. The future continues to shine brightly for this historic venue, which staged the 1906 premiere of Carl Nielsen's *Maskarade*, the most famous Danish opera to date.

Copenhagen's opera house dating to the eighteenth century has a neo-Renaissance atmosphere.

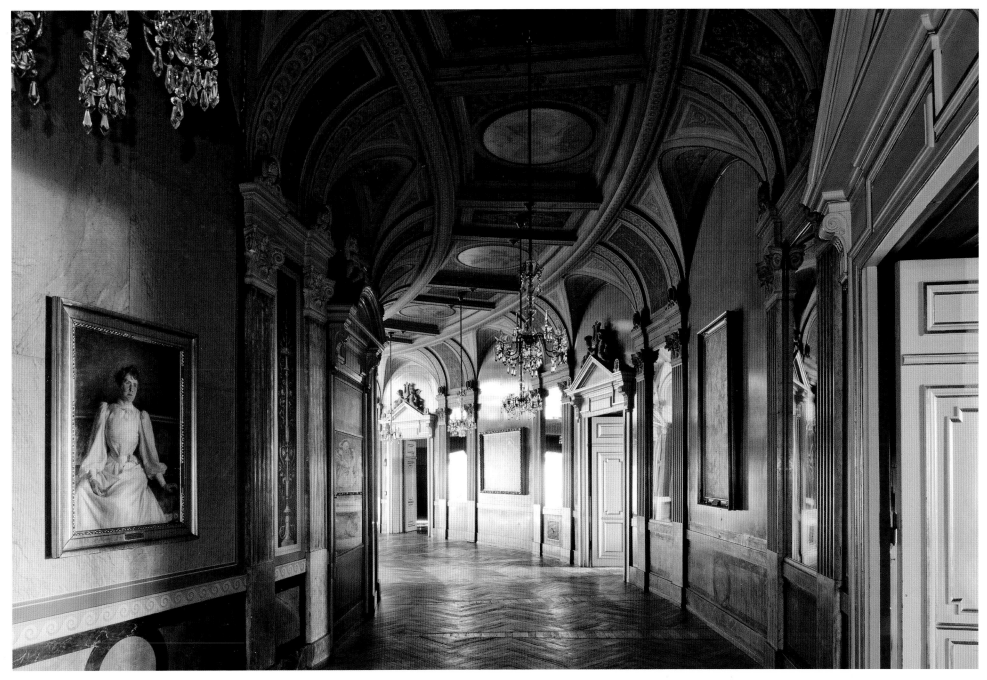

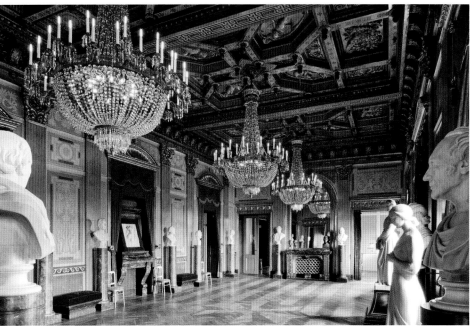

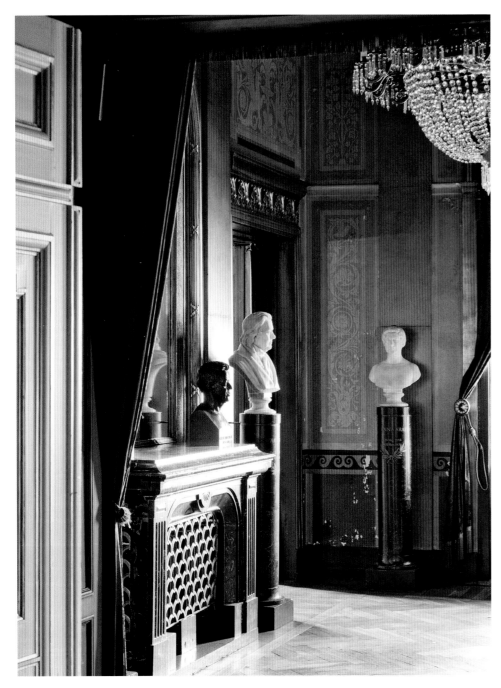

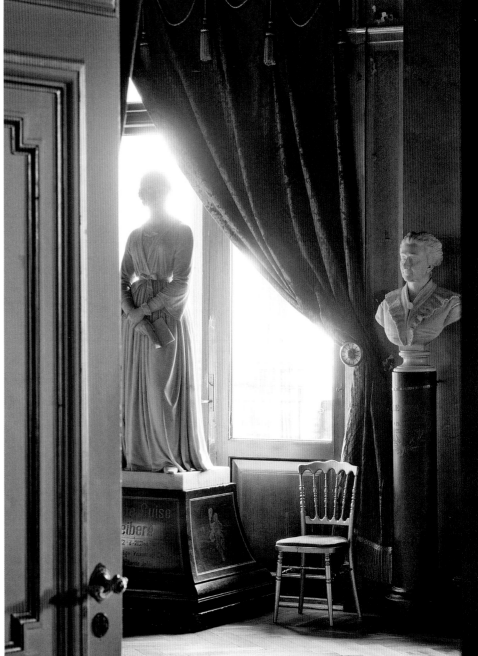

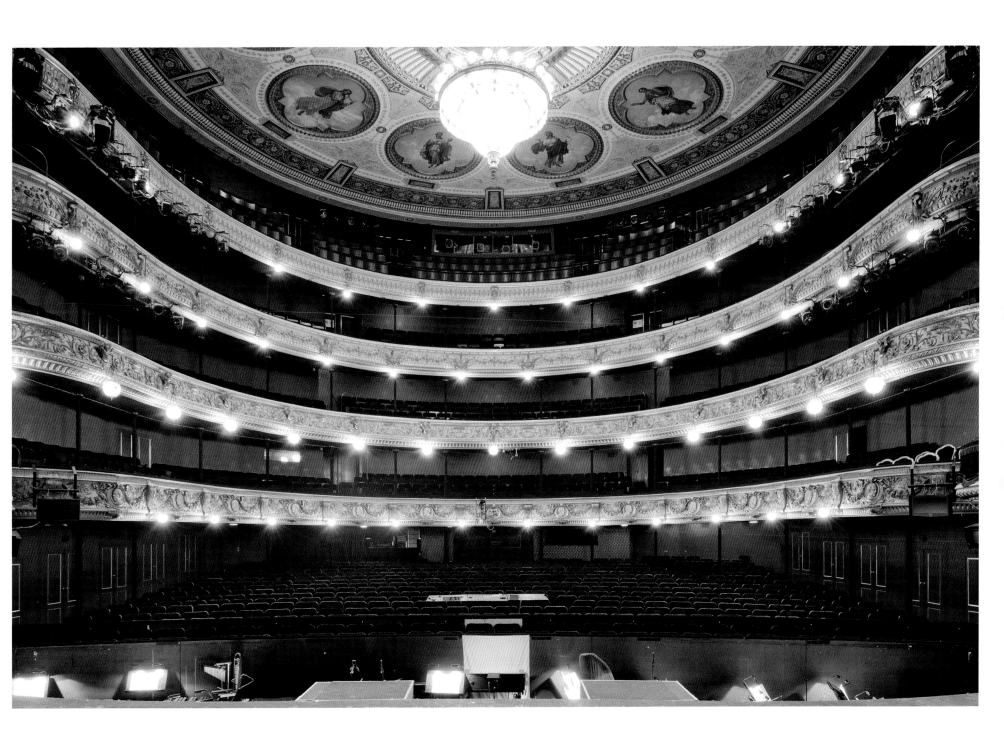

The orchestra pit was considerably expanded during the renovation, which took place from 1983 to 1985.

DET KONGELIGE TEATER,

Operaen Store Scene

COPENHAGEN

DENMARK

The eighteenth-century neoclassical queen's palace of the *gamle scene* and the contemporary opera house, the *operaen store scene*, stand opposite each other on either side of the canal that cuts across Copenhagen. Their position face-to-face couldn't be more symbolic. Beyond the aesthetic shock, their positions also confront two types of power: monarchic strength and financial brawn. The more than €300 million needed to build the modern opera house were contributed entirely by Mærsk Mc-Kinney Møller, the head of a shipping and oil group and the richest man in Denmark. No competition was held for the building's design; in 2000, the businessman directly commissioned the Danish architect Henning Larsen to build the opera house. This would be the beginning of an epic saga that lasted about five years.

Møller and Larsen never managed to agree on the building's aesthetic, beginning with its exterior: The architect wanted an entirely windowed façade to allow the maximum amount of natural light, while Møller preferred an edifice closed in on itself, largely because he thought glass would age poorly. A compromise was reached, and the glass façade was covered with a kind of steel grating. The Danes have since nicknamed the theater the "Toaster." The edifice remains impressive, covering a surface of 441,320 square feet and standing 125 feet tall. Its spectacular roof overhang is a marvel of engineering.

In the absence of a bridge connecting downtown to the opera house, many spectators take the boat to the opera, creating an unusual public procession. From the moment you enter the structure, you are struck by the ostentatious luxury of the foyer, complete with Italian marble and designer furniture. You certainly can't miss the works by celebrated Icelandic artist Olafur Eliasson, three chandeliers whose colors vary according to the light. As you reach the foyer's upper levels, the view over Copenhagen's historical center gradually expands. In good weather, you can even see Sweden from the top-level terrace.

The auditorium is initially surprising for its blue seats, rather than the traditional red. An easily explained choice: Møller's company logo is blue. Here, too, the architect's wishes did not prevail…

The egg-shaped auditorium can seat up to 1,400 and is built of maple. In Scandinavian opera houses, the orchestra pit traditionally sounds rich and full. The acoustics, prepared here by the Arup agency, are true to this rule and can make balancing the sound of singers and musicians difficult. Curtains can be hung around the auditorium for pop and rock concerts, providing a drier sound.

The opera house also contains a smaller concert hall, which can hold 500 spectators. This black box with retractable seating to allow standing-room-only crowds is primarily intended for contemporary music.

Colored chandeliers by Icelandic designer Olafur Eliasson hang in the foyer.

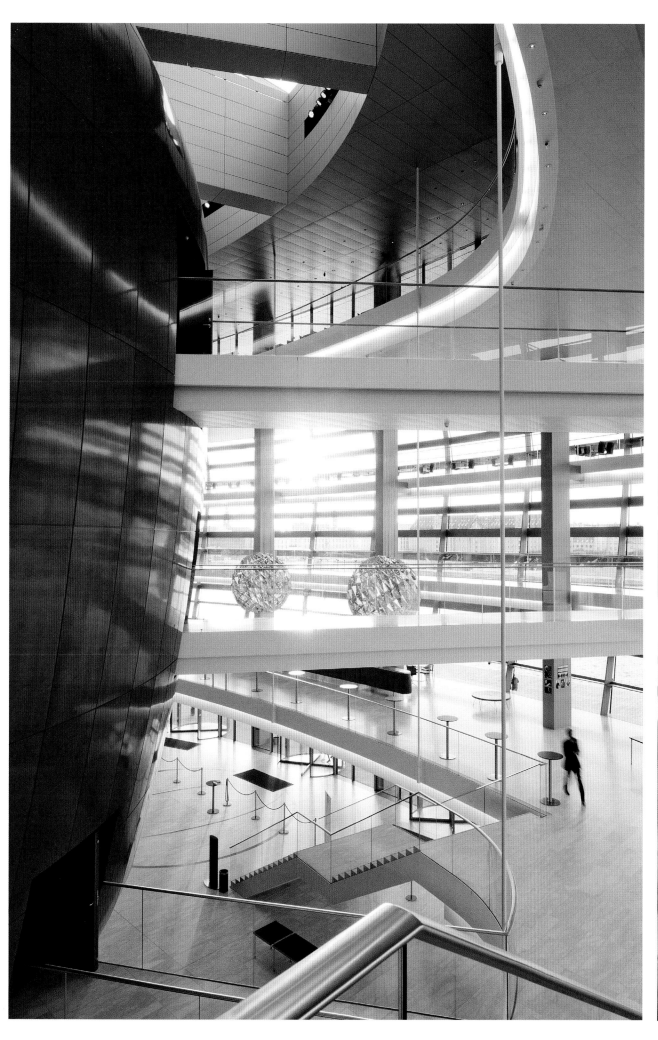
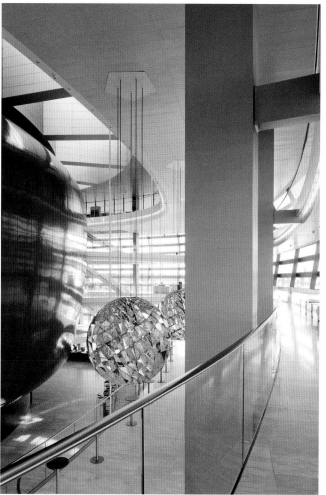

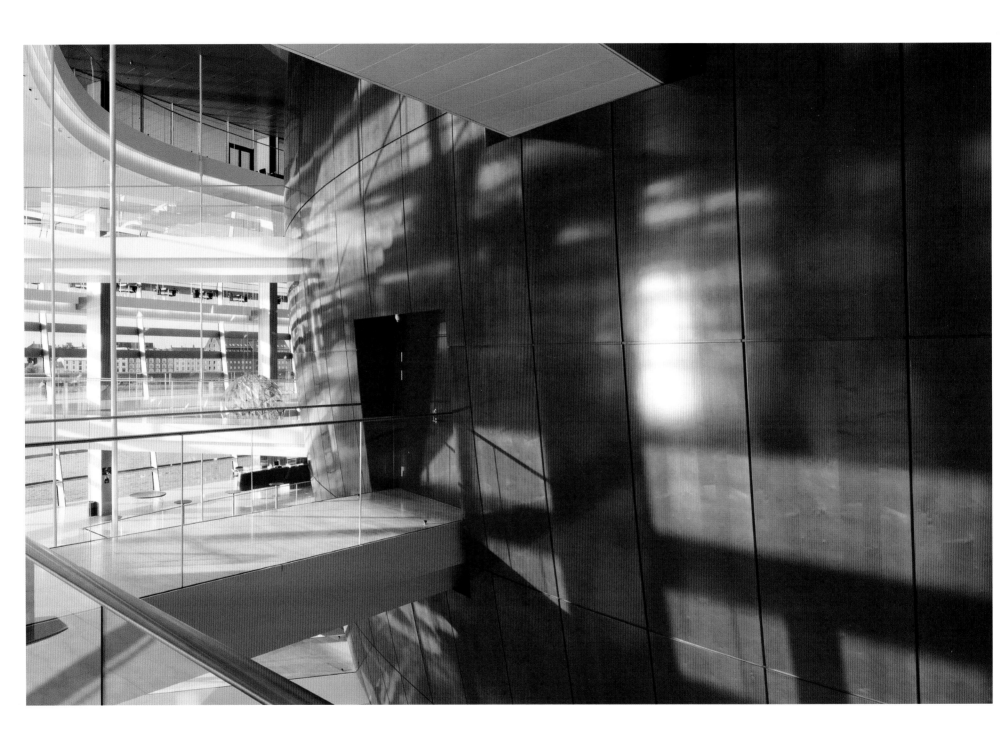

The glass façade provides a panoramic view of Copenhagen and, from the upper floors, of neighboring Sweden.

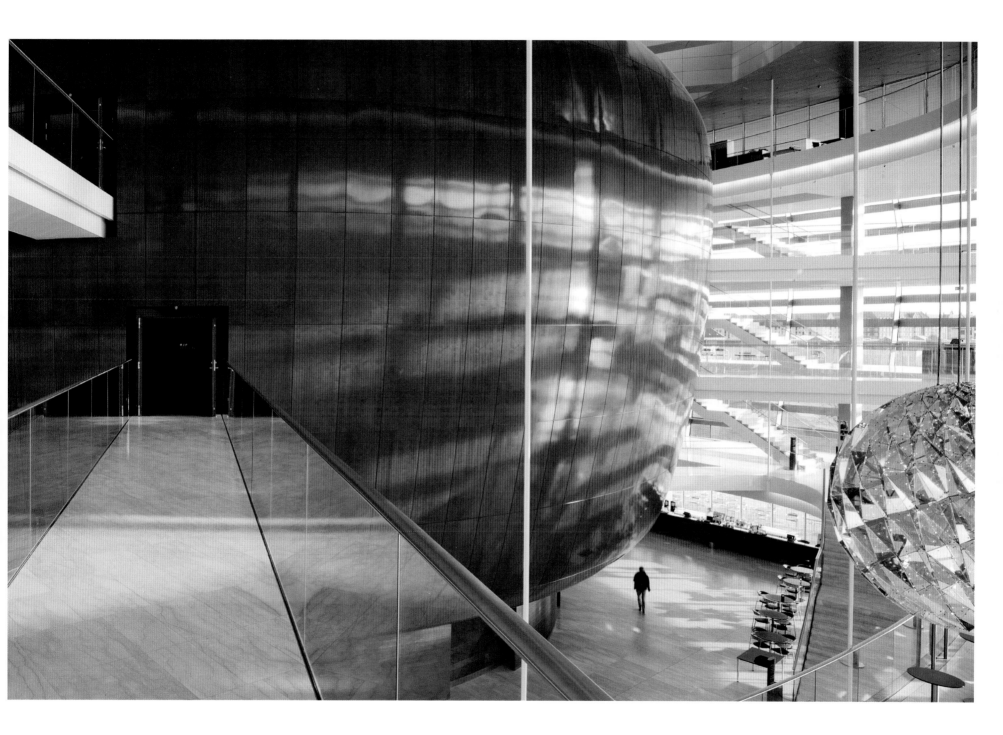

PAGES 66–67 *The theater's deep blue is also the color of the logo of the shipping company chaired by Mærsk Mc-Kinney Møller, who commissioned the opera.*

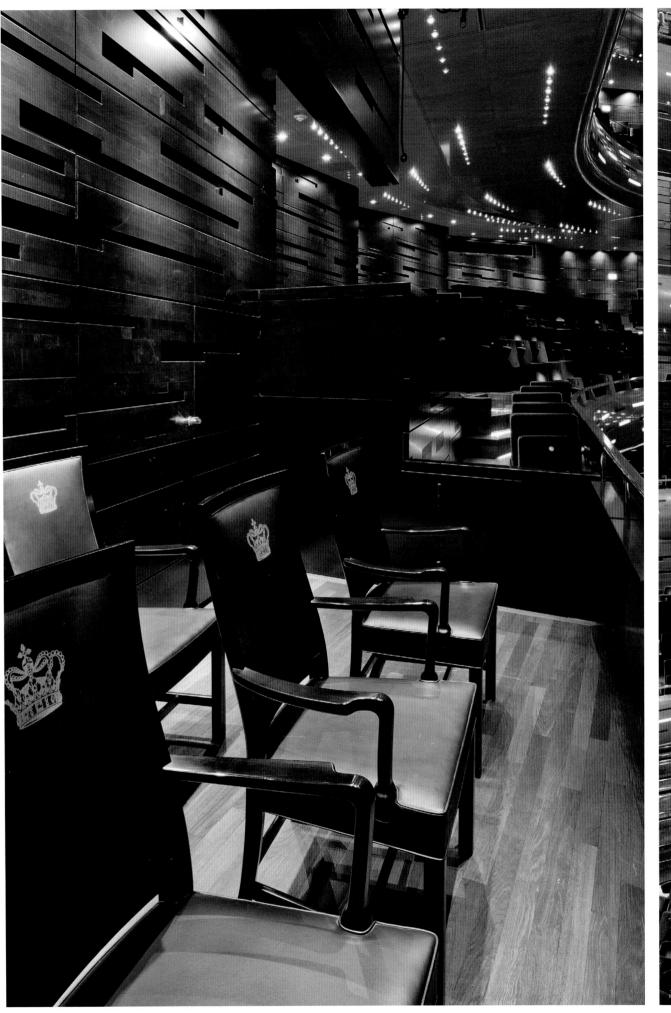
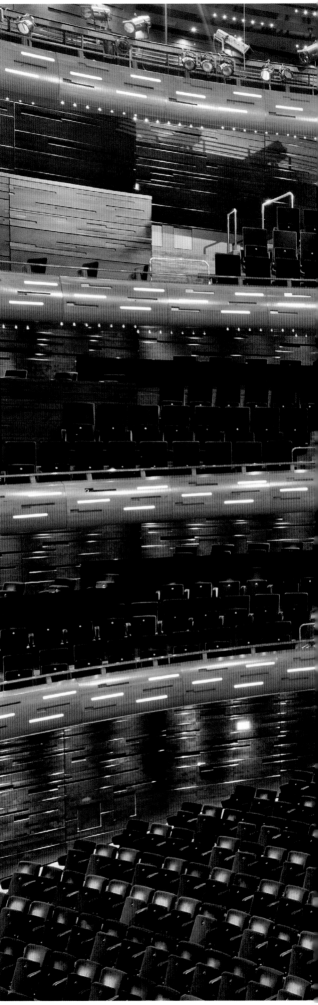

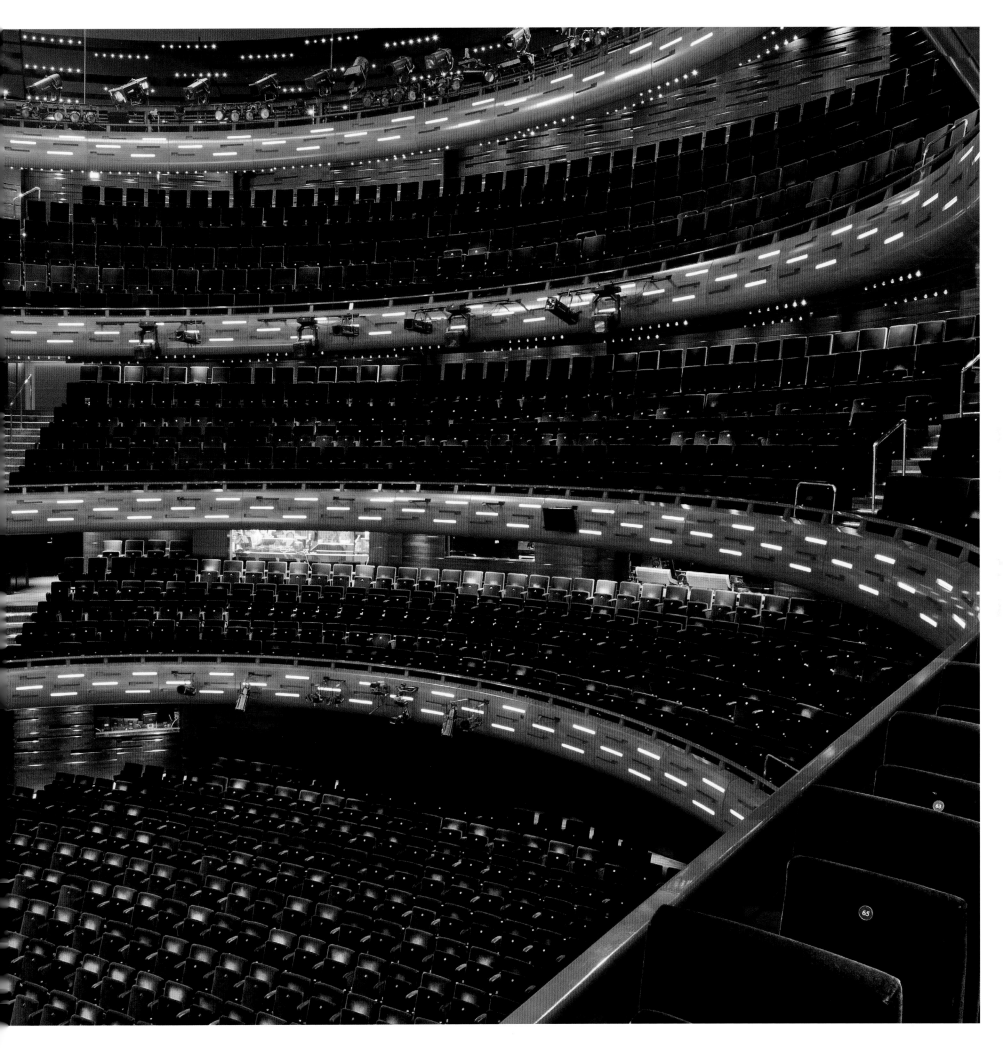

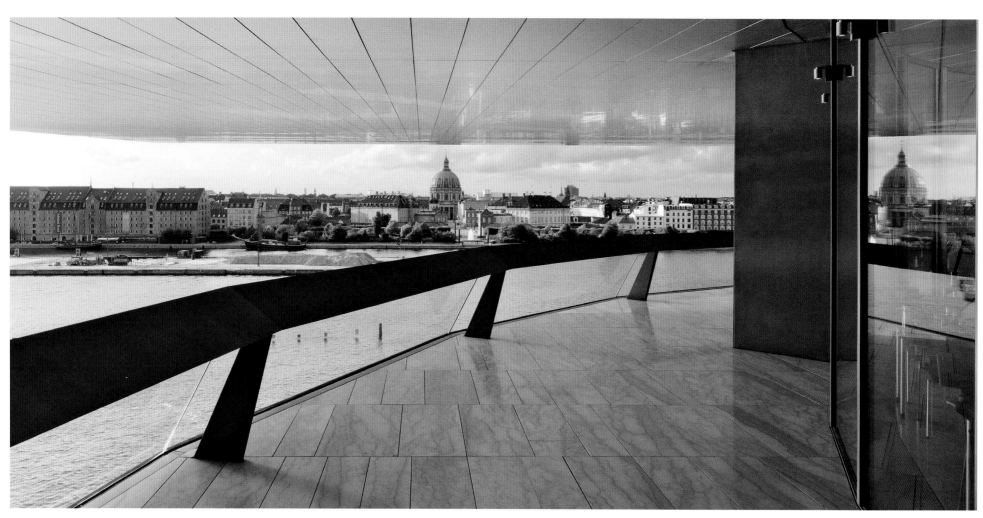

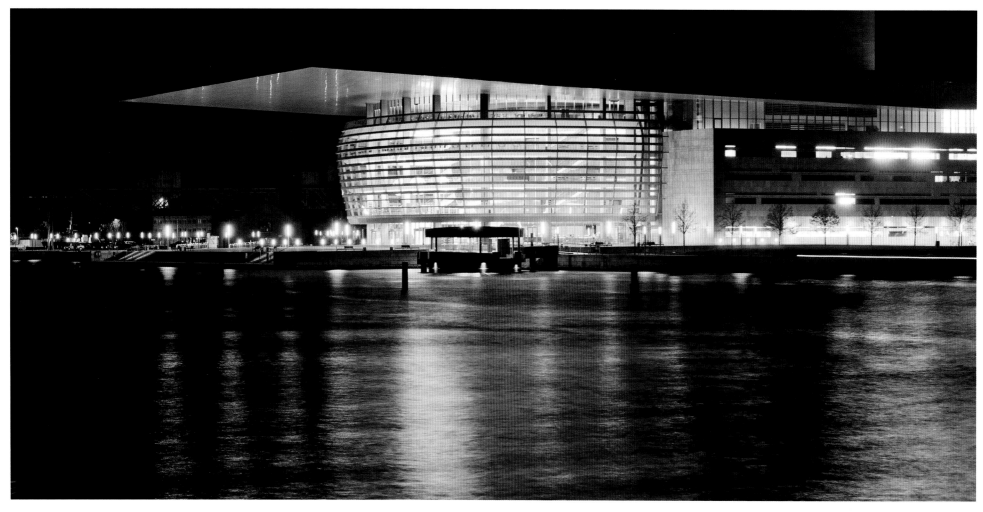

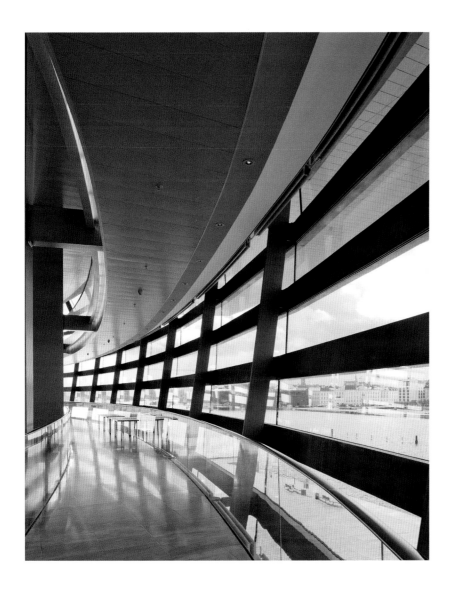

The roof's overhang is an engineering marvel.

Unfortunately, spectators do not have access to the sumptuous, exceptionally well-conceived rehearsal studios. The ballet and choir have space on the top floor, with panoramic views. The orchestra rehearses in the basement, in a room that doubles as a recording studio. Facilities also include public Internet stations, a pool table, and couches worthy of the finest lounges. These workplace perks are much appreciated by the artists and administrators who staff the opera.

Sadly, Henning Larsen came out of the experience battered. He even wrote the book *De skal sige tak! Kulturhistorisk testamente om Operaen* (You Ought to Be Thankful! A Historical Document about the Opera) relating his misadventures with his backer. But his travails did not turn him off music: He completed a concert hall in Uppsala, Sweden, in 2007 and a magnificent auditorium in Reykjavik, Iceland, in 2011.

LA FENICE

VENICE

ITALY

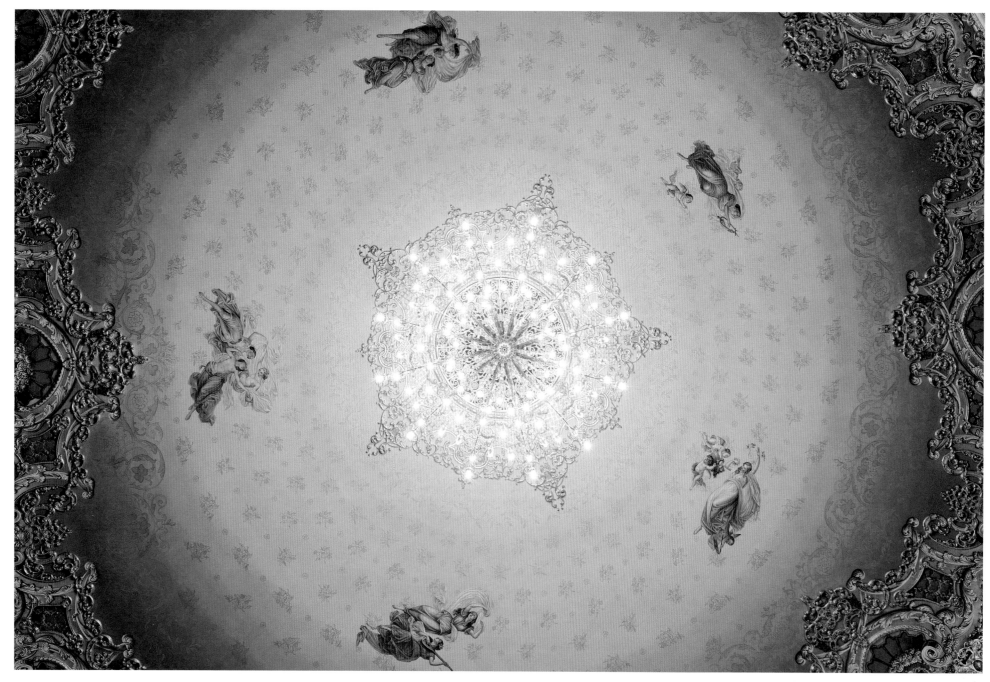

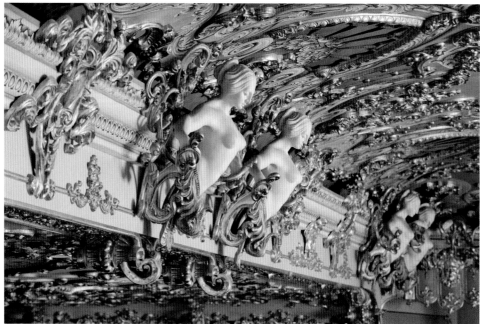

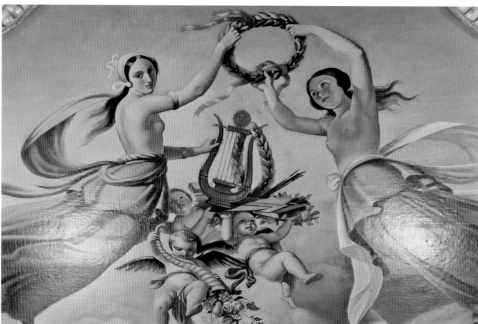

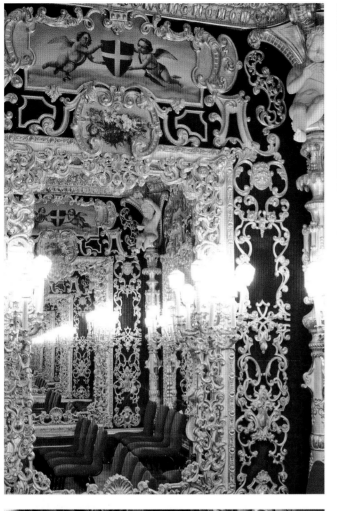

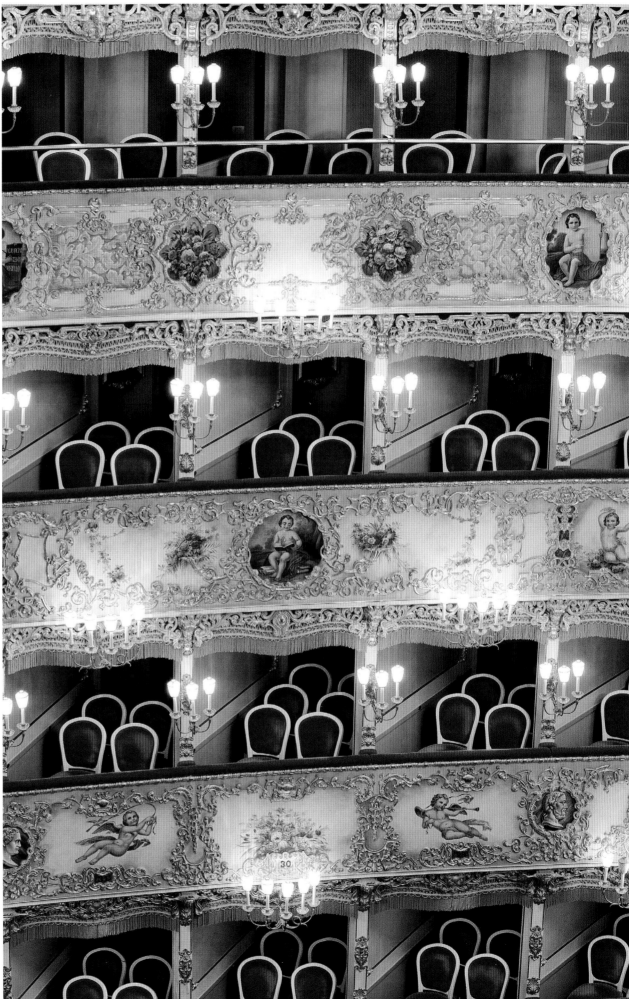

La Fenice ("the phoenix" in Italian) could not have a more appropriate name. Like the mythical bird, the Venetian theater always rises from its ashes. The most recent incident was a criminal fire, which ravaged the entire building in 1996. Two electricians were respectively sentenced to seven and six years in prison by judges of the Venice court for setting fire to the theater to avoid paying penalties for being late in their work. Not surprisingly, the mafia is rumored to be involved. After several years of oft-delayed construction, the theater finally reopened in November 2003. This identical reconstruction cost close to €60 million and was supported by a variety of individual sponsors, including music-loving director Woody Allen.

In fact, La Fenice started its life on a pile of ashes. It was built to replace the San Benedetto theater in the late eighteenth century, at the height of the Republic of Venice's decadence. Following an international competition, the design selected was by Giannantonio Selva, an Italian architect whose style was influenced by Palladio. Construction was stunningly fast: The theater was built in barely twenty-seven months and inaugurated in 1792.

As is often the case in Venice, the theater's location—just a few steps from Saint Mark's Square, in a maze of alleyways and canals—imposed strict architectural constraints. Selva therefore conceived two slightly staggered plane-parallel spaces. The first included the vestibule, the stairs, and the foyer; the second held the actual auditorium, with its 1,500 seats. The edifice is unusual in that it has two façades, one facing a modest little square, the other directly over the canal. One can therefore go to the opera by foot or gondola. From the outside, the theater's architecture clearly espouses a neoclassical aesthetic; in fact, it was one of the first Venetian buildings to adopt the style. The staircase, columns, and sculptures lend it an elegant austerity typical of northern Italy. Inside, the auditorium is impressively high, with five levels of balconies. Originally,

the decor was intended to be relatively sober, but successive renovations have made it increasingly baroque, with velvet and fake candles. In keeping with the Italian tradition, the balconies were divided into boxes, areas conceived as antechambers ideal for political negotiations and romantic intrigue. However, the acoustics, which in general are warm, are not as good here as in the orchestra. Anyone wanting to experience the racy atmosphere in La Fenice's boxes should see Luchino Visconti's film *Senso*, the first scenes of which were shot inside the theater. Some boxes were removed over the course of the theater's history in the name of democracy. Following an 1836 fire (yet another!), the upper balcony was turned into a gallery in 1838, and in 1904 the boxes on the third balcony were largely opened up. The most spectacular box remains the royal box (the former imperial box, built for Napoleon), which is located on the second level and is ostentatiously luxurious. The foyers and vestibules, however, are austere and have not been of much interest since they were renovated under Mussolini.

The Venetian theater has always attracted the greatest composers. Inaugurated in 1792 with Paisiello's *I Giuochi d'Agrigento*, a long-forgotten work, La Fenice then hosted a series of major premieres in the history of Italian music: Rossini's *Tancredi* in 1813, Bellini's *I Capuleti e i Montecchi* in 1830, and no less than five works by Verdi, including *Rigoletto* in 1851 and *La Traviata* in 1853.

Venice is often criticized for being little more than a "museum city," and La Fenice's programming does indeed give pride of place to the great classics of the Italian repertoire, from Rossini to Puccini. But in the last few seasons, the opera has boldly called on theater directors to provide contemporary perspectives and resurrect forgotten works, notably in collaboration with the Palazzetto Bru Zane Foundation, which specializes in French romantic music. The goal—and the challenge—is to attract tourists and serious music lovers alike.

Following the Italian tradition, the balconies at La Fenice are divided into boxes.
With its soaring height, the theater can seat 1,500 spectators.

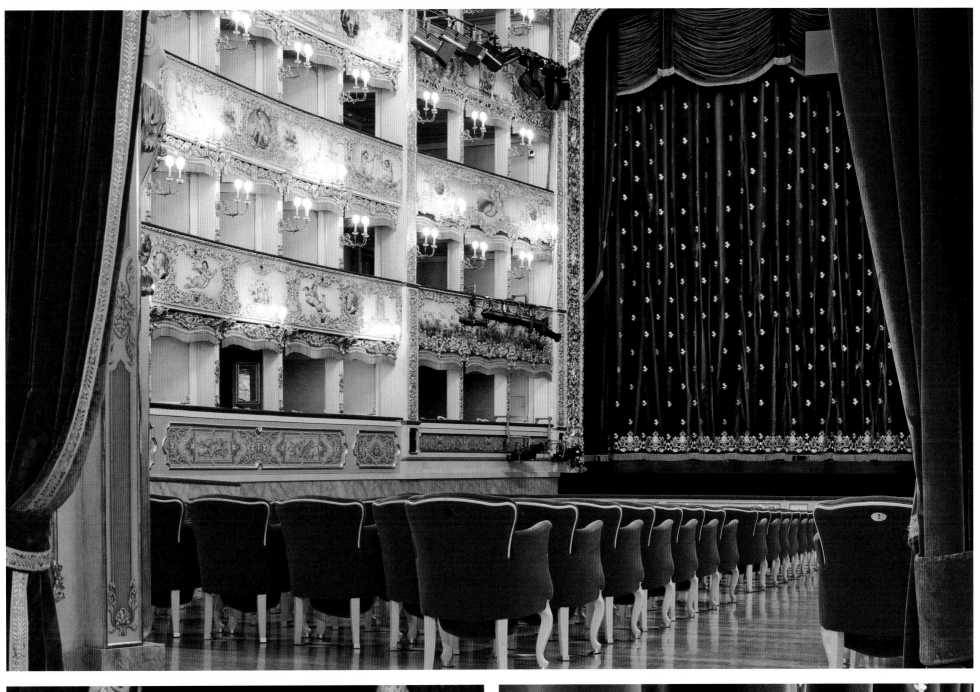

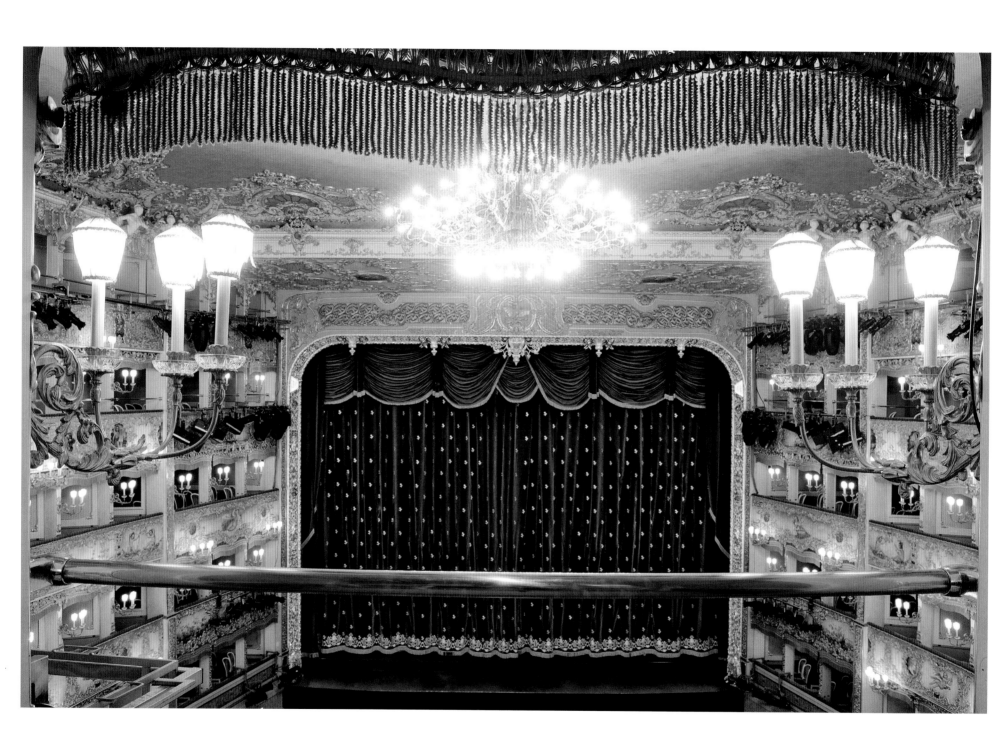

After the 1996 fire, an exact replica of the original La Fenice was built at a cost of €60 million.

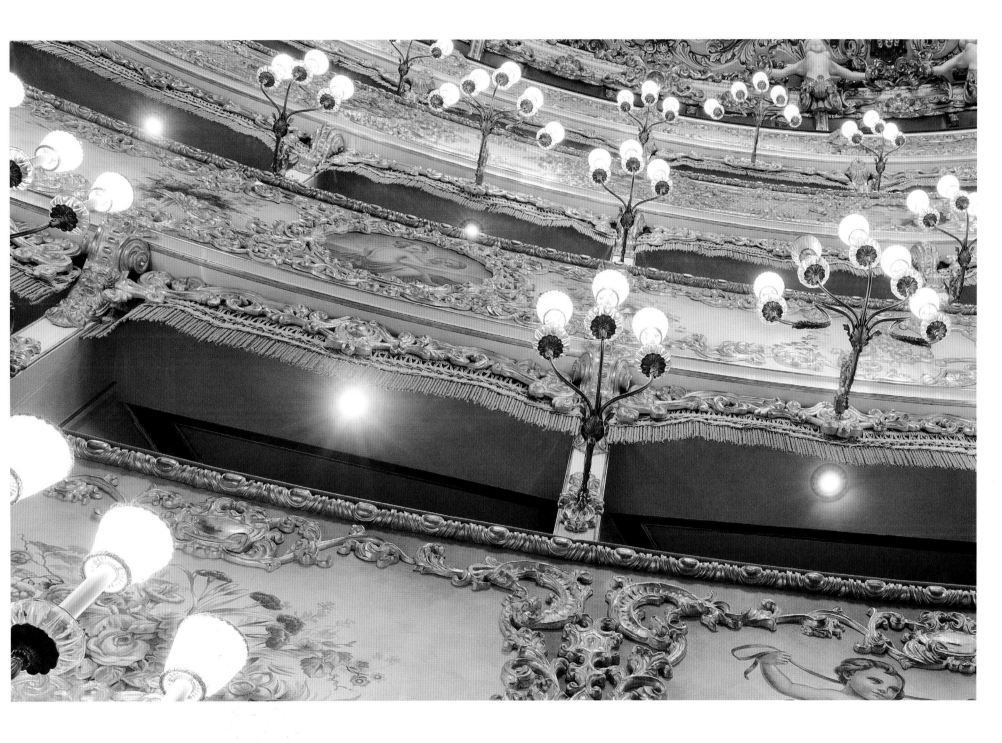

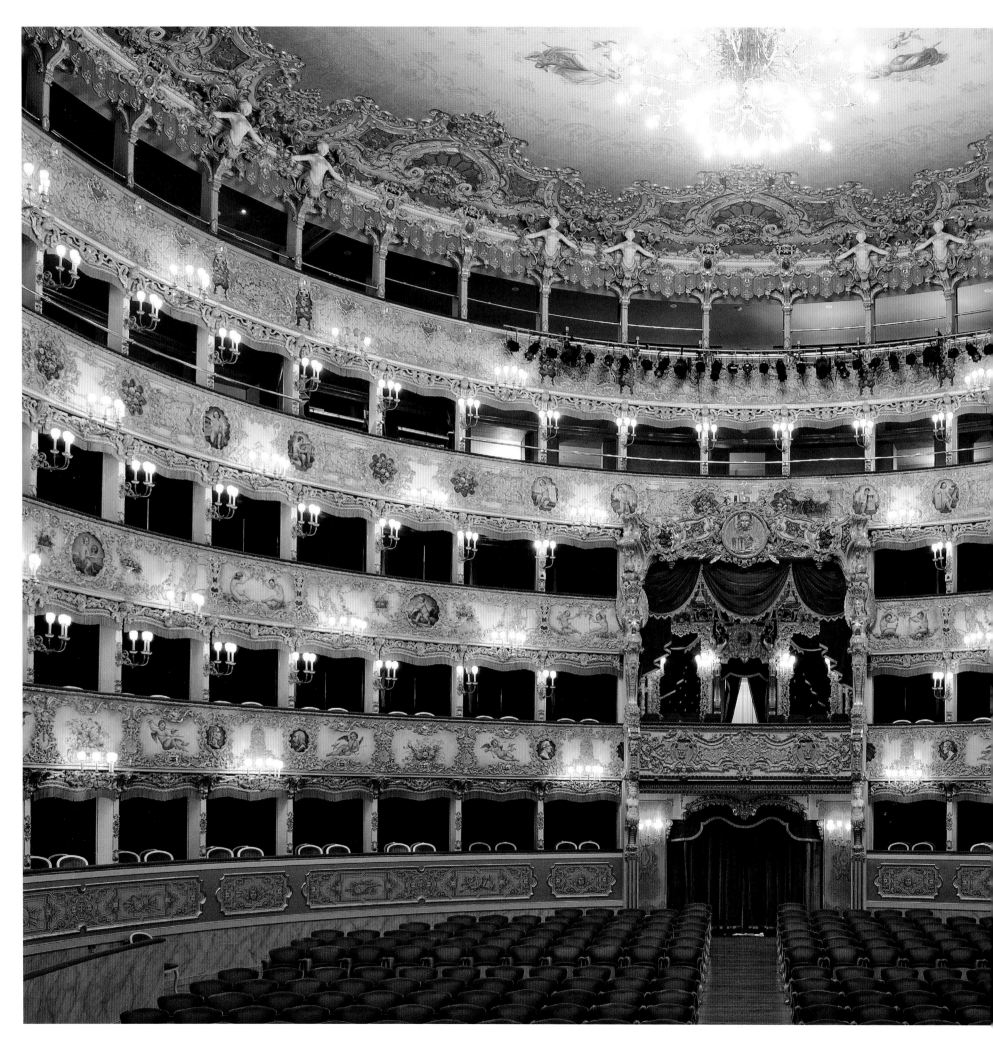

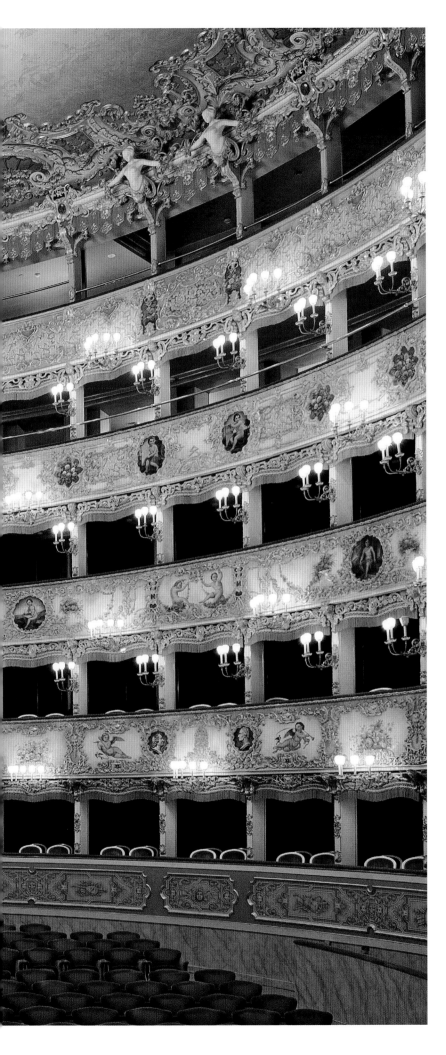

LEFT *The ostentatiously luxurious royal box, formerly the imperial box, has a central location.*

FESTSPIEL-HAUS

BAYREUTH

GERMANY

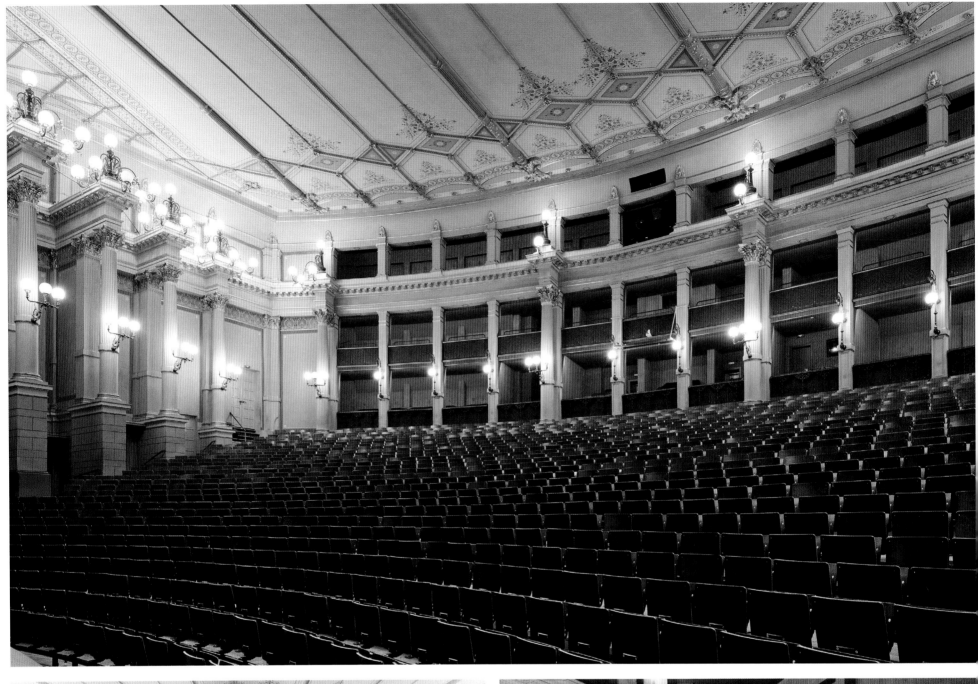

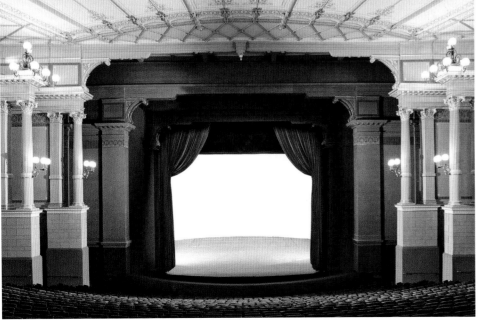

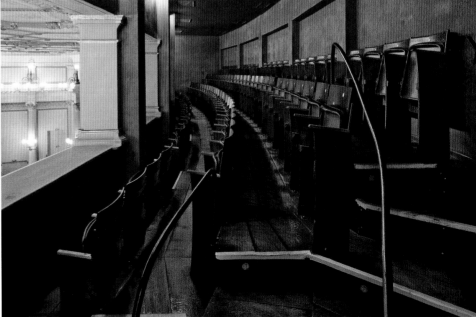

Seeing a performance at the annual Bayreuth Festival is like an initiation ritual. For starters, you have to reserve your seat several years in advance—up to ten years for some productions. Once you have obtained your precious ticket, you must climb the "holy hill" to the Festspielhaus, which stands at a short distance from the city. From the outside, the building appears modest, with a brick façade and geometric lines, but the auditorium is downright spartan, with wood seats that regulars know to soften with their own pillows. Remember that Wagner operas such as *Twilight of the Gods* can last up to six hours . . .

The Festspielhaus is one of the most legendary, revolutionary opera houses in the world, both from an architectural and an acoustic point of view. In 1850, as he was beginning to compose the *Ring*, Richard Wagner started thinking about a theater specifically conceived for his music. He considered building a theater in Munich with Gottfried Semper, who had designed the Dresden Opera House, but finally chose Bayreuth, which already had a magnificent theater (see page 106), for his Festspielhaus. To complete this project, launched in 1872, Wagner joined forces with the architect Otto Brückwald and the engineer Karl Brandt. The inauguration in August 1876 was attended by composers Liszt, Mahler, and Bruckner, as well as Nietzsche, Tolstoy, and King Ludwig II of Bavaria, Wagner's patron.

The Festspielhaus had nothing in common with most theaters of the period. The use of simple materials such as brick and wood—partly for financial reasons—was a radical shift from the gilding found in neoclassical theaters. The architecture was not used as a display of wealth or power but to create an ideal setting for the music. Nothing was to distract the audience . . . The auditorium's floor plan proved particularly audacious. No balconies or stage boxes: Wagner adopted the fan shape of the classical amphitheater and included seats for 1,800 spectators, all of whom are treated equally.

The Festspielhaus, built in the shape of an amphitheater, has cold but grandiose decoration.
PAGES 84–85 *Regulars are quick to put their own cushions on the wood seats.*

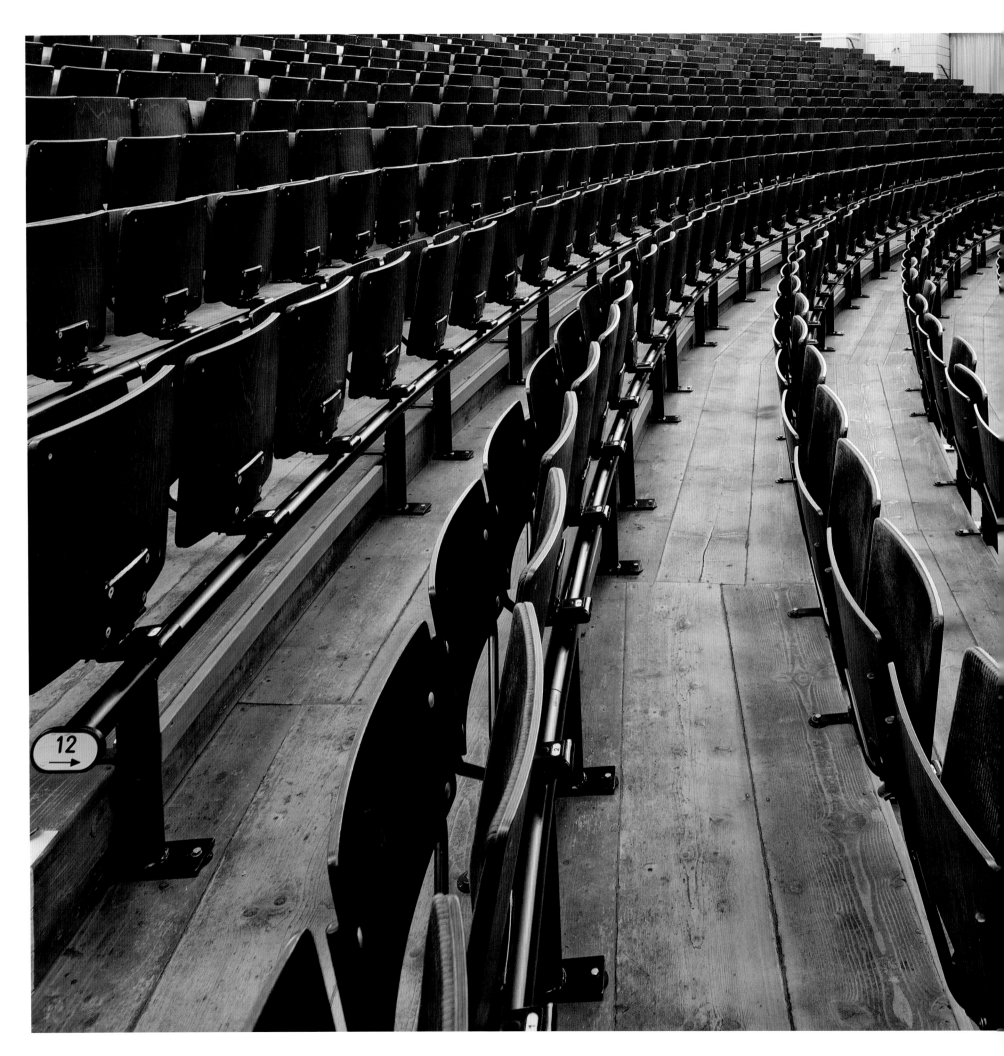

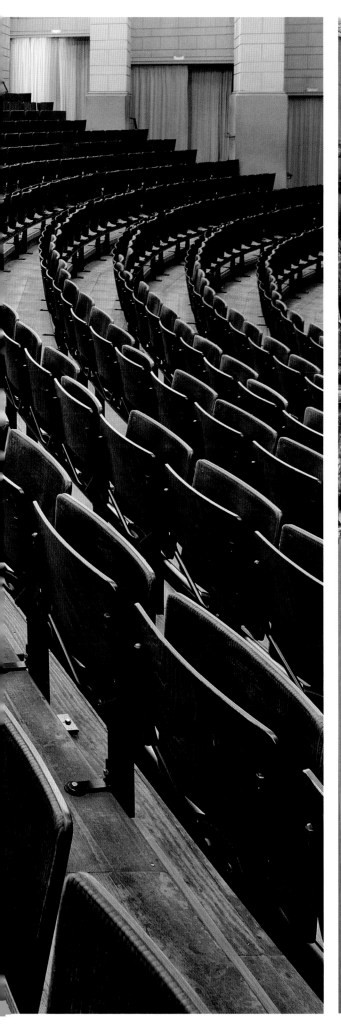
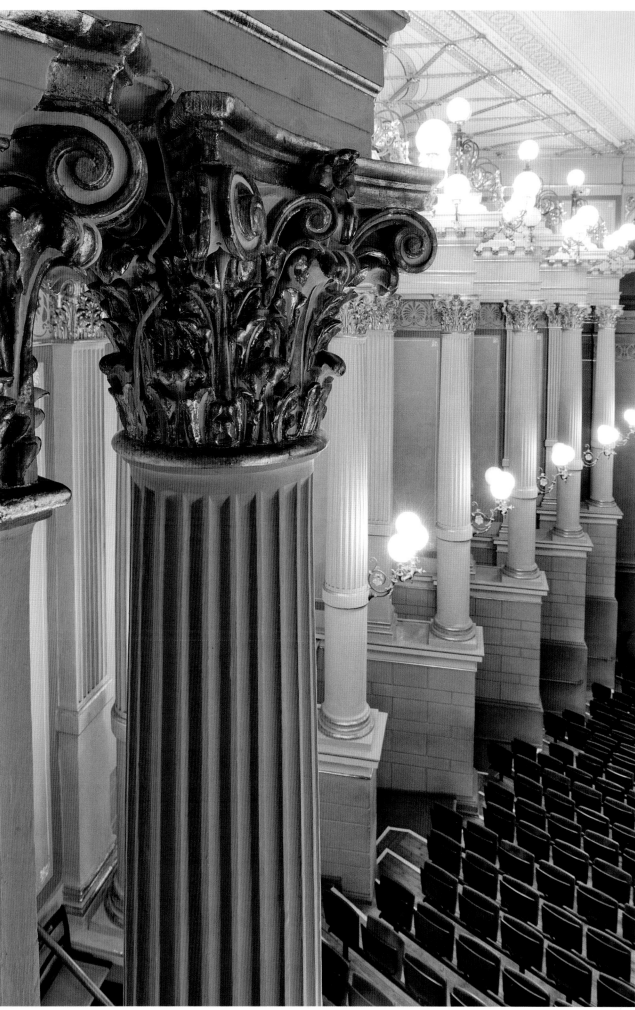

The presence of a proscenium inside the house itself creates an effect both theatrical and acoustic.

The major innovation was in the treatment of the orchestra pit, which is almost entirely covered. The sound of the orchestra (Wagner's music requires numerous musicians) never overwhelms the singers' voices and, most importantly, develops an aura of mystery, a distant, unreal feeling. The principle of the covered pit had been developed in the late eighteenth century by the architect Claude-Nicolas Ledoux for the Besançon theater, the interior of which has sadly been entirely rebuilt.

After the *Ring*, the Festspielhaus premiered *Parsifal* in 1882. At the end of this religious-themed opera, the audience respected the composer's wishes and did not applaud. In Bayreuth, every performance is like a ritual, devoted to a total art (the famous *Gesamtkunstwerk*).

After Wagner's death, the festival weathered turbulent times. Under National Socialism, the composer's heirs associated with the top echelon of the regime, and Hitler became a regular at the Festspielhaus. Wagner's work was claimed by the Nazis. The festival was not held for the first six years after the war. It resumed thanks to the young Wieland Wagner, who gave it new life by directing more-modern productions, fearlessly updating his grandfather's operas. After his death in 1966, the festival continued in this spirit and hosted legendary productions such as the *Ring* directed by Patrice Chéreau and conducted by Pierre Boulez.

In 2008, the festival was taken over by Eva Wagner-Pasquier and Katharina Wagner. Their leadership has divided critics, some of whom have denounced certain staging choices as purely provocative. It remains to be seen whether this legendary stage can one day be headed by a stranger to the Wagner family and open its doors outside of the festival season.

The highest Nazi dignitaries once climbed the Festspielhaus steps.

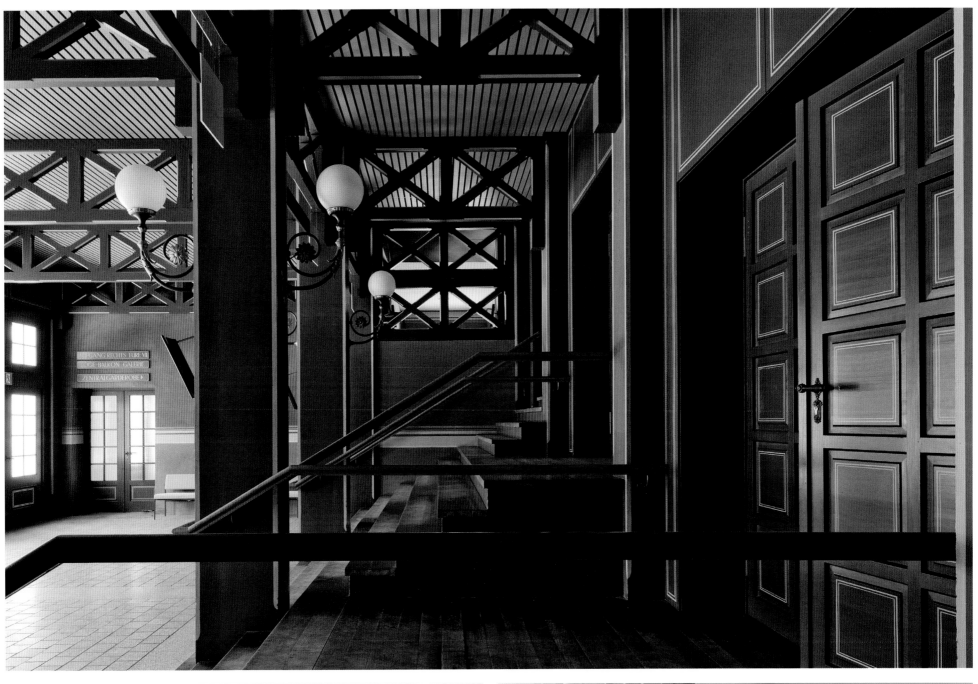

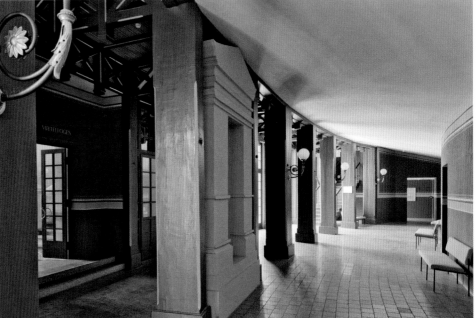

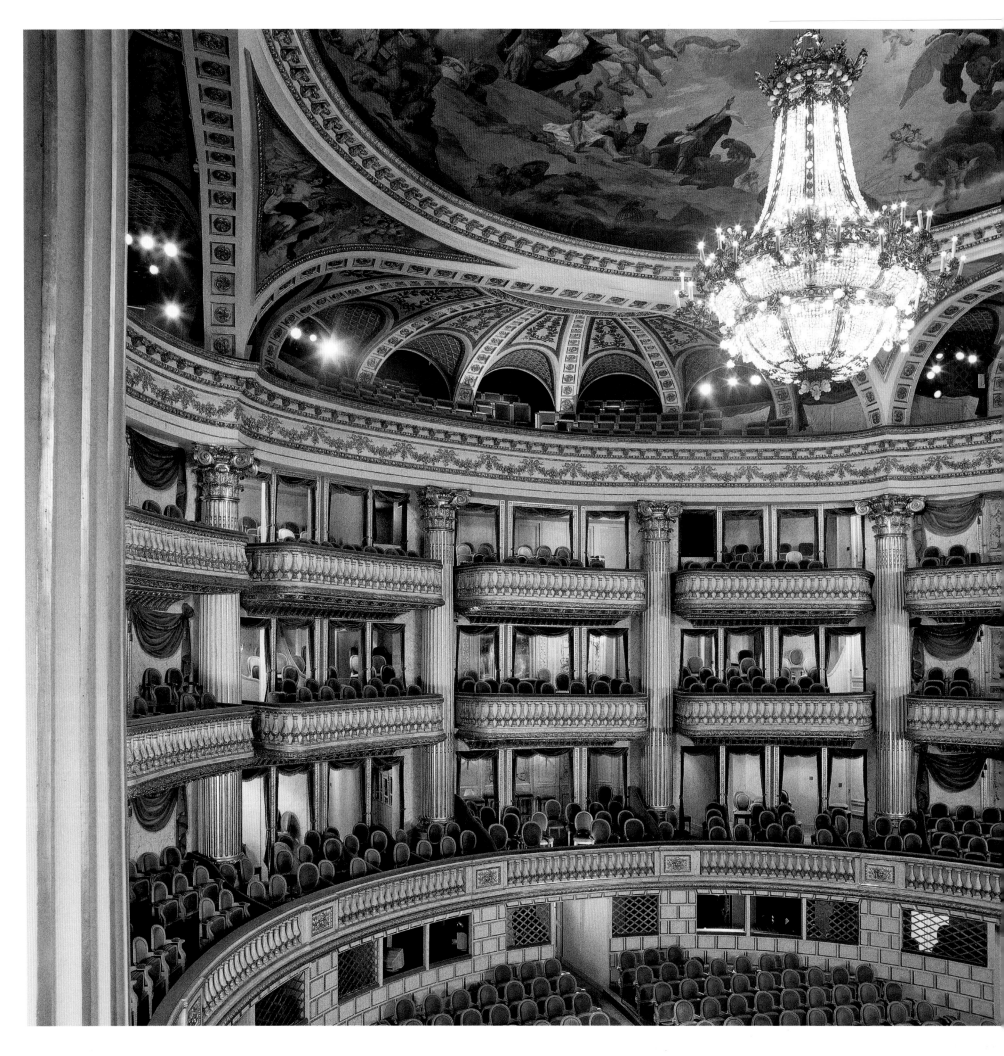

GRAND THÉÂTRE

BORDEAUX FRANCE

Built by Victor Louis, the Grand Théâtre de Bordeaux was one of the first theaters to include so many areas outside of the actual auditorium, including a vestibule, foyer, and grand staircase. The architect also made no attempt to conceal the volume around the stage, clearly revealing the edifice's function from the outside. These distinguishing characteristics would have a strong impact on Charles Garnier, who was present at the opera house's centennial in 1880.

But to start at the beginning, in the eighteenth century, Bordeaux was in the midst of major transformations, notably due to the creation of the Place Royale by Jacques Gabriel and his son Jacques Ange. During this Enlightenment euphoria, the Duc de Richelieu commissioned a new theater from Victor Louis, and construction began in the heart of the city in 1773. Yet the atmosphere on the building site soon became extremely tense: the people of Bordeaux were openly critical of Louis, largely for financial reasons. The architect did not even attend the building's inauguration. In its early years, personalities such as Victor Hugo and Stendhal mocked the Grand Théâtre for its ugliness and pretentiousness. Today their reactions are hard to fathom.

In an ideal location, without an adjoining façade, the Grand Théâtre is a model of classical architectural perfection, both solemn and harmonious. Built of white Bordeaux stone, the façade stands out for its peristyle of twelve Corinthian columns decorated with a balustrade and sculptures representing muses and goddesses. The Grand Théâtre was always conceived as a living part of the city, with three cafés and a dozen boutiques in its lateral areas.

With its stage-level boxes and columns, the Grand Théâtre de Bordeaux is a masterpiece of classical architecture.

Once inside, one is captivated by the neoclassical decor, particularly the grand stone staircase. The gilding in the main foyer is in the pure neo-baroque style that also influenced Charles Garnier. As for the theater itself, it has 1,200 seats arranged in a circular floor plan, offering optimal visibility for the maximum number of spectators. This relationship between the stage and the house also proves excellent from an acoustic perspective. Bordered by a series of columns, the open balconies contrasted with boxes in the Italian style.

Unfortunately, Louis' edifice has been subjected to many alterations, notably to the ceiling paintings and the position of stage-level boxes in the back of the balconies. The architect Charles Burguet completed a major renovation in 1853.

Most recently, a major project was undertaken in 1991 to restore the Grand Théâtre to its original splendor. The edifice's only flaw is its small orchestra pit. However, the nearby Bordeaux Auditorium, a symphonic concert hall with a pit accommodating 120 musicians, offers a venue for operas that require a large orchestra. Only a few hundred meters away, the Bordeaux Auditorium opened in January 2013. Now both Wagner and Strauss' major works can finally be performed on the banks of the Garonne.

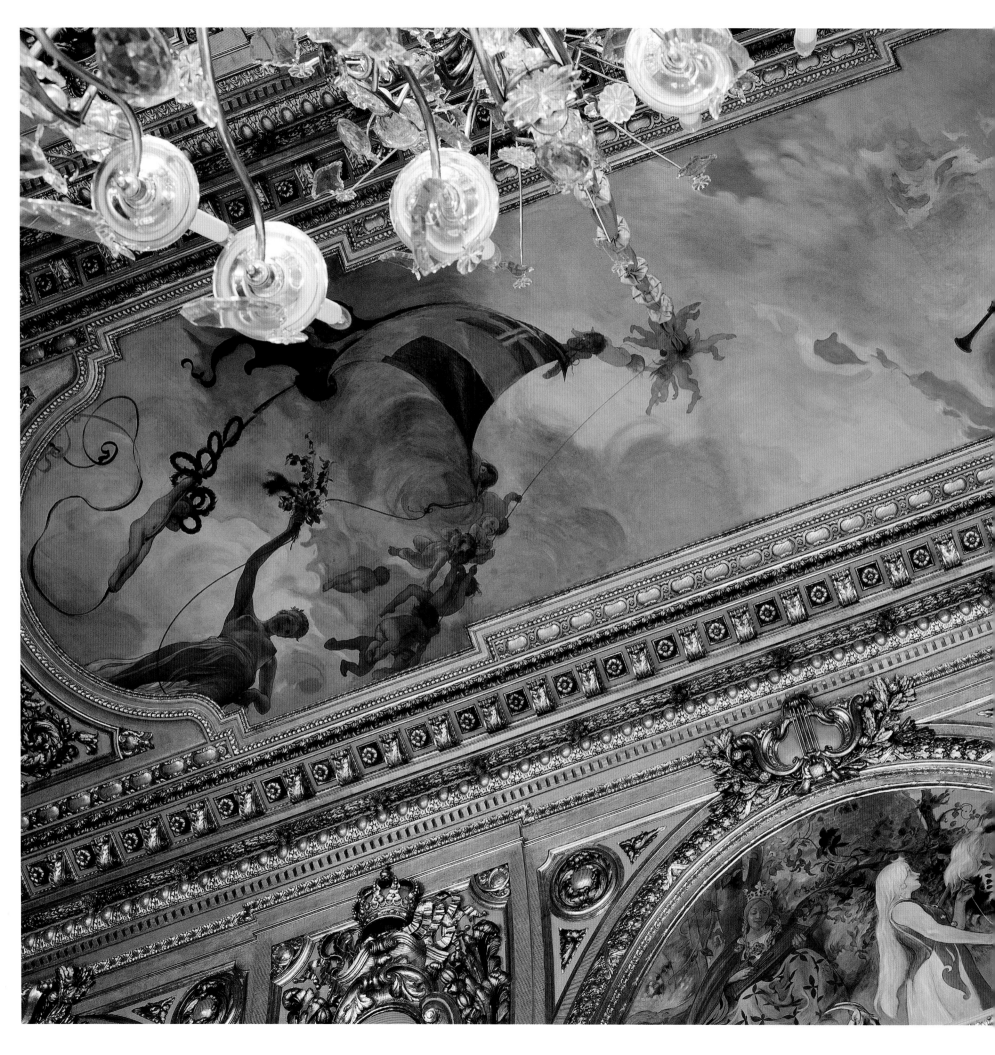

KUNGLIGA OPERAN

STOCKHOLM

SWEDEN

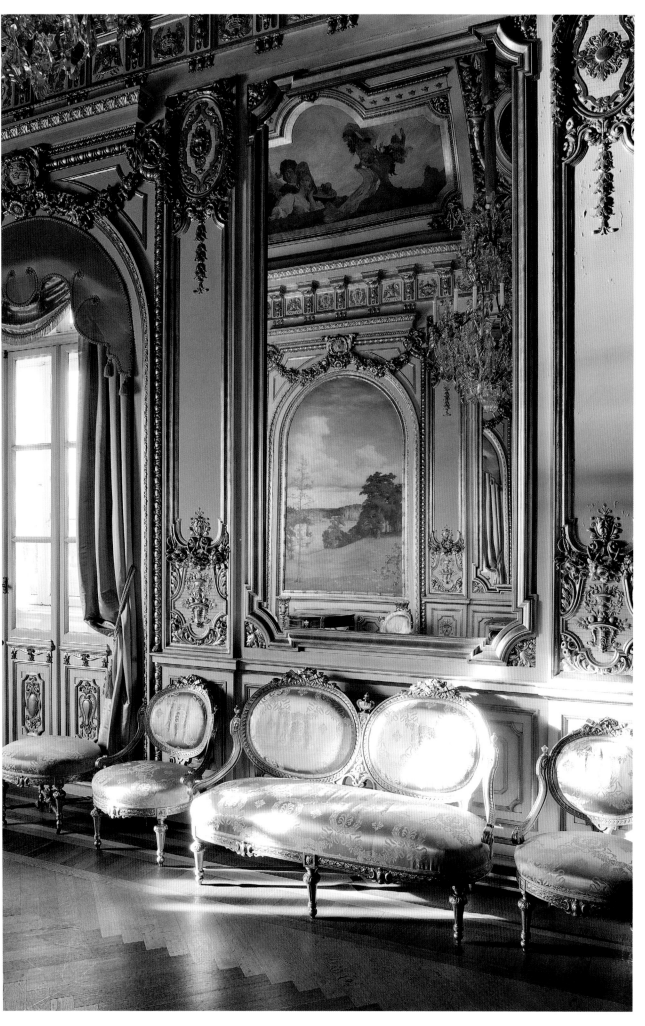
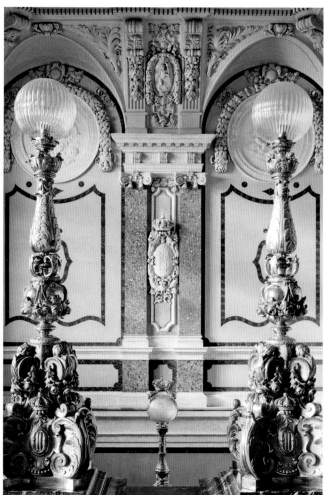
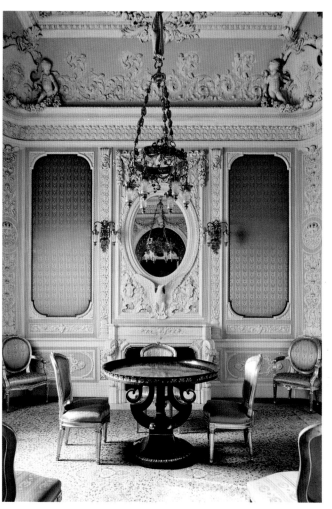

*S*wedish architect Carl Fredrik Adelcrantz is known for the exceptional theater he designed for the royal residence in Drottningholm. What is less well known is that some fifteen years after the latter edifice's inauguration, King Gustav III of Sweden charged the same architect with building an opera house in the very center of Stockholm. All eyewitness accounts agree that it was a grandiose structure with two façades, respectively overlooking Gustav Adolf Square and the canal. The plans for this building, reminiscent of those by Claude-Nicolas Ledoux, were allegedly developed in close collaboration between Adelcrantz and Gustav III himself—as a proper enlightened despot, the Swedish sovereign was a great lover of art. The king was assassinated in 1792 during a masked ball in the very theater he loved so much. This dramatic episode in Swedish history was related in Verdi's opera, *Un ballo in maschera.*

A century later, a momentous decision was made after much discussion: Adelcrantz's theater would be razed in order to build a more modern edifice. And so a masterpiece of Swedish architectural heritage disappeared, to be replaced by the current Kungliga Operan. Built by Axel Anderberg, the edifice was inaugurated in 1898. The architect adopted an overly safe, rather monumental neoclassical style. The building's massive footprint was largely intended to allow for colossal public areas. With a vestibule, grand staircase, and two foyers (the court did not mix with mere mortals), the style was intentionally demonstrative and clearly inspired by the already legendary Palais Garnier in Paris. Anderberg worked with artists including Axel Jungstedt and Carl Larsson for the paintings in the foyers and on the staircase.

The theater holds 1,200 seats divided between the orchestra, two balconies, and a large-scale amphitheater gallery. An eye-catching succession of colonnades at the gallery level forms an appealing pattern.

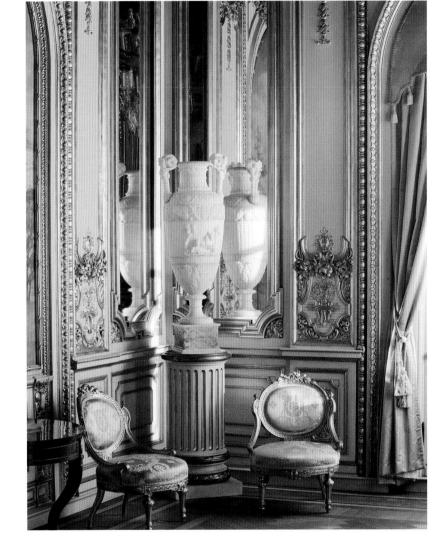

The public spaces of the Stockholm opera are impressively ornate.

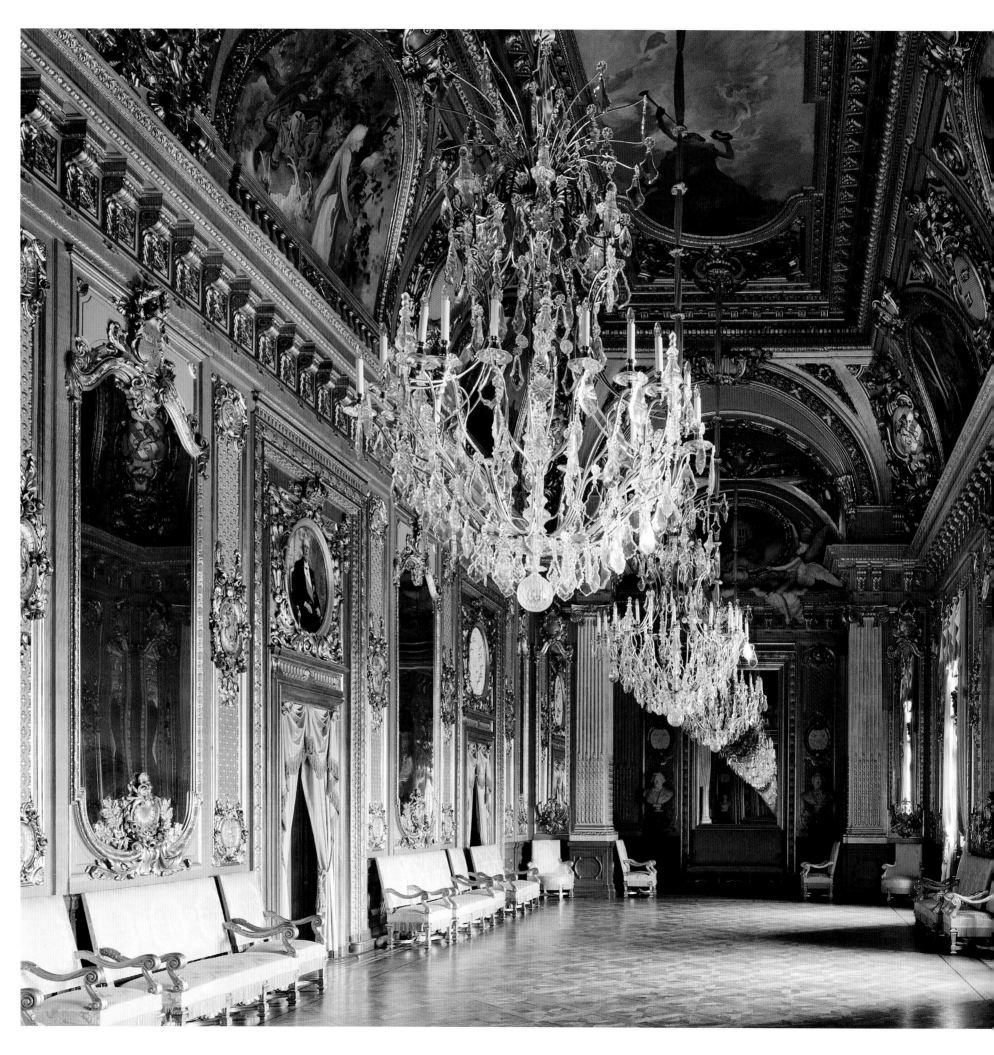

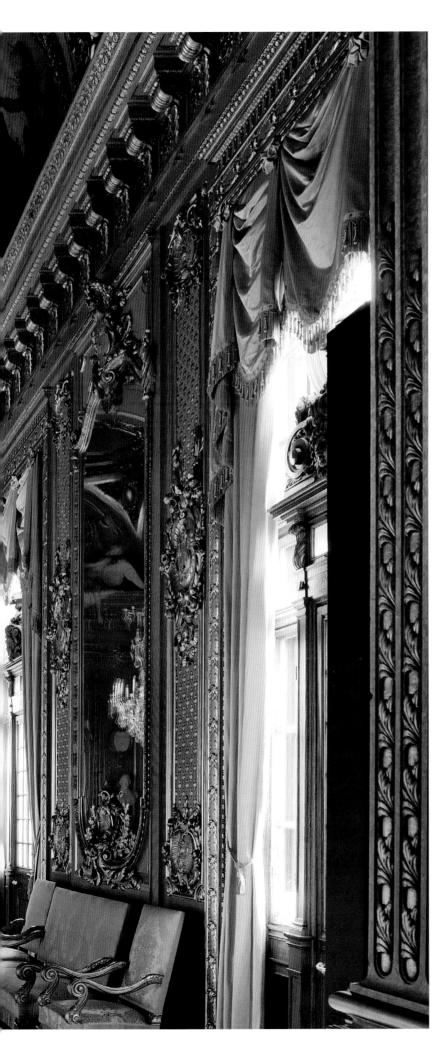

Though it lacked audacious architecture, the new theater quickly distinguished itself by its programming. In 1907, it held the highly anticipated Stockholm premiere of Wagner's *Ring*. Since then, the Wagnerian repertoire has always been superbly served by Swedish opera singers, ranging from Birgit Nilsson to Nina Stemme. The Kungliga Operan has also regularly highlighted contemporary music, both Swedish and international. It was notably here that Ligeti's *Le grand macabre*, whose themes of death and sexuality make it one of the most scandalous operas in the repertoire, was premiered in 1978.

A distinguishing feature of the Stockholm opera house is its tradition of leadership by former singers, of whom Birgitta Svendén is the latest. In this nation where parity is a fundamental political issue, many women hold the top positions in cultural institutions. The opera has 550 permanent employees, including a company of twenty-five soloists and an orchestra of 107 musicians, which makes it one of the biggest Scandinavian symphony orchestras. The opera house is also home to the Royal Swedish Ballet, whose former dancer Alicia Vikander is now a rising star in Hollywood.

PAGES 96–97 *Ligeti's* Le grand macabre, *one of the landmark operas of the second half of the twentieth century, was first performed in this theater.*

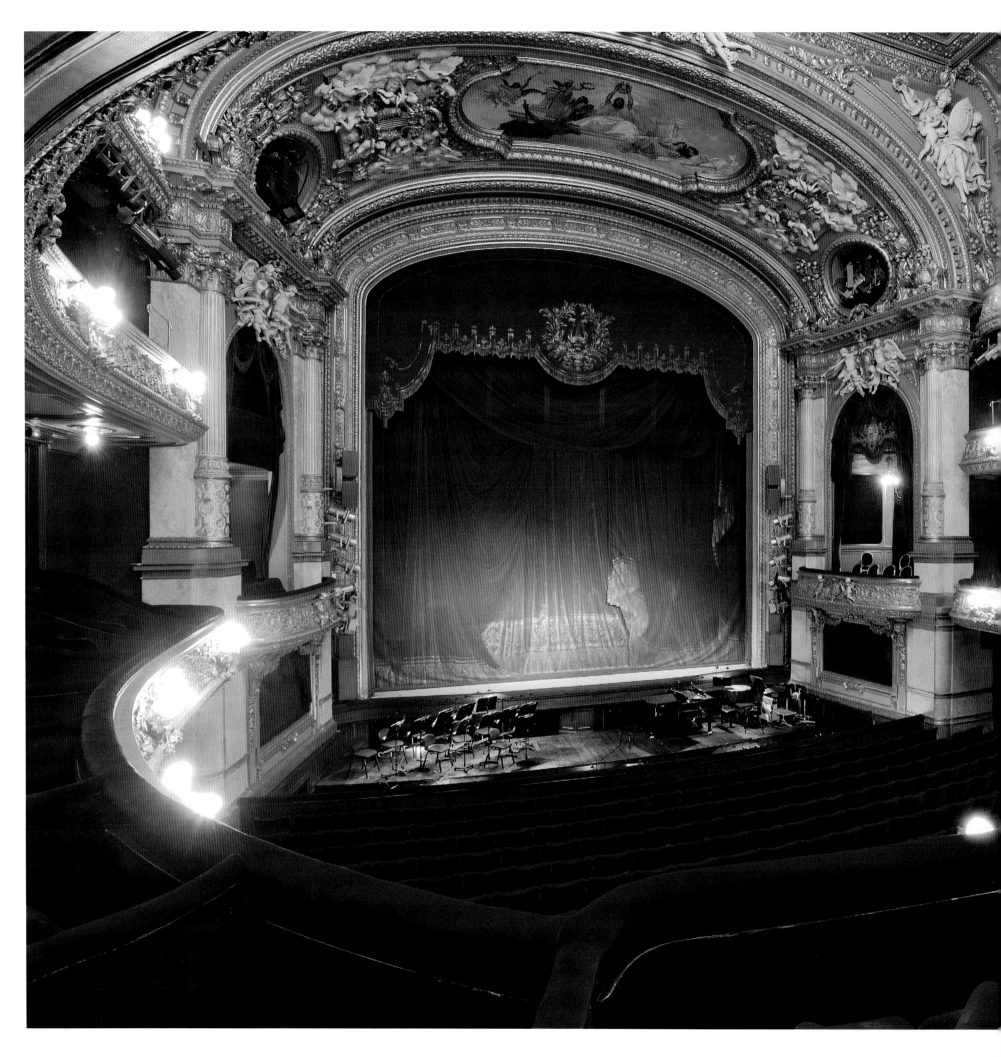

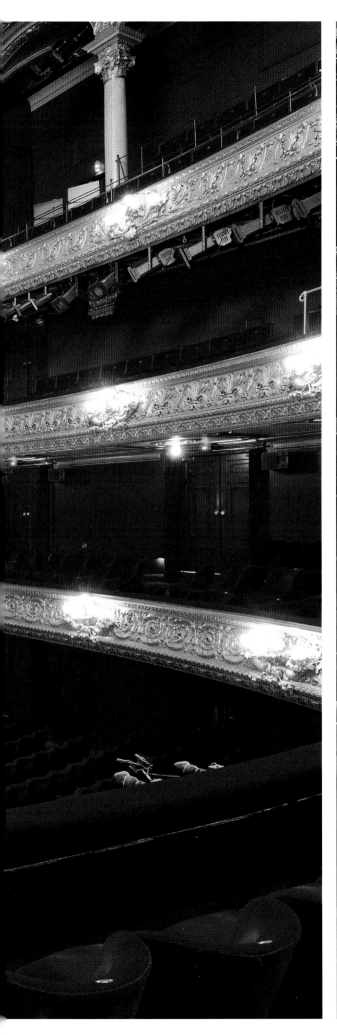
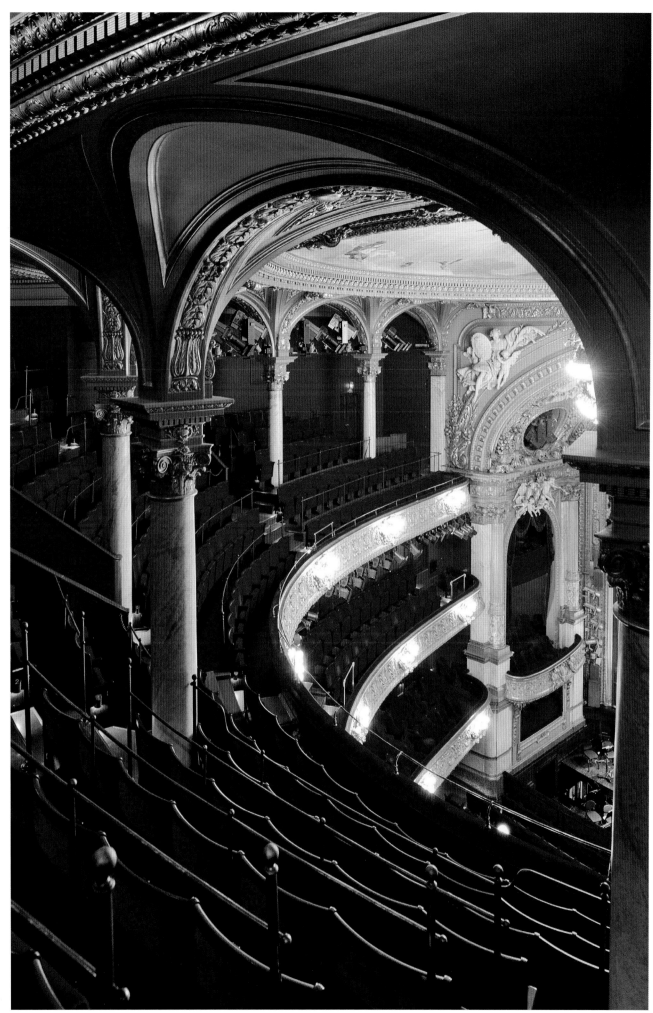

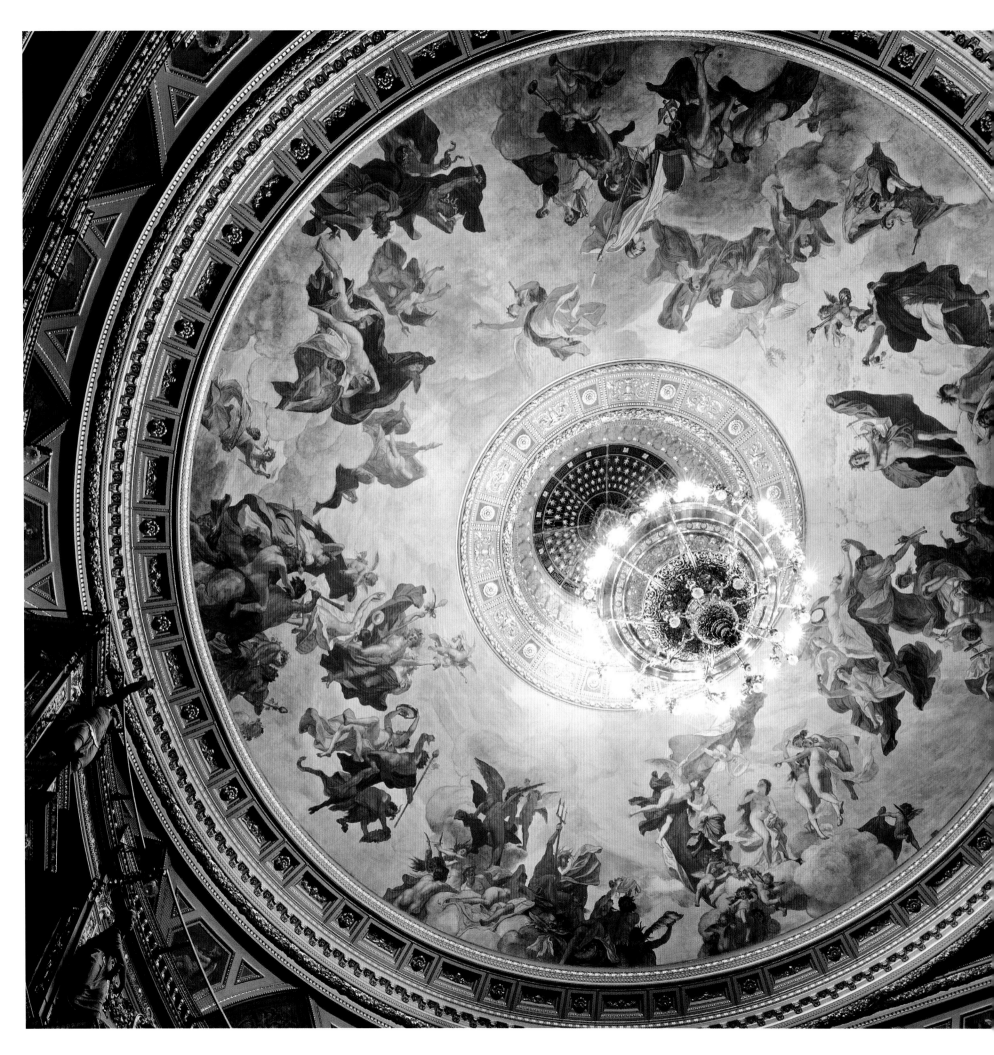

MAGYAR ÁLLAMI OPERAHÁZ

BUDAPEST

HUNGARY

he Budapest Opera House has witnessed the early careers of some of world's greatest orchestra conductors. In the 1920s and 1930s, Georg Solti, Antal Dorati, Eugene Ormandy, and Ferenc Fricsay took turns at the music stand. Aside from these Hungarian conductors, the opera house also welcomed Thomas Beecham, Bruno Walter, and Herbert von Karajan. But the most famous of them all was the man who headed the theater from 1888 to 1891, Gustav Mahler, better known today as a composer.

The selection of this Austrian musician, then barely thirty years old, had nothing to do with chance. The Budapest Opera was inaugurated in 1884, at a time when Austrian Emperor Franz Joseph's domination was increasingly contested by rebellious independence movements. The Austro-Hungarian regime was trying to make its mark in Budapest and balance both cultures' influences. Indeed, excerpts from Hungarian operas and the first act of Wagner's *Lohengrin* were chosen for performance at the inauguration.

It comes as no surprise that the building's design by Miklós Ybl is reminiscent of the Vienna Opera, inaugurated fifteen years earlier. Both edifices have an imperial dome towering over the theater, covering both the auditorium and the stage house. From the inception, it was made clear that not a single aesthetic detail could exalt the Hungarian national identity. The exterior arcades, columns, and loggia are in an Italian neo-Renaissance tradition. Once inside the building, the public follows a grand staircase also reminiscent of the opera house in the Habsburg capital. With their wood paneling, the halls surrounding the foyer have a slightly old-fashioned cachet, an impression reinforced by the use of velvet. Designed in the Italian style, the house has 1,260 seats divided among the orchestra, three levels of balconies, and a gallery.

The intrictately carved and gilded wood paneling of the foyer creates an opulent setting.

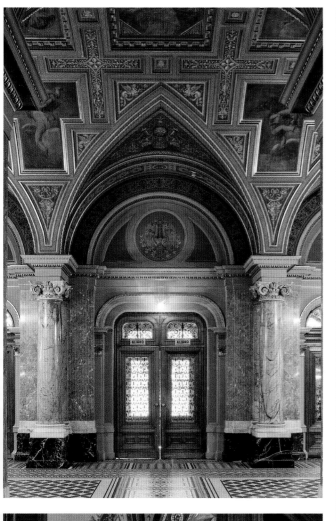

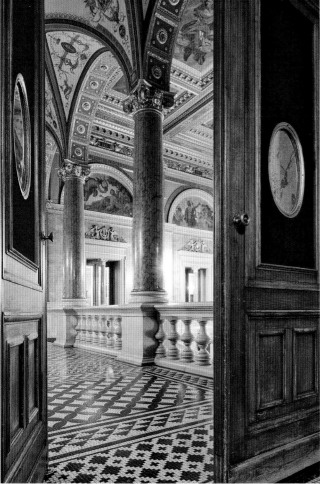

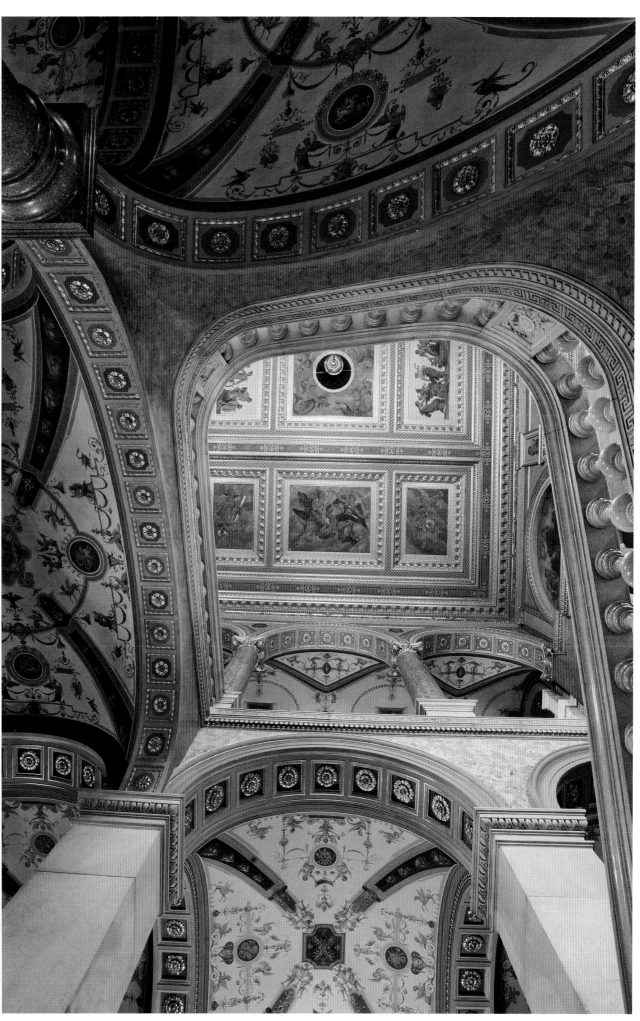

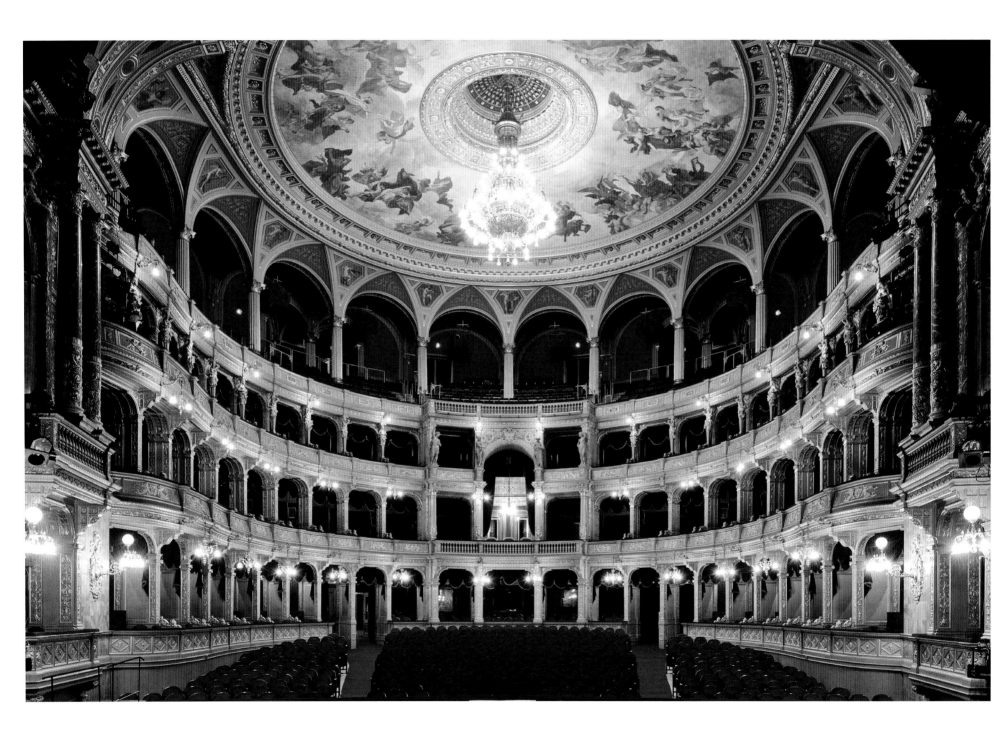

Though it lacks an innovative architectural gesture, the theater has an intimate atmosphere and superb acoustics.

The theater was ahead of its time in terms of safety. In the late nineteenth century, theaters all over Europe were lost to fires, which occasionally claimed many lives. Emphasis in this theater was thus placed on technical equipment that could prevent or at least limit the spread of fire. The Budapest Opera House was one of the first to install an iron security curtain to separate the stage and the house. Audience evacuation routes were also planned, with discrete staircases for each balcony level. To the same end, an aisle divided the orchestra down the middle to avoid any crowd clustering. The stage equipment in the wings was cutting edge, without any flammable materials.

While the theater successfully avoided fires, it could not ward off the constant turmoil of political life. In 1918, Hungary declared its independence. Programmers pushed Magyar music to the fore: Bartók's *Bluebeard's Castle* was premiered the same year. During the Second World War, the opera house's basement regularly served as an air raid shelter, and the edifice was only slightly damaged by bombing. The situation became more delicate under Soviet rule. The authorities censored many works and insisted on giving pride of place to scores that glorified communism. The opera house underwent major renovation from 1980 to 1984.

Today the Budapest Opera showcases a classic repertoire and banks on Hungarian singers. Yet it must be admitted that its programming has lost some of its luster, with few premieres and rare appearances by foreign conductors ... We can only hope that this historic stage of Central Europe will one day experience a renaissance.

Built in the Italian neo-Renaissance style, the Budapest Opera House is reminiscent of the Staatsoper in Vienna (see page 172).

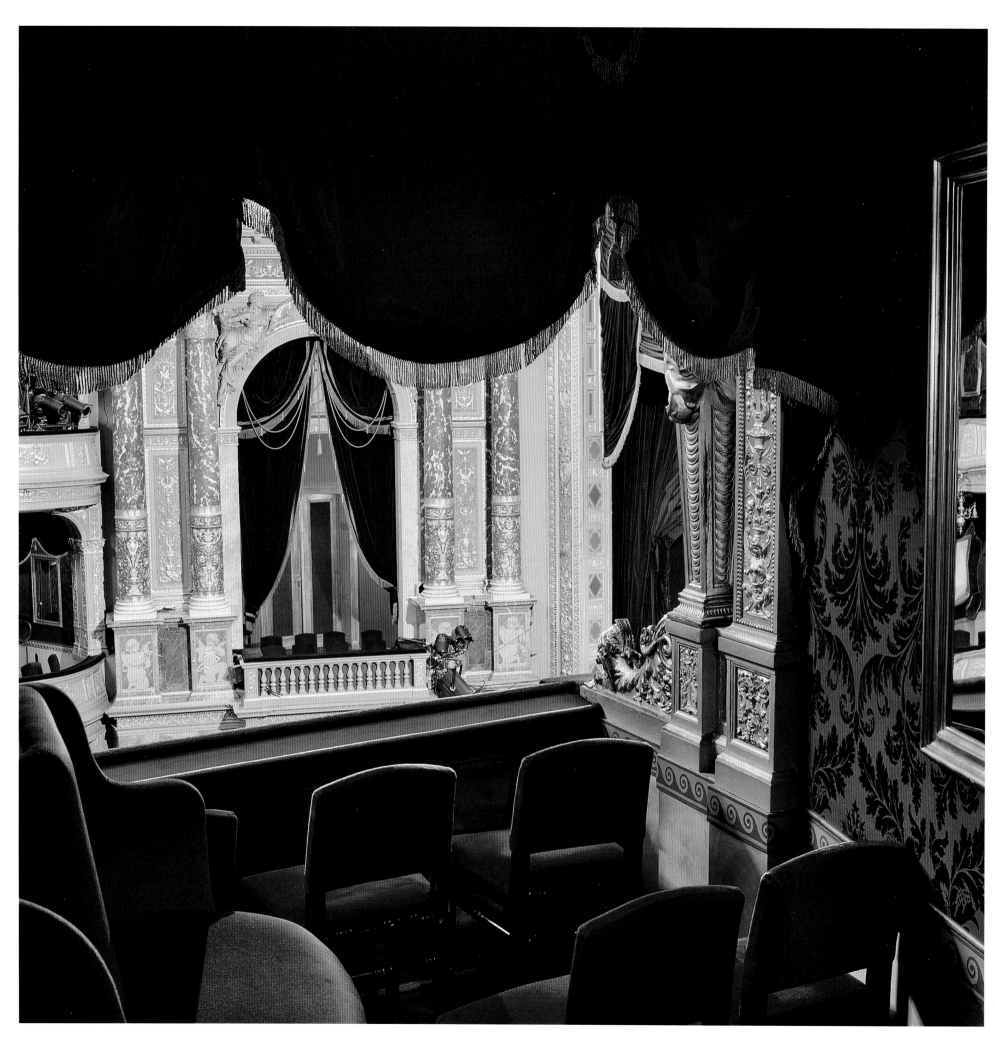

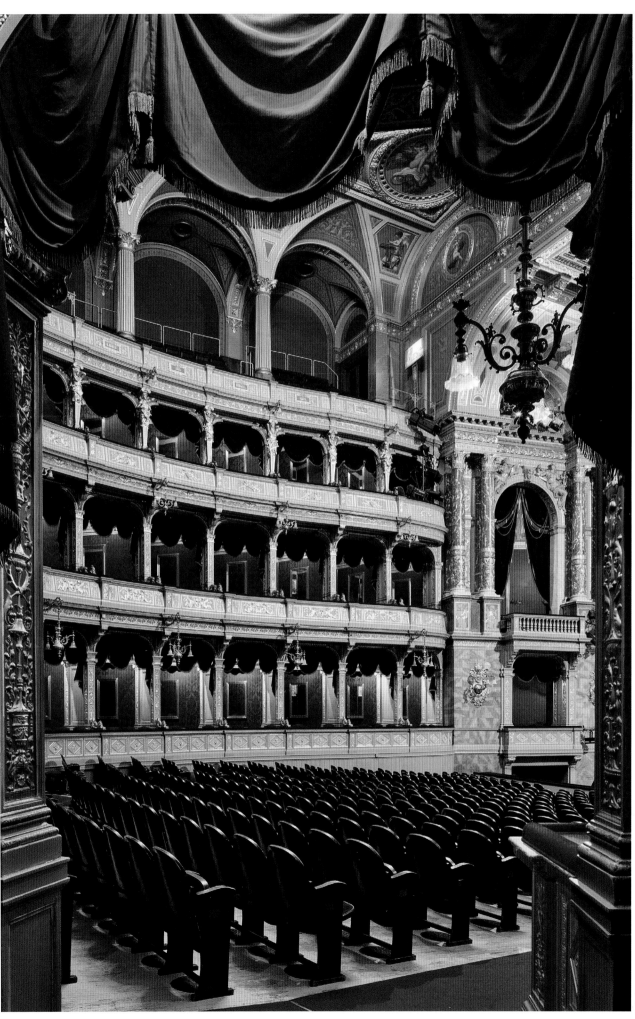

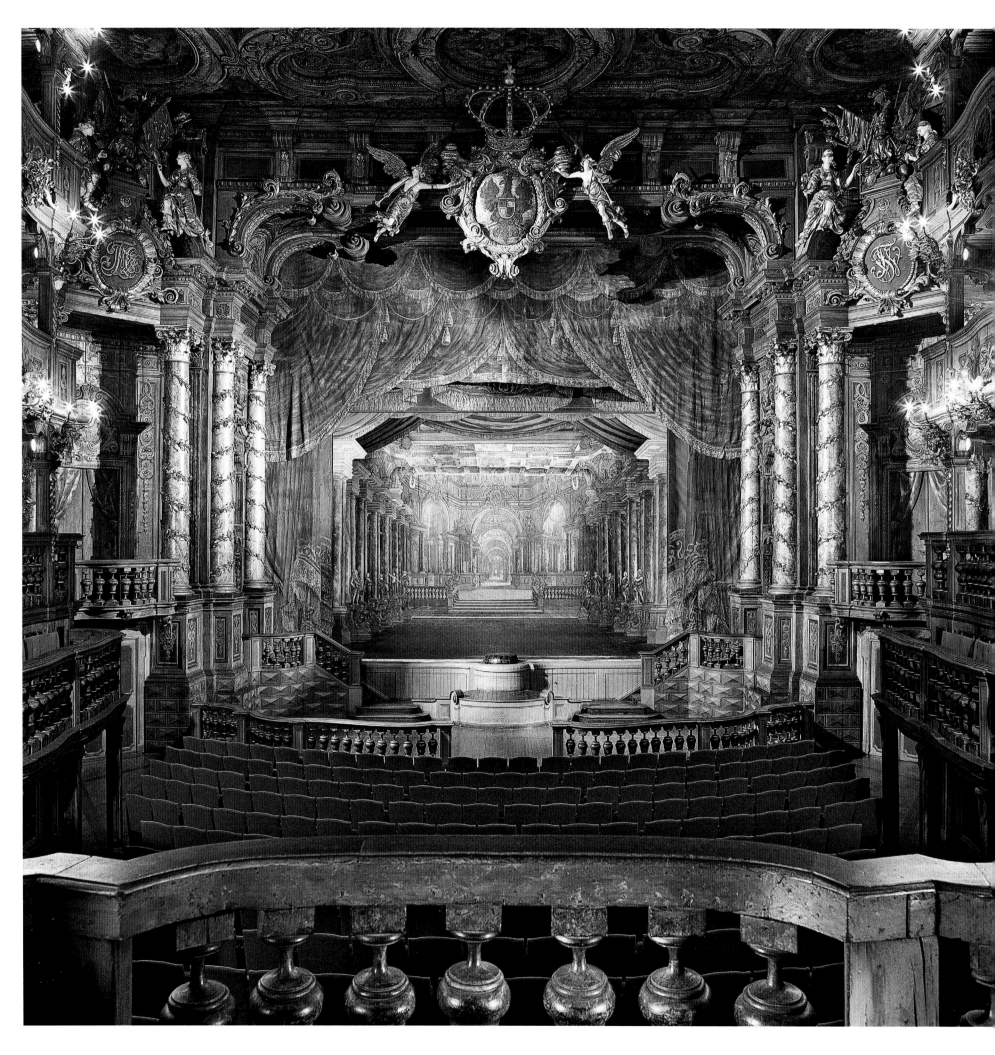

MARKGRÄF-LICHES OPERNHAUS

BAYREUTH GERMANY

Bayreuth is always associated with Wagner and his Festspielhaus. Yet the Bavarian city also boasts one of the most beautiful baroque theaters in Europe, the Markgräfliches Opernhaus. The opera house was built for the Margravine (the equivalent of a marquise) Wilhelmine of Prussia, sister of Frederick the Great. A lover of the arts, she was a composer herself and wrote an opera titled *Argenore*. Inaugurated in 1748, her theater is in the center of Bayreuth, close to the castle, living proof that the court now mixed with the bourgeoisie and no longer concentrated artistic life inside its palaces.

The edifice was designed by a Frenchman, Joseph Saint-Pierre, and an Italian, Giuseppe Galli Bibiena. The former conceived the exterior, a conventional façade with Corinthian columns. The latter, a member of a family of Italian artists who specialized in building theaters, turned the interior into a genuine masterpiece. In blue and gold, lit by some hundred candelabras, the auditorium is fascinating for its ornamental richness. Paintings and sculptures form a brilliant setting, without appearing ostentatious.

The roughly 500 spectators are divided among the orchestra (entirely flat, it also serves as a ballroom) and three levels of balconies, following the bell-shaped floor plan typical of Galli Bibiena. At the foot of the royal box, two staircases lead to a passageway and the first balcony, both of which are bordered by elegant balustrades. These same balustrades also frame the area for the orchestra, which does not have an actual pit. A staircase from the house to the stage creates an unsettling sense of intimacy. Two boxes facing the audience on either side of the stage were used for trumpet fanfares to announce the sovereigns' arrival: In Bayreuth, the spectacle is also inside the auditorium.

The edifice was miraculously spared by fires and wars. Nonetheless, this UNESCO World Heritage Site, now more than 250 years old, badly needed a makeover. The Markgräfliches Opernhaus has been closed for renovation since 2012. The State of Bavaria has invested close to €18.7 million in this major project, whose outcome is eagerly awaited.

The splendidly baroque Bayreuth Opera House was built for Margravine Wilhelmine of Prussia, herself a composer.

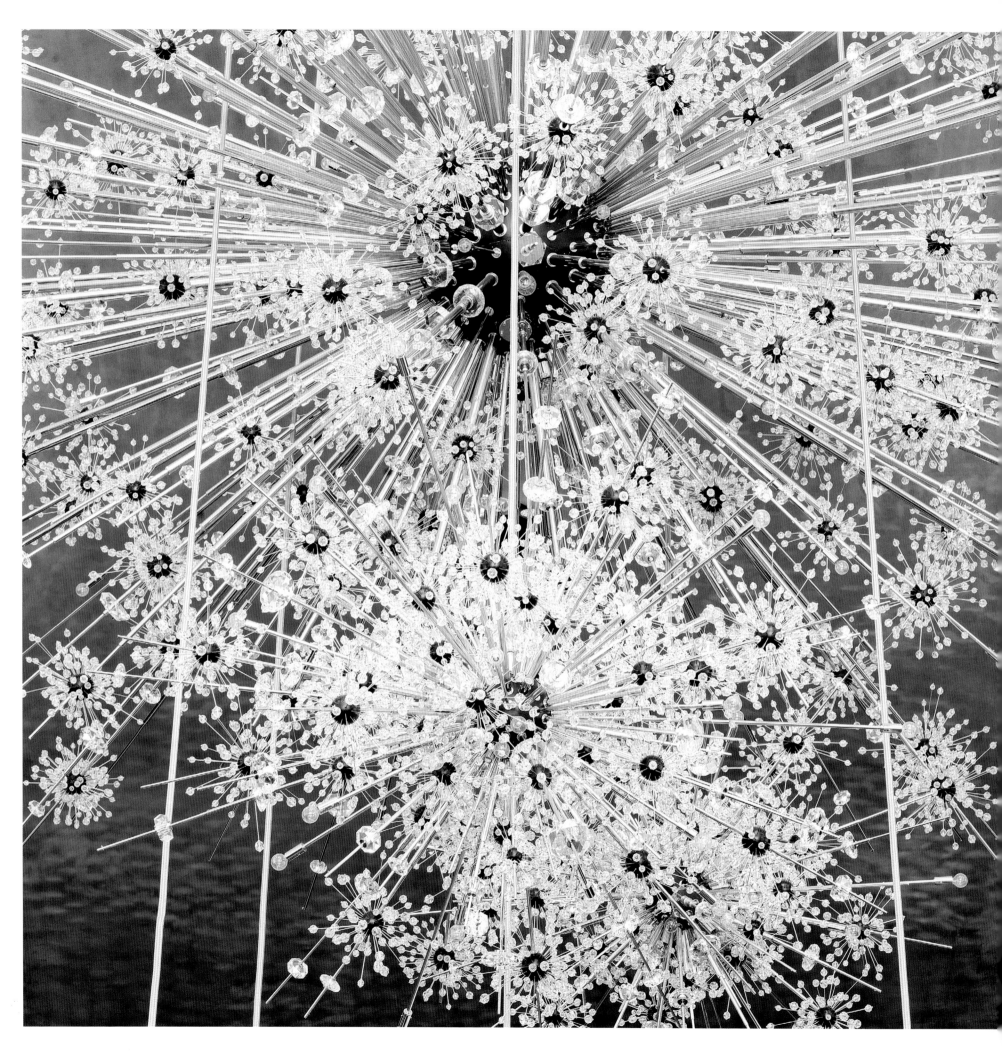

THE METROPOLITAN OPERA

NEW YORK

UNITED STATES

Lincoln Center, one of the nerve centers of New York cultural life, sits a couple of blocks from Central Park. The complex primarily consists of three buildings around a pedestrian plaza with an emblematic fountain at its center. On one side, the David H. Koch Theater, built in 1964; on the other side, Avery Fisher Hall, the New York Philharmonic's concert hall, completed in 1962; and in the center, the Metropolitan Opera House, which opened in 1966 with the premiere of Samuel Barber's *Antony and Cleopatra*.

Before it was incorporated into Lincoln Center, the Met was in a theater at Broadway and Thirty-Ninth Street. Despite its ideal location, the building had become technically outdated and run down, with inadequate wings. The "old Met" was demolished in 1967—a tragedy for New York's theatrical heritage.

The architecture for the "new Met" was entrusted to Wallace Harrison, the coordinator of the Lincoln Center complex. The façade features a row of five great arches, whose bay windows create a beautiful sense of transparency, particularly once the theater's lights are lit on performance evenings. The flat roof masks the stage house and conceals the building's function. While the structure remains imposing from the outside, if not downright austere—the real treasures lie within.

The Metropolitan Opera House boasts first-rate artworks. The moment you enter the red and gold vestibule, your gaze is drawn to Aristide Maillol's bronzes; his sensual sculpture titled *Femme s'agenouillant: le monument à Debussy* (*Kneeling Woman: Monument to Debussy*) is specifically dedicated to music. Stairs lead to a second-floor foyer dominated by two wall paintings by Marc Chagall, *Le triomphe de la musique* (*The Triumph of Music*) and *Les sources de la musique* (*The Sources of Music*). Visible from outside, these large-format paintings combining a profusion of colors and a strong sense of composition are among Chagall's masterpieces. A dozen crystal chandeliers, made in

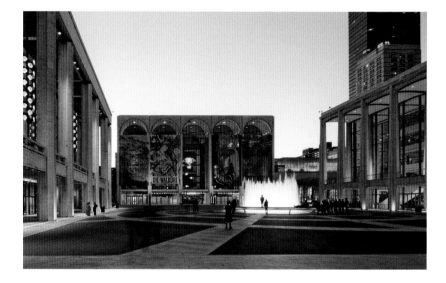

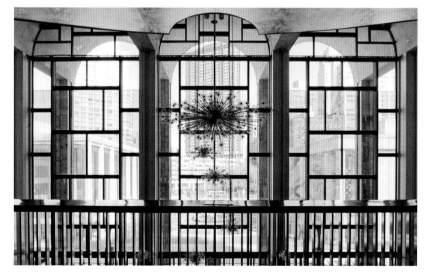

PAGES 110–113 *Crystal chandeliers and bronzes by Aristide Maillol play off each other in the Met's impressive public spaces.*

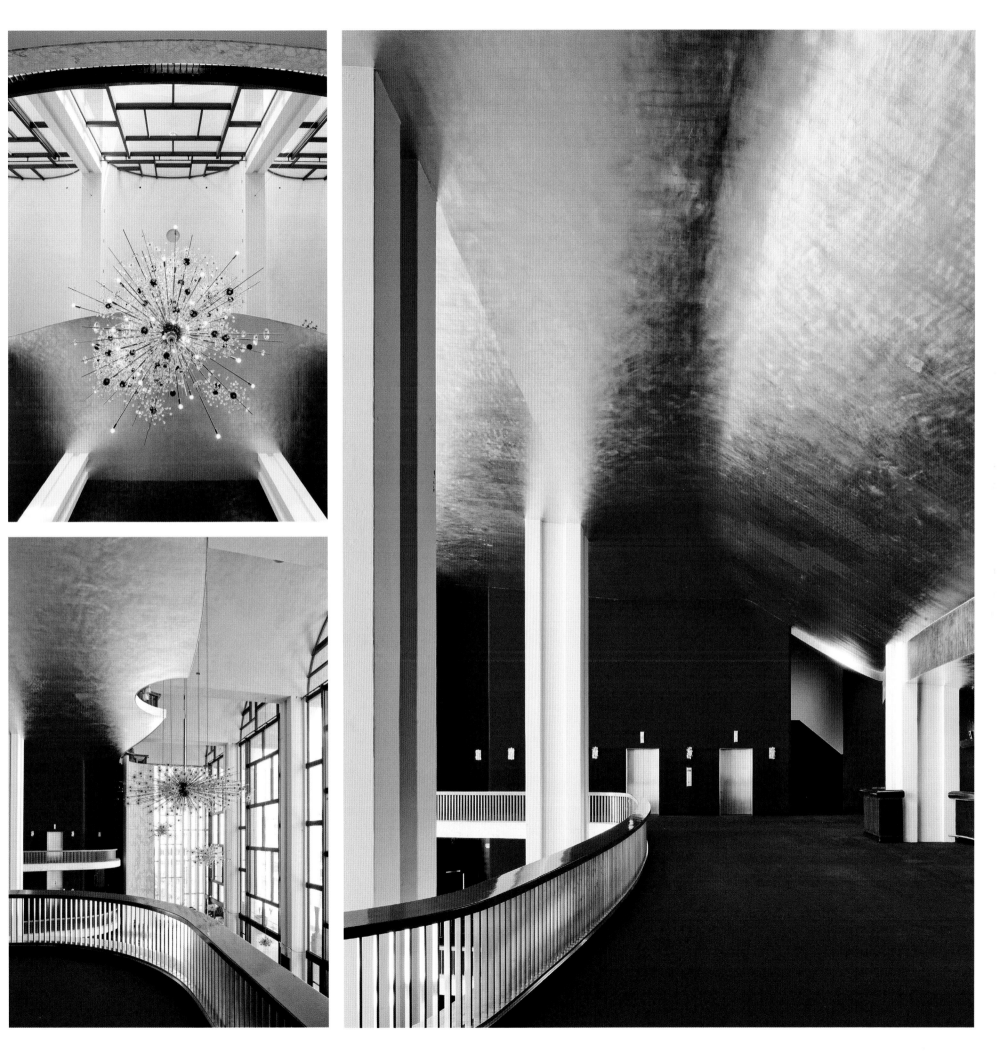

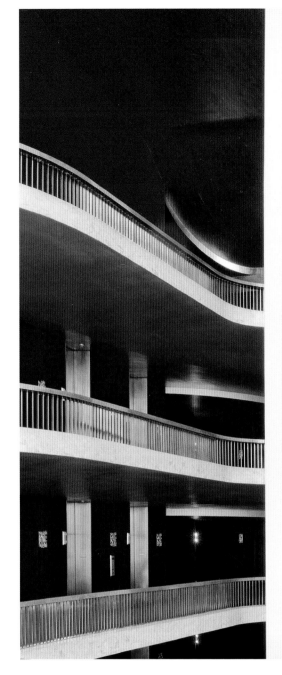
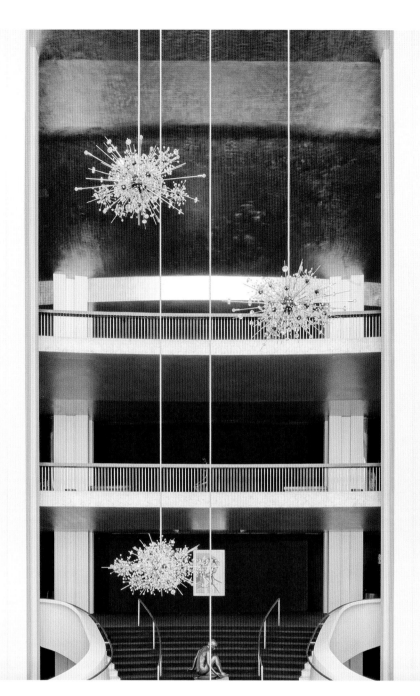
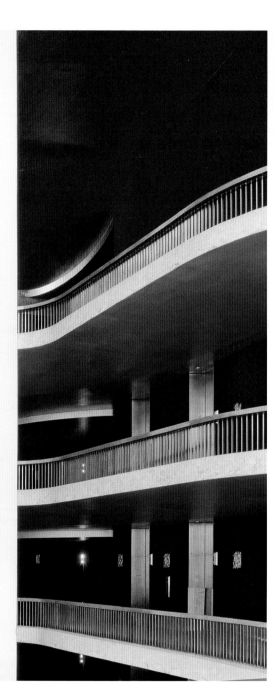
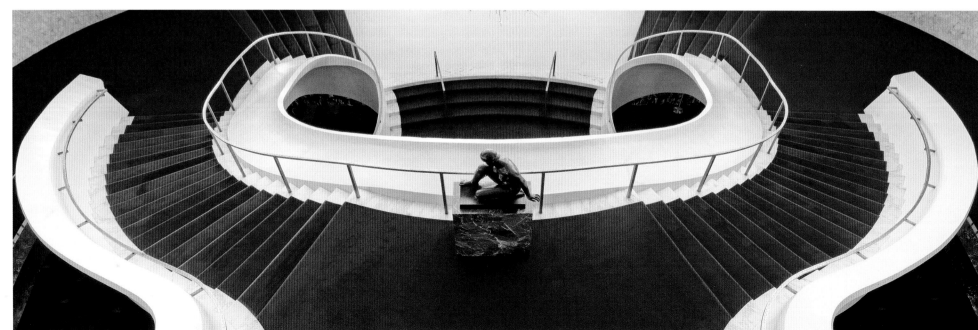

Vienna and presented to the opera house by the Austrian government, illuminate the entire foyer. On sunny days, audiences crowd onto the loggia overlooking the plaza.

The performance hall is one of the biggest in the world, with no less than 3,800 seats divided among an orchestra and five balconies, with an additional 200 standing places. The figures are dizzying: a fifty-two-by-fifty-two-foot proscenium, a stage seventy-eight feet deep, seven stage lifts and three full-stage wagons, which move sets on and off the stage. This kind of technical equipment was specifically conceived to enable productions to alternate from one night to the next.

Another of the Met's greatest technological innovations has been in the area of media. In 2006, it launched live broadcasts of its operas in movie theaters. The "Live in HD" phenomenon has gone global: A December 2012 performance of Verdi's *Aida* was seen by close to 300,000 viewers in sixty-four countries.

On movie screens, the Metropolitan has also become the best-known opera house in the world.

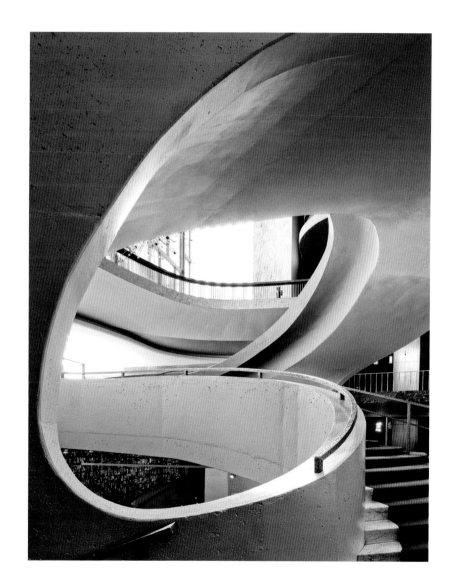

PAGE 115 *The Met's auditorium boasts 3,800 seats—one of the largest opera-hall capacities in the world.*

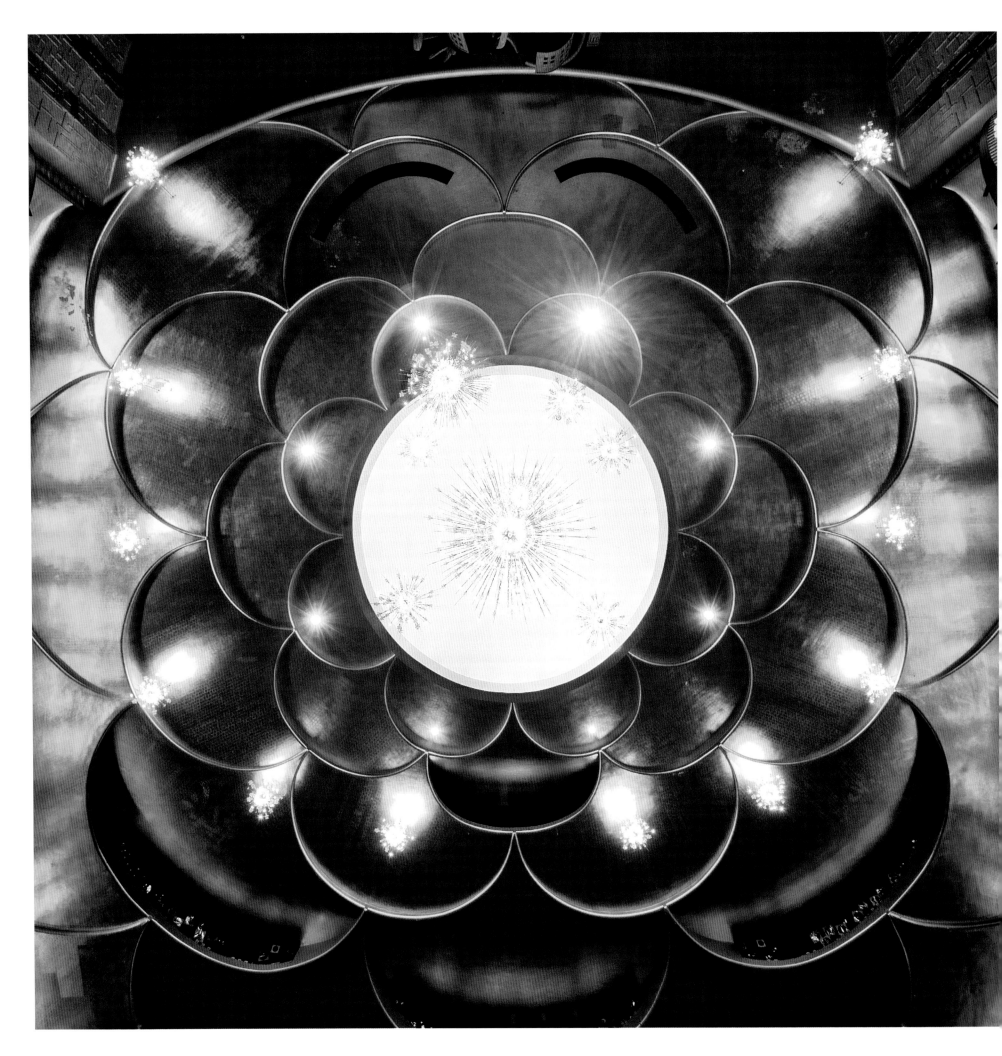

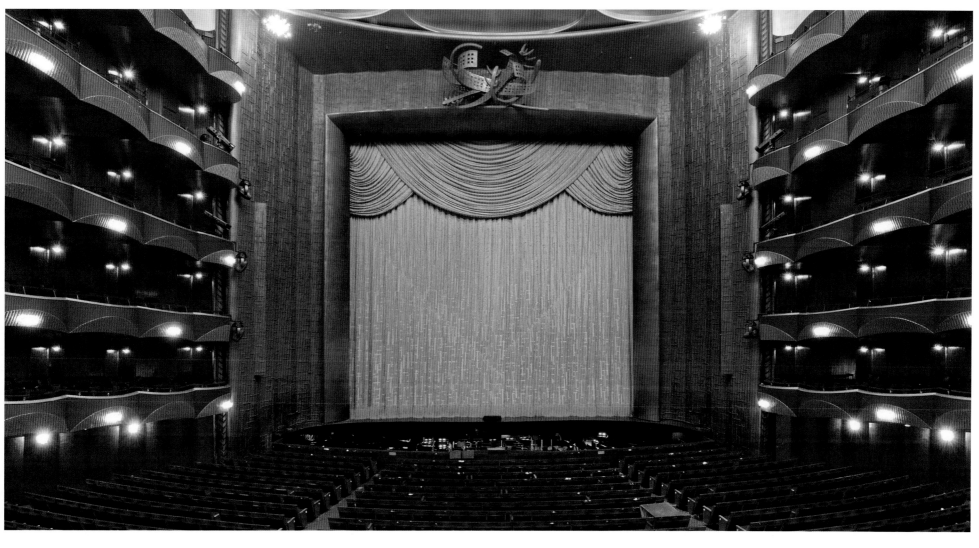

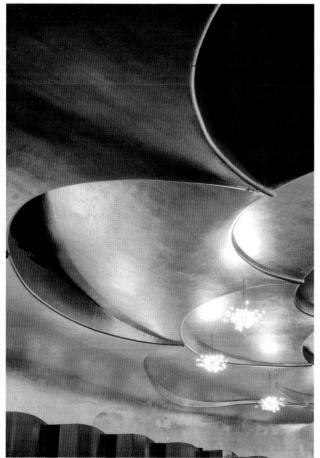
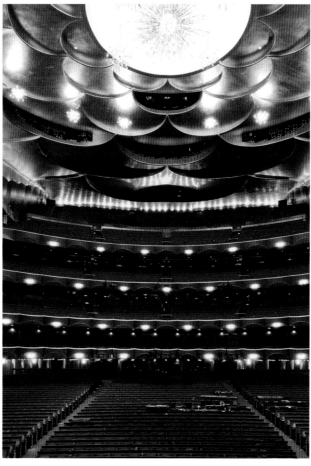
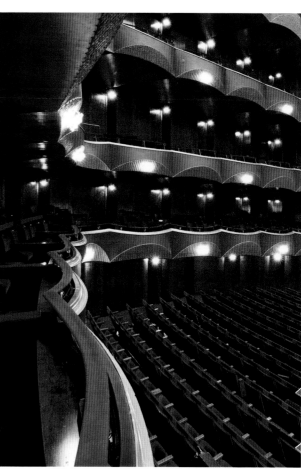

NEW
NATIONAL
THEATRE

TOKYO

JAPAN

here is no denying that today's best acousticians are Japanese, from Tateo Nakajima, one of the heads of Artec in New York, to Yasuhisa Toyota, codirector of Nagata Acoustics. Founded in Tokyo, Nagata Acoustics has worked on the largest symphonic concert halls in Japan: the Suntory Hall in Tokyo, the Kyoto Concert Hall, the Sapporo Concert Hall . . . Tokyo's New National Theatre, the country's most important hall devoted to opera (a repertoire historically less developed in Japan than symphonic music), was also supervised by Nagata.

The edifice is part of Tokyo Opera City, a 767-foot, forty-five-story skyscraper in Shinjuku. Inaugurated in 1997, the building was conceived by the architect Takahiko Yanagisawa in a functional, grandiloquent but monotonous style—a far cry from the daring of Kenzo Tange or, more recently, Arata Isozaki. The complex remains interesting because it is not solely devoted to corporate offices. Various cultural venues occupy its lower floors: a museum of contemporary art, a symphonic concert hall, and the New National Theatre. The theater has three performance spaces: the Pit, a modular room with about 400 seats; the Play House (1,038 seats) for theater; and, in its largest space, the Opera House (1,814 seats), which is intended for the opera repertoire.

Inaugurated on October 10, 1997, the New National Theatre has been nicknamed "Opera Palace, Tokyo" since 2007. It is indeed a sumptuous space: With its raked orchestra (with uninterrupted rows of twenty seats) and three balcony levels, it combines the historical form of opera houses with the most modern technical equipment. The main stage is surrounded by two lateral wings and a rear stage, allowing for an efficient, rapid load-in of stage sets. The 1,582-square-foot pit can accommodate up to 120 musicians.

The New National Theatre is located in the neighborhood of Shinjuku.

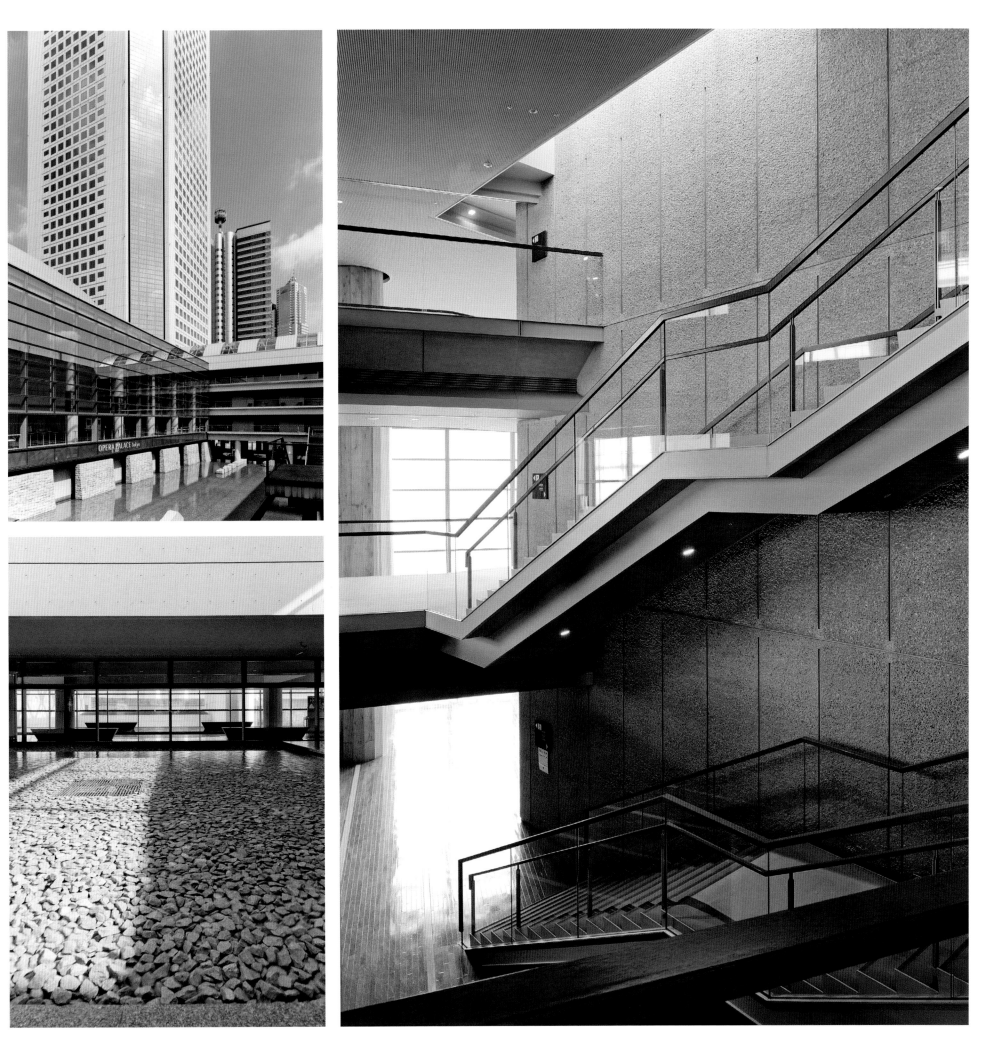

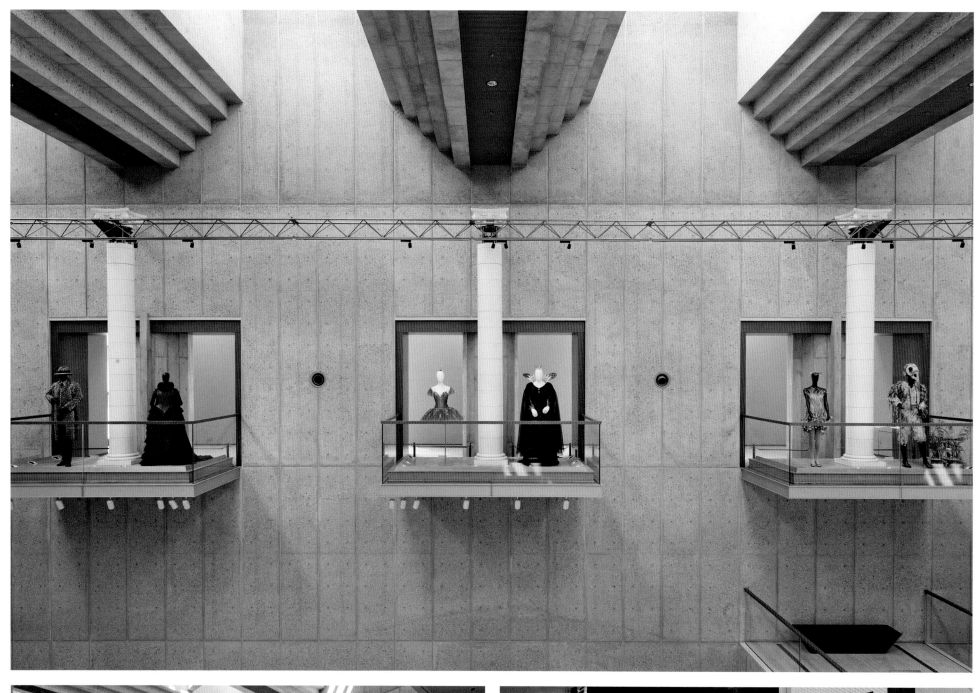

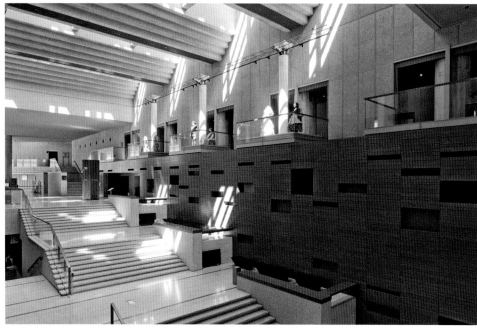

The predominant use of wood in the house creates a feeling of intimacy, lending itself to "psychoacoustics," a theory that the public hears better if it feels good in a room. From a more scientific perspective, Nagata Acoustics' work resulted in a reverberation period that varies from 1.4 to 1.6 seconds (with an audience), an ideal period for opera, neither too dry nor too resonant.

Programming is dominated by the great classics of the opera repertoire, but each season, one can attend a Japanese contemporary opera, most often with traditional sets: an example of the legendary compromise between tradition and modernity at the axis of the Japanese artistic identity.

The New National Theatre stands out for its acoustics and technical equipment, as well as its sleek design.
PAGES 122-123 *With three balconies and a raked orchestra, the auditorium holds 1,814 seats.*

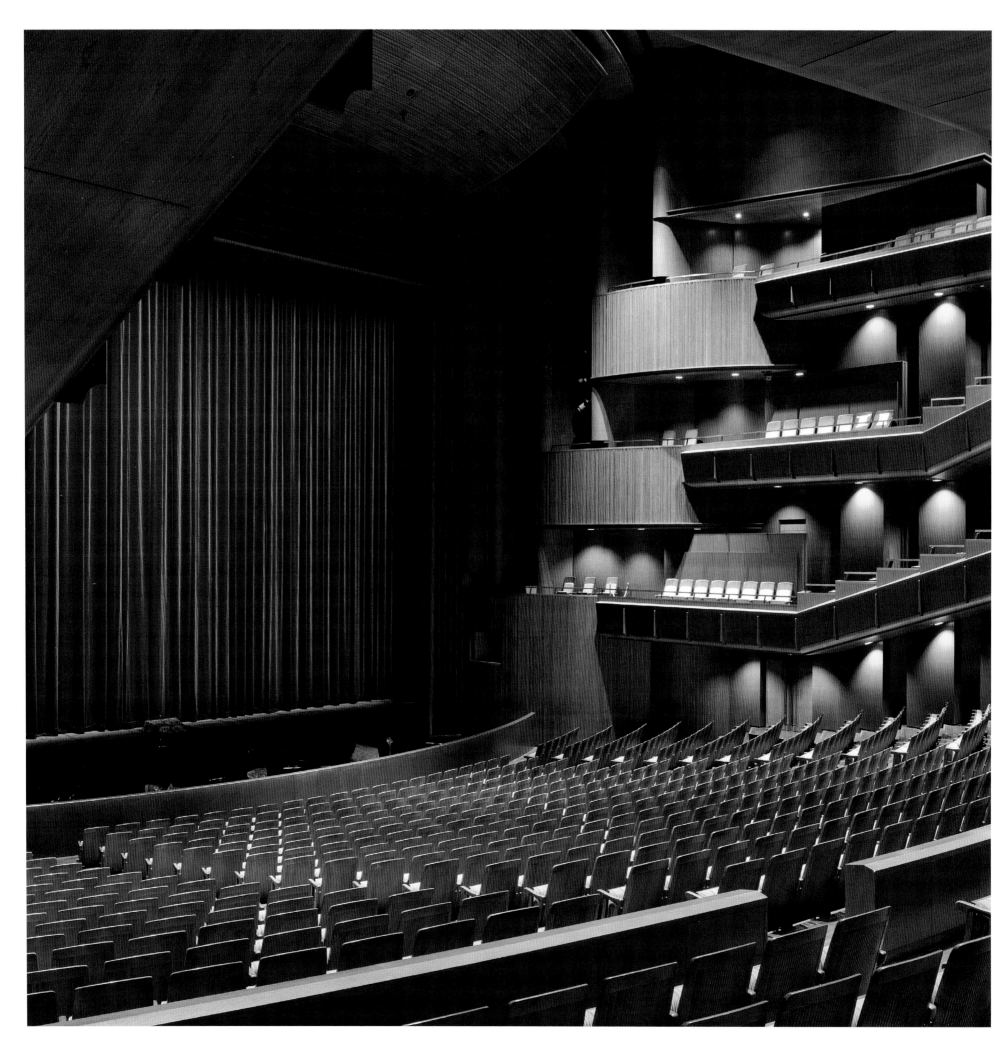

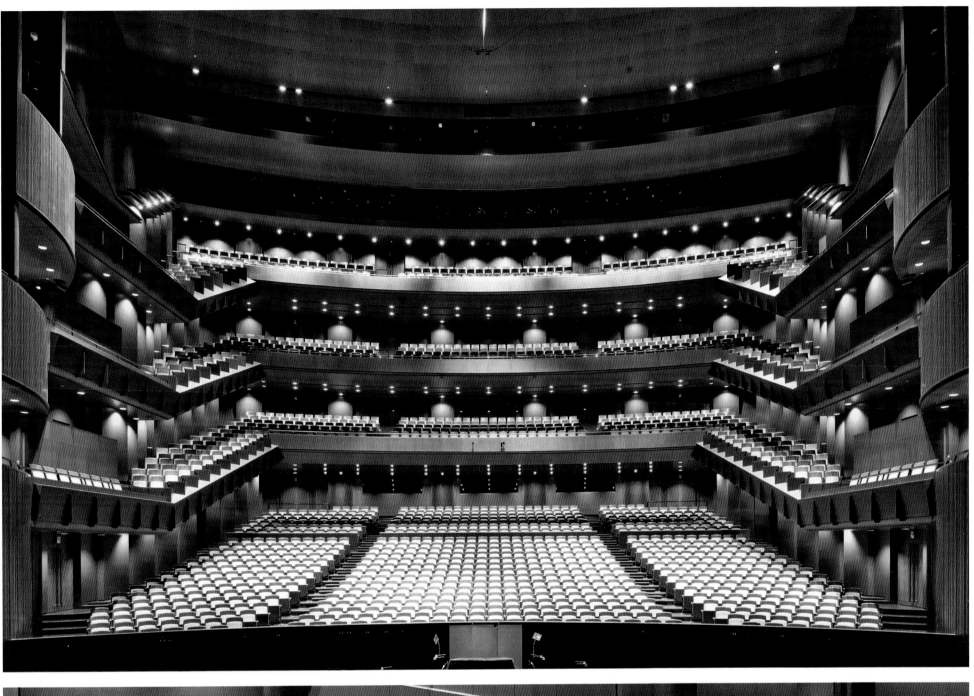

OPÉRA ROYAL

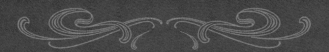

VERSAILLES

FRANCE

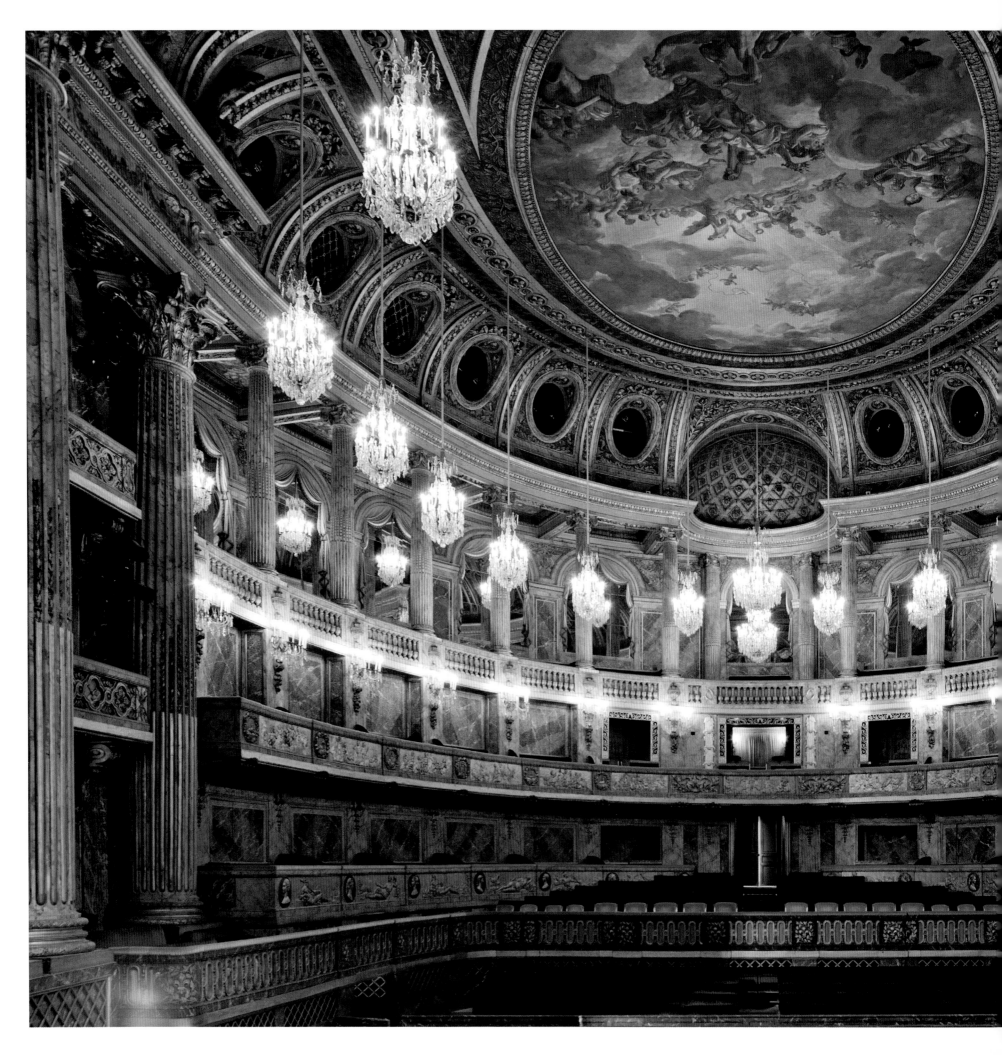

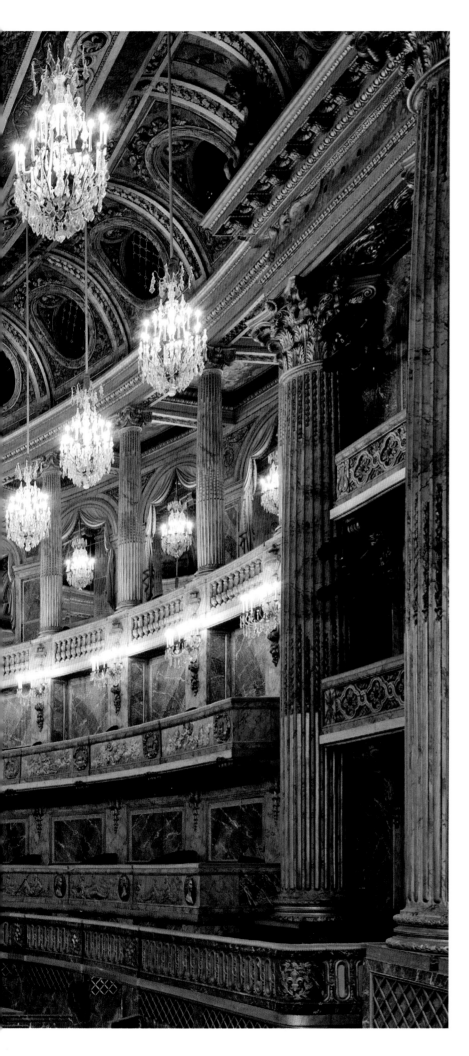

One could not imagine a more lavish inauguration. The royal opera house of the Château de Versailles opened on May 16, 1770, for the wedding of the Dauphin, the future Louis XVI, with Archduchess Marie-Antoinette. To the sound of Lully's *Persée*, based on a libretto by Quinault, guests discovered the architectural masterpiece of Jacques Ange Gabriel, the king's first architect. At 800 seats, the royal opera house was then the largest theater in France.

Though it was executed under Louis XV, the idea for a theater inside the château goes back to Louis XIV. The Sun King chose the location in the château's north wing, which was respected by his heir. It was also a practical choice due to its proximity to the reservoirs—handy in case of fire—and its location on a steep slope in which to store machinery. Unfortunately, architect Jules Hardouin-Mansart's plans for the opera house were never entirely realized due to financial constraint. For several decades, performances were thus held in the château's reception rooms or in temporary theaters.

In 1748, after much dithering, Louis XV assigned the building of the royal opera house to Jacques Ange Gabriel, who began by studying Italian theaters, notably those in Vicenza and Parma. Begun in 1768, it was finished in twenty-three months, an astonishing achievement for the period. Gabriel would later design part of the Louvre, the Place de la Concorde (including the façades of its *hôtels particuliers*), and the Place de la Bourse in Bordeaux, all sterling examples of neoclassical elegance.

From the outside, the wing containing the opera house blends harmoniously with the château's other parts. You would never guess that the royal residence includes a theater. Inside, the stone halls leading to the theater are markedly austere—a stark contrast with the luxuriously ornamented auditorium. Gabriel built everything inside the auditorium out of wood, including the sculptures and the faux marble of the Ionic columns.

A perfect illusion—the auditorium, which appears to be marble, is made entirely of wood.

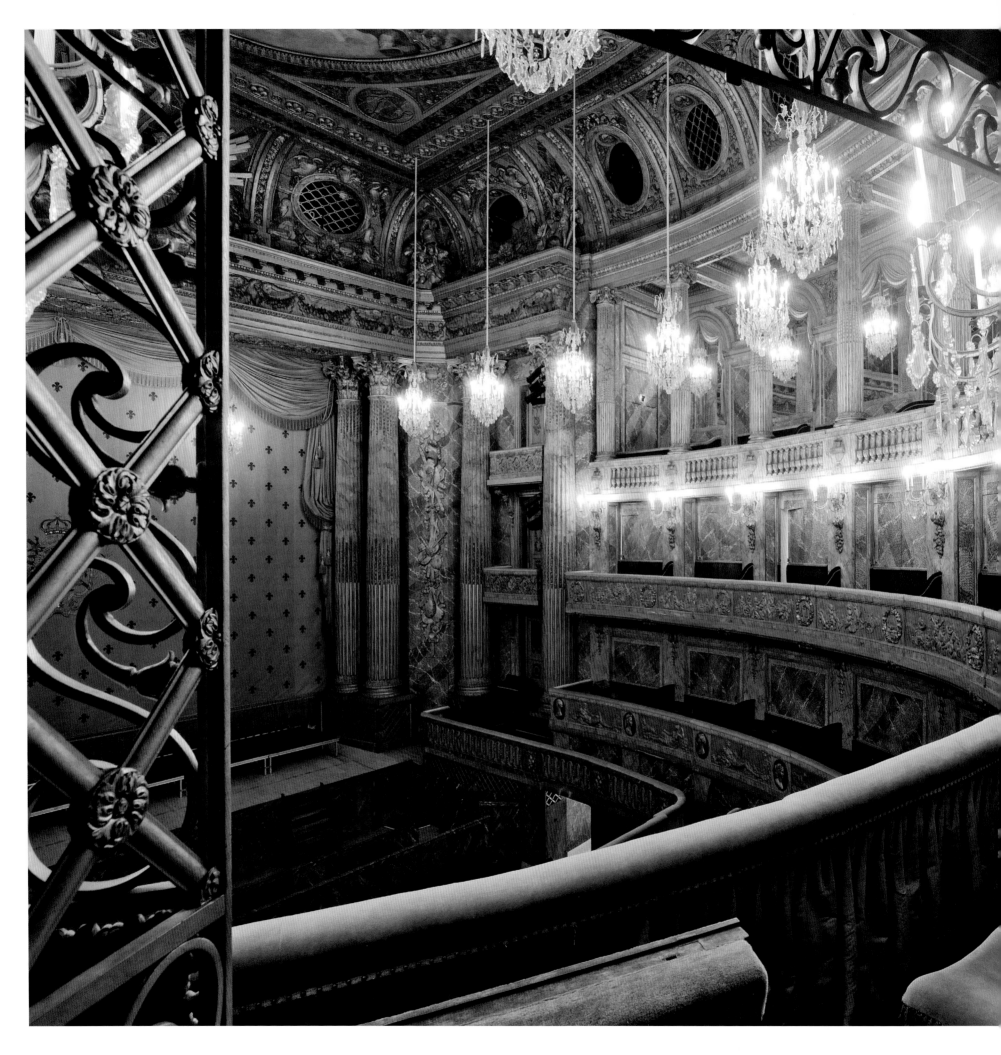

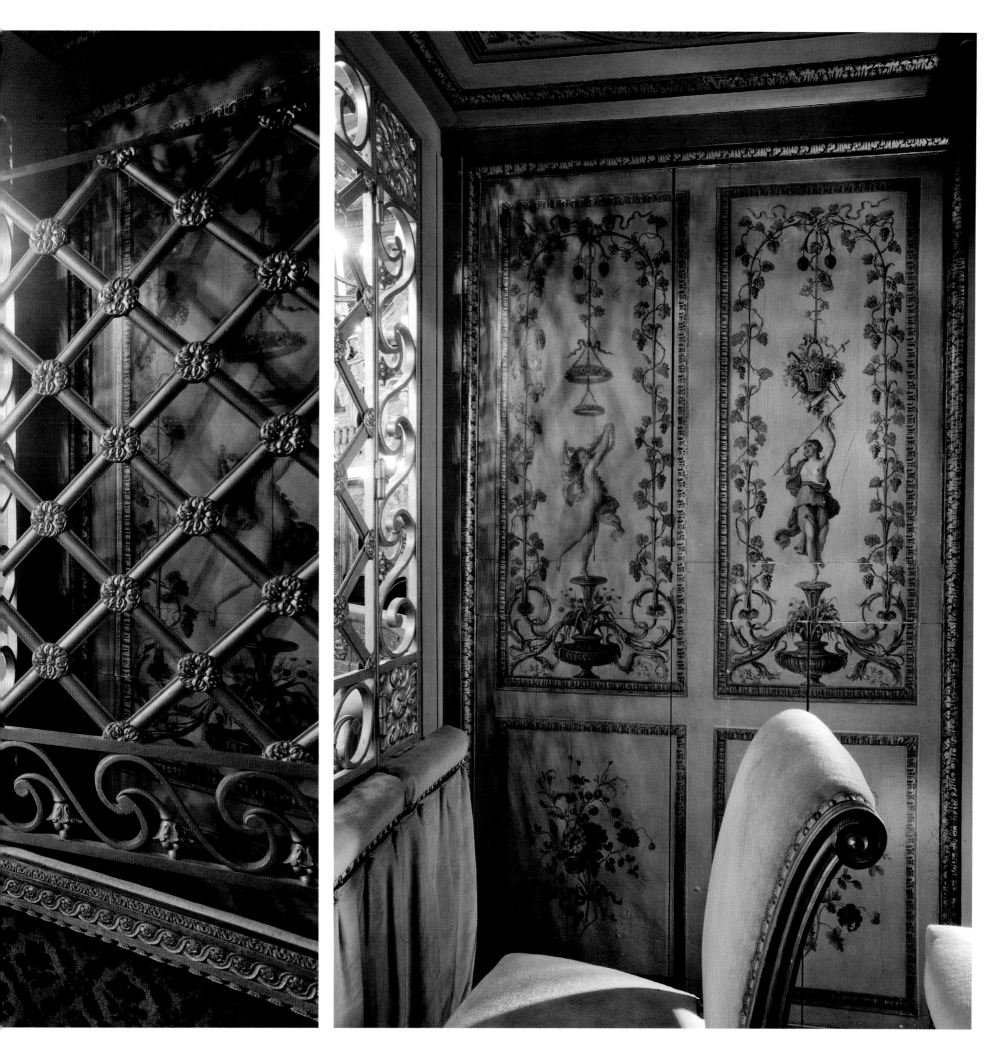

The truncated oval floor plan, with an amphitheater orchestra and two balconies, the second of which is set back, strikes a balance between neo-antique theaters in the style of Palladio and the nineteenth-century Italian-style halls with vertical balconies. The succession of mirrors in the gallery on the third level seems to echo the Hall of Mirrors. As for the wire-meshed boxes, they allowed the king and his entourage to attend performances discreetly.

Extremely complex machinery was installed under the stage to realize special effects likely to dazzle the court. Yet there were few opportunities for the court to enjoy the royal opera house: Due to the extravagant operating cost of running the theater, only some twenty performances were held from its inauguration until 1789. The revolution put a stop to the theater's activities, and it was not used again until Louis-Philippe came to power. The last king of France radically transformed the theater, expanding the boxes and adding the traditional red and gold then used in opera houses. An unexpected twist came in 1871, when the Senate took over the theater to hold its assemblies. At that time, the installation of a glass roof caused part of the structure to collapse.

Finally, in 1957 serious work was undertaken to return the edifice to its past glory. The use of wood made this a painstaking and extremely complex restoration project. In 2007, the opera house was under construction again for two years, at a cost of €12.5 million, to meet safety regulations. Since 2009, the royal opera house has offered ambitious programming, focusing on baroque works played on period instruments, with the occasional special event. It has taken no less than two and a half centuries for this theater to finally achieve regular programming.

OPPOSITE, TOP *At Versailles, the royal boxes are covered in wire mesh, which allowed sovereigns to watch performances in total privacy.*
PAGES 132–133 *The* loge du roi *is an early example of Louis XVI style.*

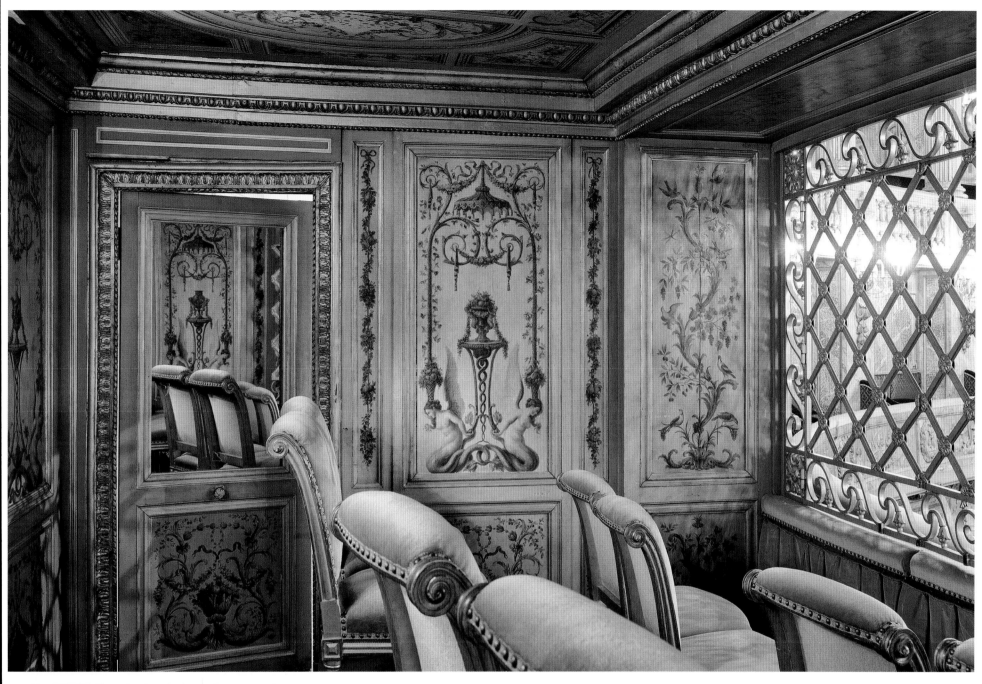

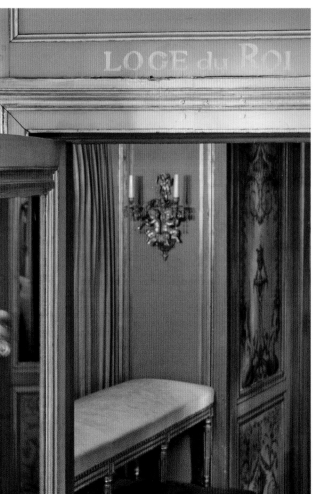

LOGE du ROI

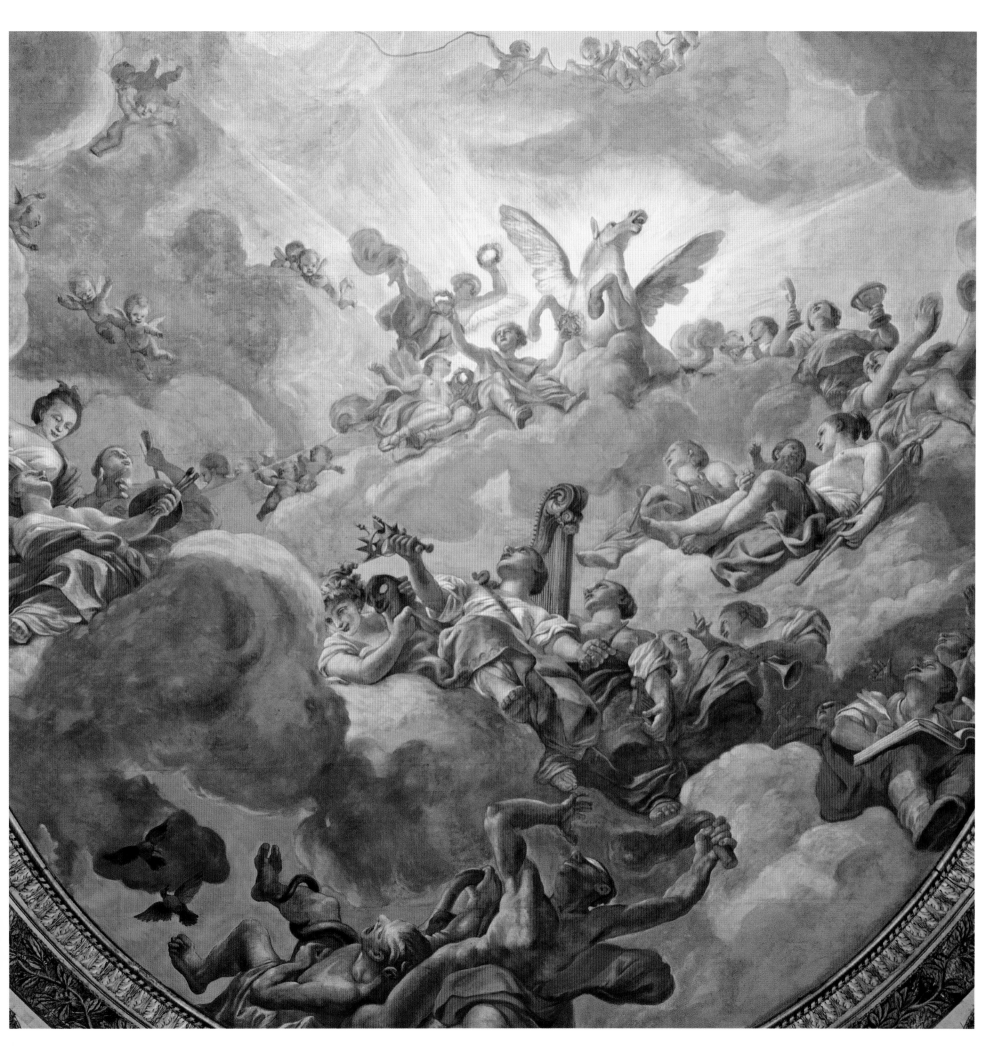

PALAIS
GARNIER

PARIS

FRANCE

harles Garnier (1825–1898) was much more than one of the most audacious architects of his time; this former student of the Beaux-Arts in Paris, winner of the Grand Prix de Rome in 1848, also made his mark as a writer (he was a member of the *Société des gens de lettres* [Society of Literary People]) and a caricaturist who specialized in portraits. His approach was based on a blending of the arts and various cultures. A great traveler, he roamed the Orient with the writer Théophile Gautier.

Garnier was only thirty-five years old when he won the 1861 competition to build the Paris opera house, a major project decreed by Napoleon III. Yet the competition had been fierce, drawing no less than 171 candidates, including Viollet-le-Duc, famous for his neo-gothic additions to the Cathedral of Notre Dame de Paris. Garnier's project, which was chosen unanimously, was undoubtedly the most emblematic. Built during the reorganization of Paris by Georges-Eugène Haussmann, the construction accompanied the demolition of many buildings in the area and the opening of a new street, the now famous Avenue de l'Opéra, which offered an open view of the edifice.

The least one can say is that the opera house's façade is in an eclectic style. With arcades, columns, gilding, cupolas, and winged horses, it is pure aesthetic excess, miles away from the traditional neoclassical edifices fashionable in the second half of the nineteenth century. Rather than adopting the usual rectangular shape, the architect opted for a more open floor plan, with two domes surrounding the edifice (the dome on the left was reserved for the emperor, who had faced an assassination attempt and did not want to share an entrance with the public). Garnier also wanted the building's various parts to be symbolically identified from the exterior: The pedimented top holds the stage house, the great cupola represents the audience seating, the loggia reminds us of the public foyer . . .

Garnier claimed only one source of inspiration: the Grand Théâtre de Bordeaux by Victor Louis. As in Bordeaux, the entrance to the building serves to condition the audience, welcoming them into a world of opulence. First one must pass under the arcades, then cross a low vestibule, like a kind of airlock, before discovering and inevitably being overcome by the legendary grand staircase. This approach is also reminiscent of the placement of the narthex before the nave in great Romanesque churches like the Vézelay Abbey. With its abundance of marble, sculptures, and chandeliers, the opera house's grand double staircase is flamboyantly opulent. Dozens of balconies overlook the staircase, a reminder that the opera is a place to see and be seen.

The foyer's succession of mirrors evokes the famous Hall of Mirrors at the Château de Versailles. Also striking are the sculpted allegories filigreed throughout the building in typical "industrial revolution" fashion. A second foyer, known as the dance foyer, is less well known to the public. Located behind the scenes, as an extension of the stage (it is visible when all set elements are removed), it long had a bad reputation: Gentlemen used to come here to watch dancers practice . . .

In the wings, which are now outdated and shabby, one finds the dressing rooms, a handful of administrative offices, and the staff cafeteria (where star tenors rub shoulders with technicians in a convivial setting). Far more surprising is the artificial lake in the basement, a reminder of the water table's proximity. You can see this lake in the classic French film *La Grande Vadrouille*, directed by Gérard Oury. Today, Paris firefighters train here, sharing the space with a few fish.

On the building's roof, bees are the stars: The opera's honey, which is sold at the gourmet food shop Fauchon, is a tourist favorite.

All this would nearly lead us to forget the actual theater—which does occupy only a quarter of the public surface area. It is typically Italian, in red and gold, with

OPPOSITE *The double Grand Stairway is the symbol of the Palais Garnier.*
PAGES 138-139 *The succession of mirrors in the foyer is reminiscent of the famous Hall of Mirrors at the Château de Versailles.*

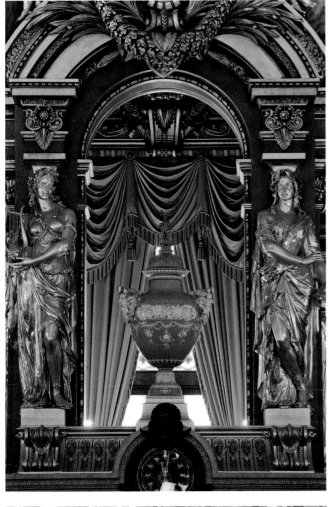

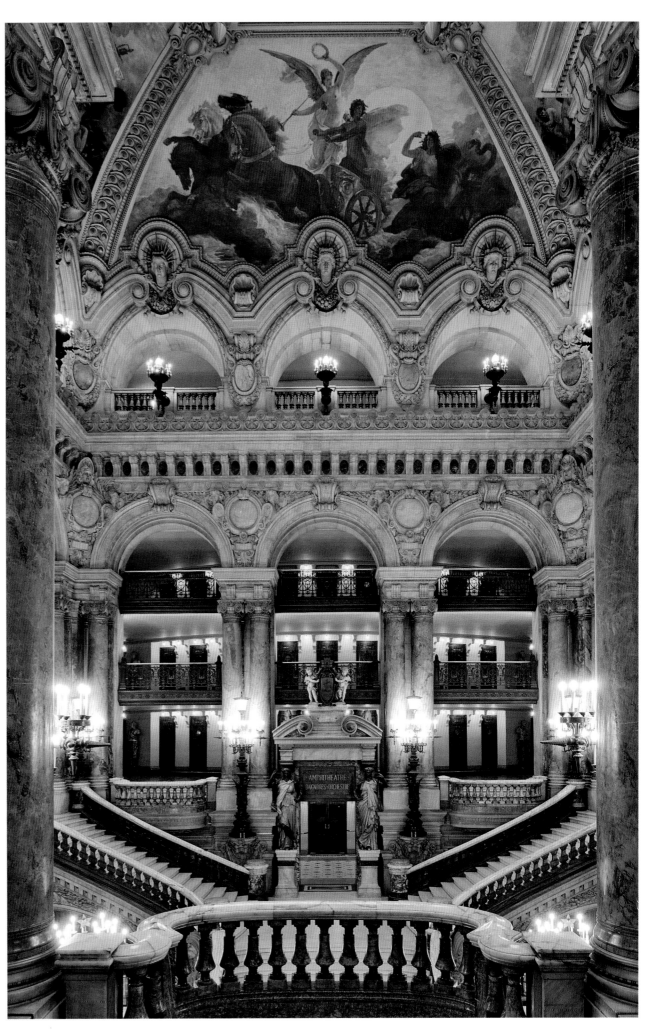

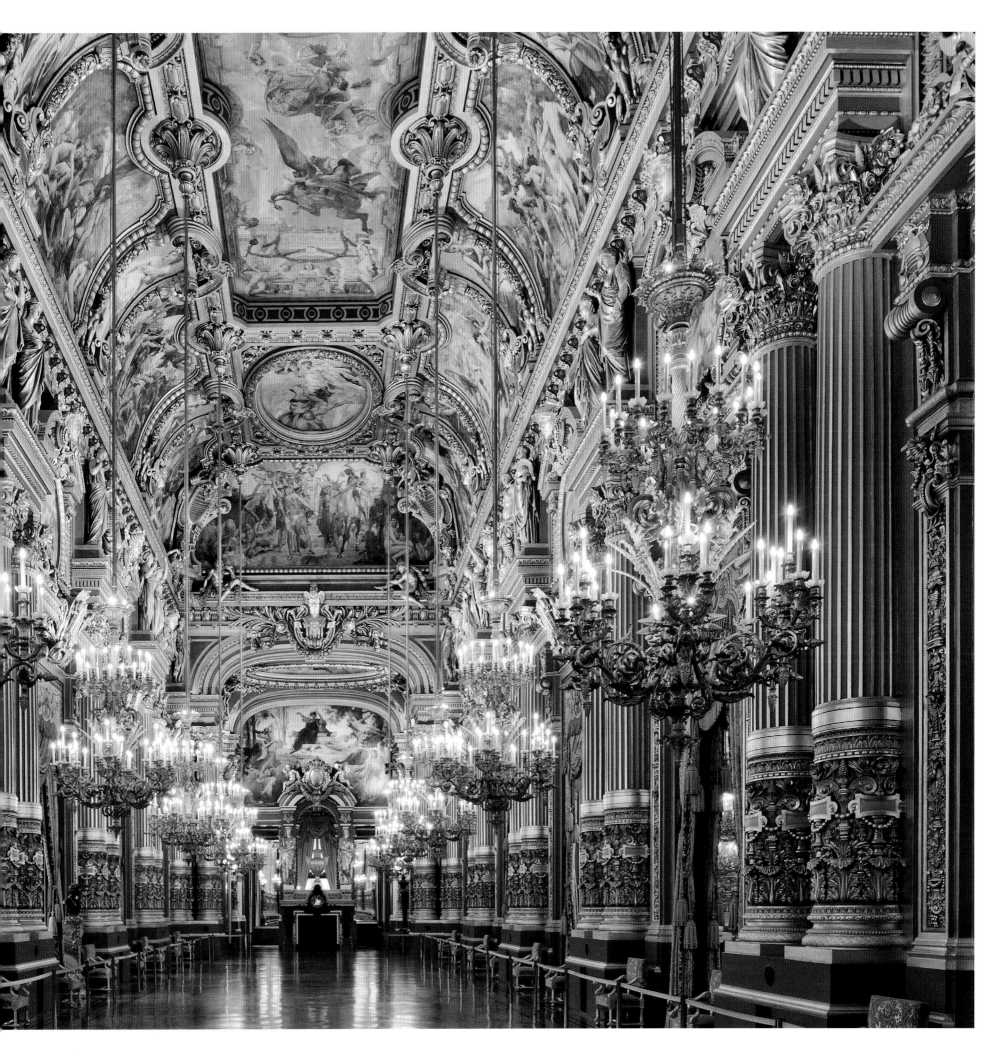

a succession of balconies and a gallery. It seats 2,000. At the time it was built, acoustics were still directly supervised by the architects, who proceeded intuitively. Garnier even referred to acoustics as a "bizarre science." During some performances, the sound can seem slightly muffled, probably due to the large amount of velvet and carpeting in the theater. Conductors must therefore strive to obtain the maximum amount of subtlety from the orchestra. Garnier supposedly also considered covering the pit, as Claude-Nicolas Ledoux did at the Théâtre de Besançon (sadly demolished), anticipating Wagner's method in Bayreuth.

Since 1964, spectators' eyes have been irresistibly drawn to the theater's colorful ceiling by Marc Chagall. This is not the only recent change; in 1987, vast rehearsal rooms were built under the cupola, and in 2011, a restaurant was opened in one of the lateral wings—a lovely piece of architecture by Odile Decq, whose organic shape blends perfectly with the Napoleon III style, which is proof that the daring of Garnier, who also designed the Opéra de Monte-Carlo, outlived his own century.

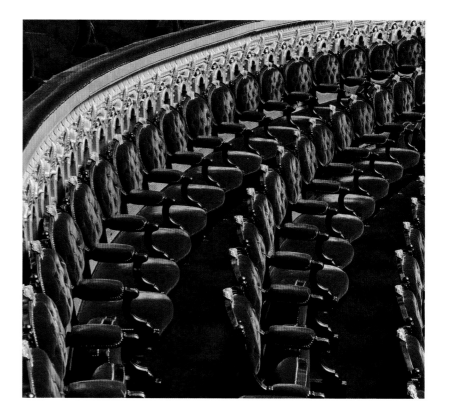

The auditorium's floor plan, with some 2,000 seats, is in the Italian style.

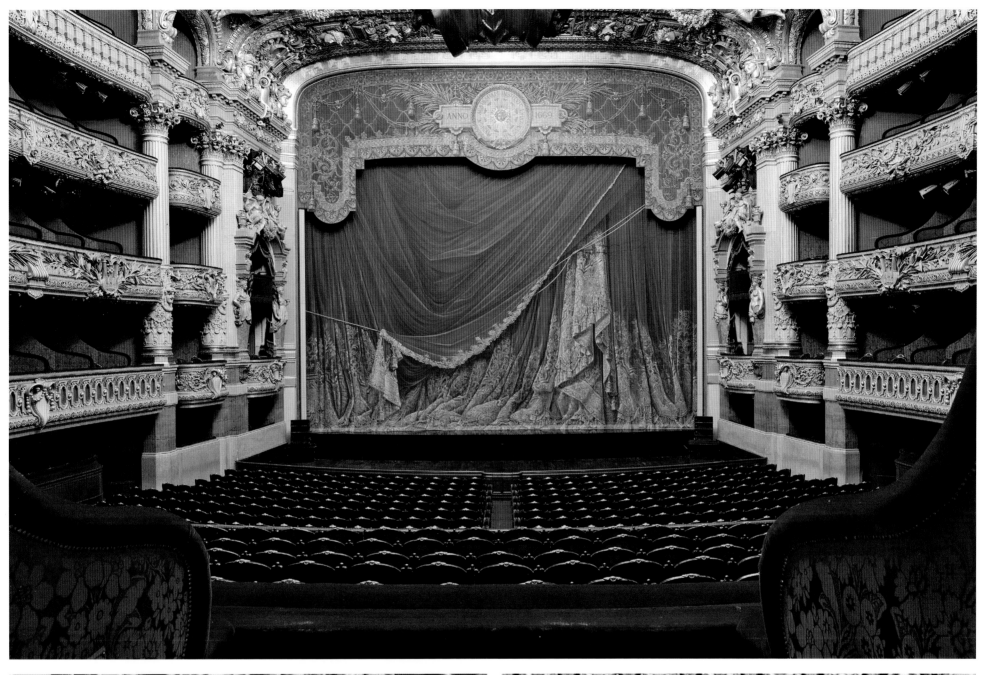

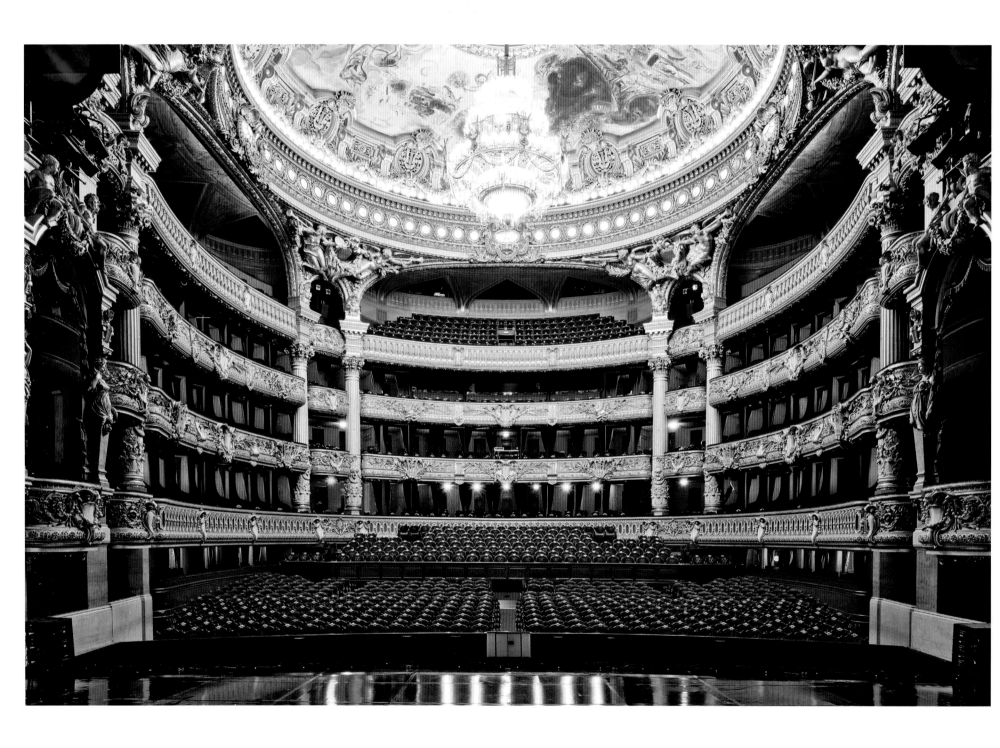

The colorful ceiling by Marc Chagall was completed in 1964.

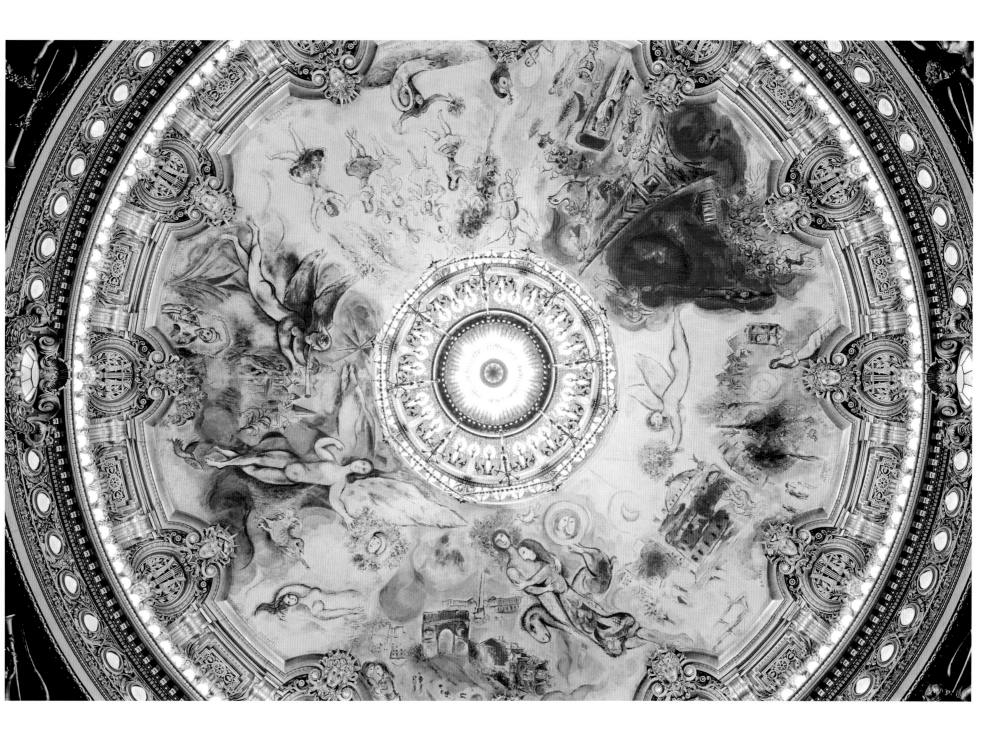

PALAU DE LES ARTS REINA SOFÍA

VALENCIA

SPAIN

From the Olympic Stadium in Athens to the train station in Liège and a residential tower in Malmö, Santiago Calatrava's designs are always marvels of engineering. Their sculptural outlines evoke organic shapes, both animal and vegetal. In Valencia, his native city, the architect delivered his most spectacular complex, the City of Arts and Sciences. Known as "Calatrava City" by locals, the complex is located at the mouth of the Túria River, which is now dry and has been turned into a pedestrian passage from the old city to the edges of the Mediterranean. The Palau de les Arts Reina Sofía is inside this complex and includes both an opera and a symphonic concert hall, inaugurated in 2005.

The building's scale is awe-inspiring: It stands 229 feet and covers a surface area of 398,264 square feet! This virtuosic architectural gesture stimulates the imagination: Regulars say the Palau looks like a fish, a boat, or a warrior's helmet. The edifice is covered by a feather-shaped structure, supported at only two points and lending this imposing building a feeling of lightness. The Palau is also known for its dazzlingly white façade. Calatrava used both raw white concrete and *trencadís*, a traditional Valencia ceramic technique reminiscent of Gaudí's work, to connect a very contemporary style with his region's heritage. The building also features a few touches of blue, a color traditionally found on Valencia's churches. Though it is undoubtedly fascinating aesthetically, the building can appear cold and remote, like the other edifices in the City of Arts and Sciences (it also includes a planetarium, a museum, and a botanical garden), which stand apart from the rest of the city due to their colossal size. You must also cross a bridge to reach the Palau de les Arts, as if you were entering a fortress.

The opera house's foyer appears to be inside a ship's bow, with a view of the City of Arts and Sciences' artificial lake. With a capacity of 1,700 seats, the theater also makes use of blue coloring and *trencadís* on its lateral walls. The floor plan is more classical, in the Italian style, with an orchestra and four balconies, including reduced-visibility seats. The theater's technical equipment is cutting edge, with a 1,937-square-foot pit that can hold up to 120 musicians (the Valencian Community Orchestra was created for this new hall) and opera subtitles that scroll directly on the seatbacks. Unfortunately, the glass ceiling originally conceived to serve as a curtain and rise from the stage at every performance proved too expensive to operate and is at a permanent stop. Yet the main drawback relates to the acoustics, which were supervised by conductor Helmut Müller with decidedly mixed results: The sound has some depth but is too often on the verge of distortion.

Still, this is a far cry from the acoustic disaster in the Palau de les Arts' other hall, which is dedicated to symphonic concerts and is far too resonant (initially, Calatrava had considered making this an open-air space, protected from the rain by the feather-shaped structure topping the building). The complex also includes a smaller room, Teatre Martín i Soler, which is dedicated to zarzuela, or Spanish operetta; it is located at the foot of the bridge that leads to the Palau.

Nearly all of Santiago Calatrava's projects have led to debate, particularly on aesthetic grounds, as was the case with his bridge over the Grand Canal in Venice. But the controversy over Palau de les Arts' construction cost of €373 million reached a new level. A protest was even held in front of the building on the day of its inauguration. Several subsequent incidents have considerably tarnished its image: Part of the stage equipment collapsed in 2006, and the basement was flooded in 2007.

The question now is whether Valencia has replicated the situation in Sydney (see page 182): an incontestable architectural triumph marred by technical, financial, and acoustic fiascos.

Standing 229 feet tall and covering a surface area of 398,264 square feet, the Palau de les Arts is an architectural marvel.
OPPOSITE, BOTTOM LEFT *A bridge leads spectators into the Palau de les Arts.*

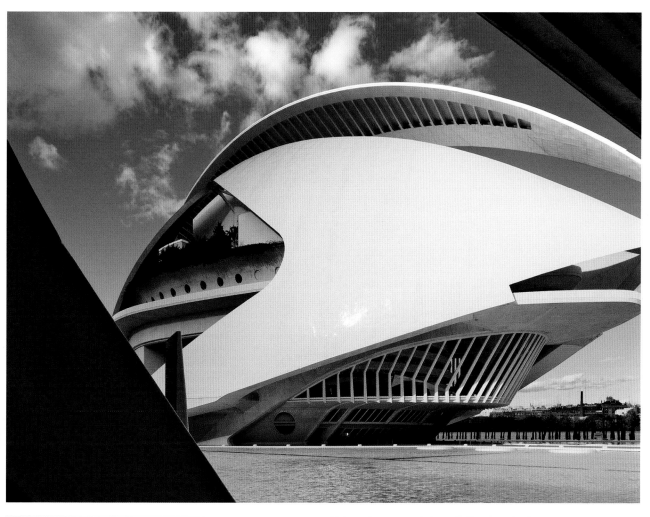
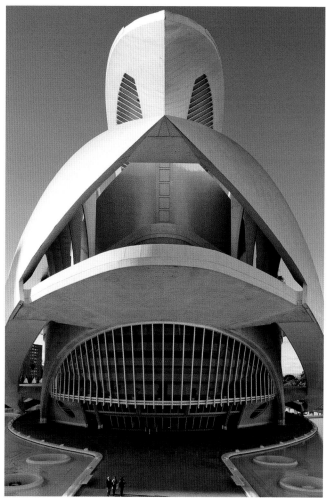
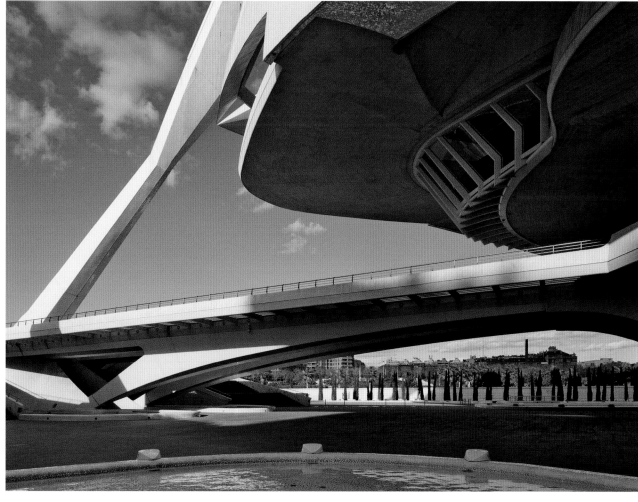
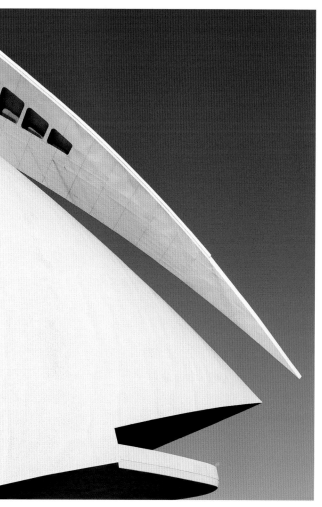

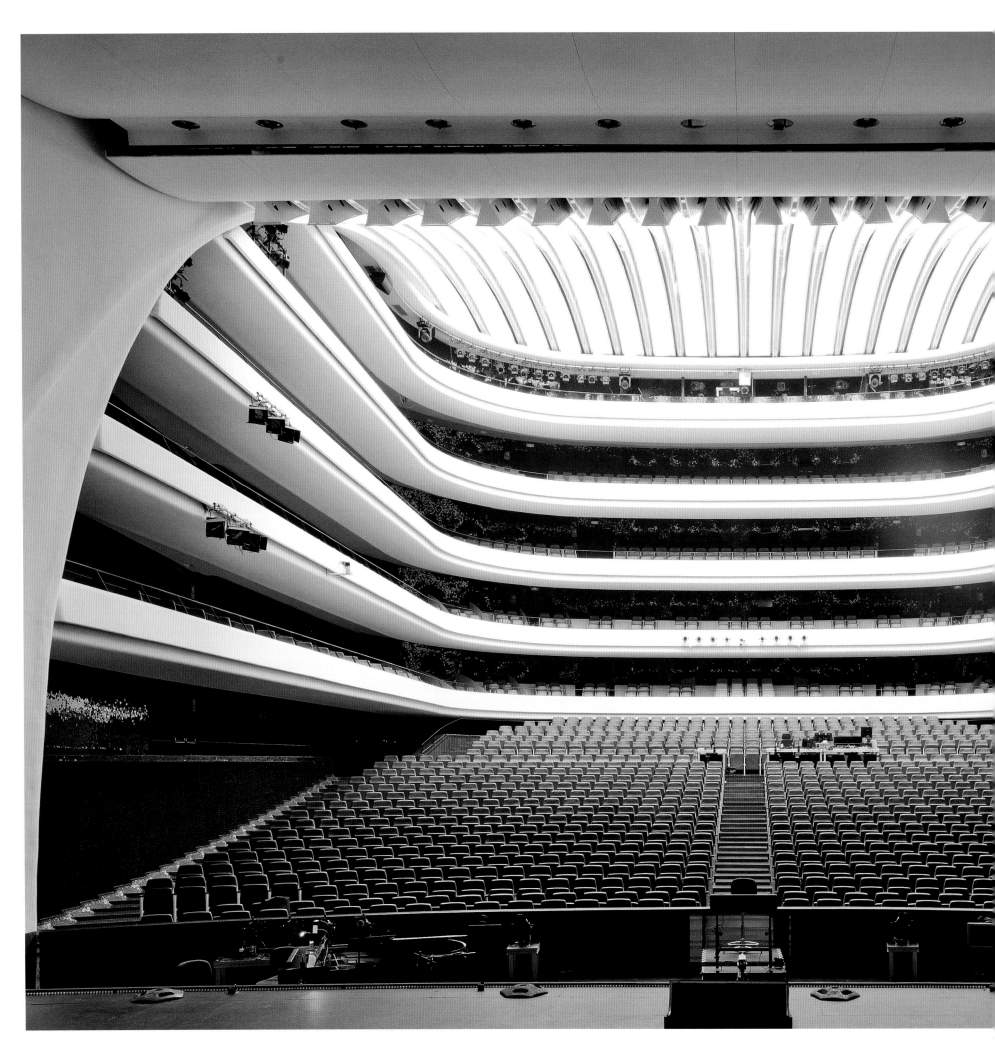

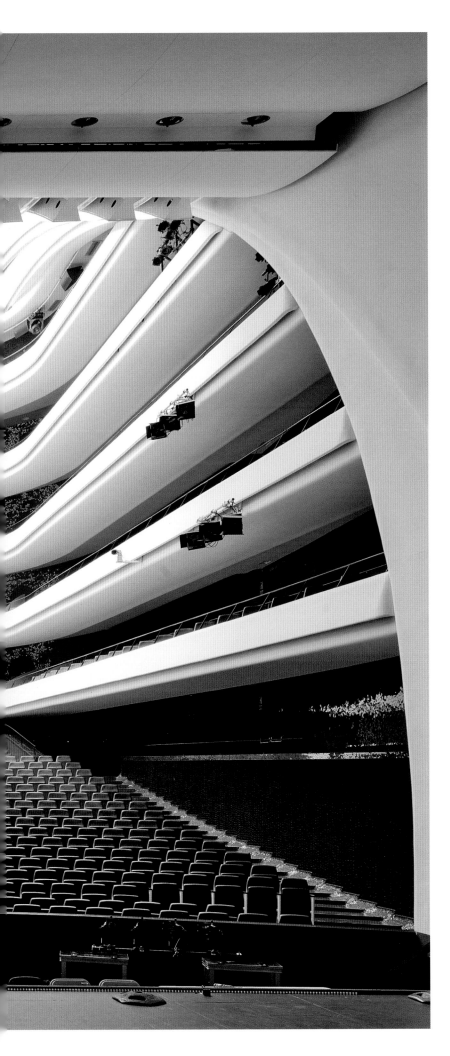

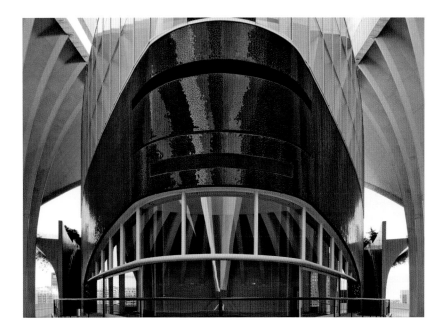

The glass ceiling was originally intended to serve as a stage curtain and come down for each performance.

PAGE 150, TOP This fresco with typically Iberian patterns was designed by Calatrava himself.

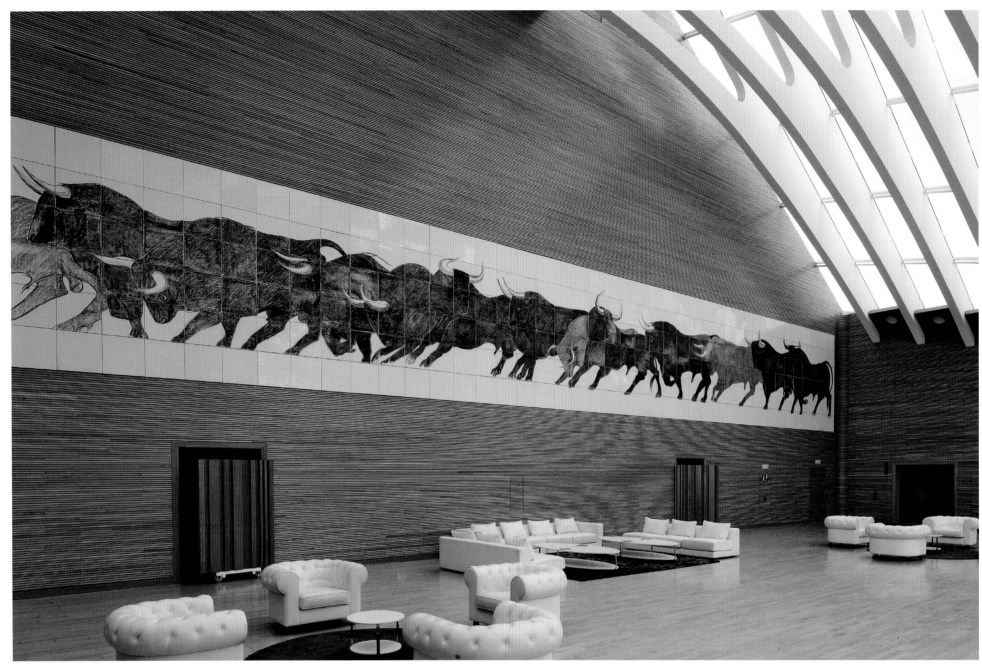

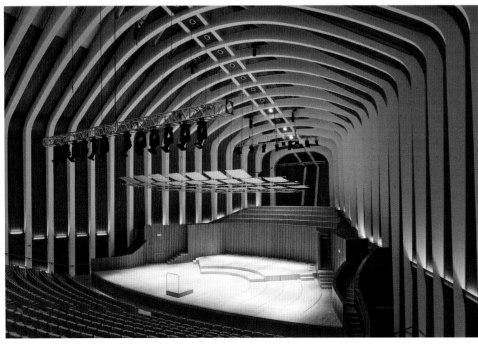

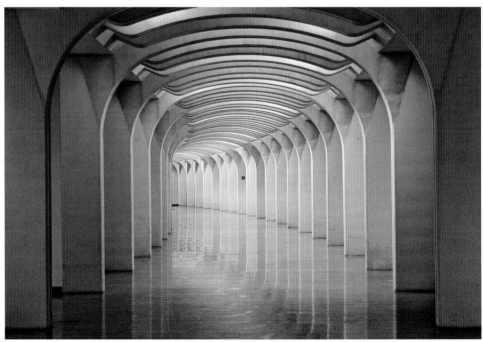

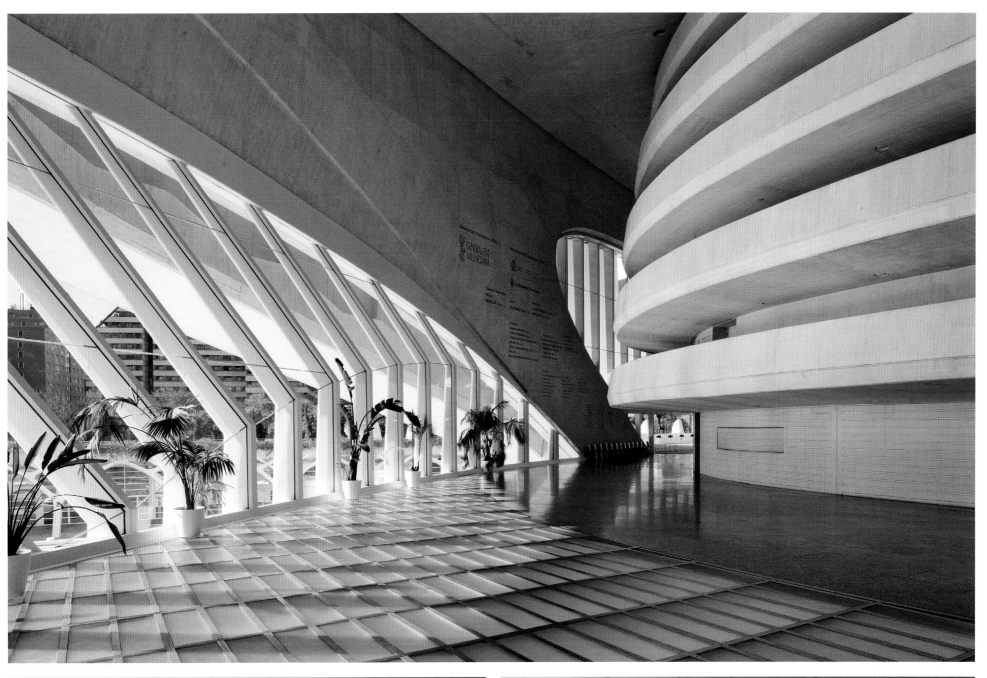
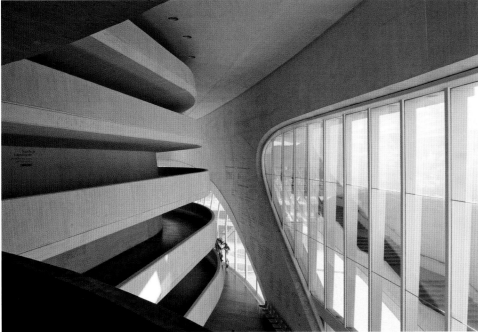

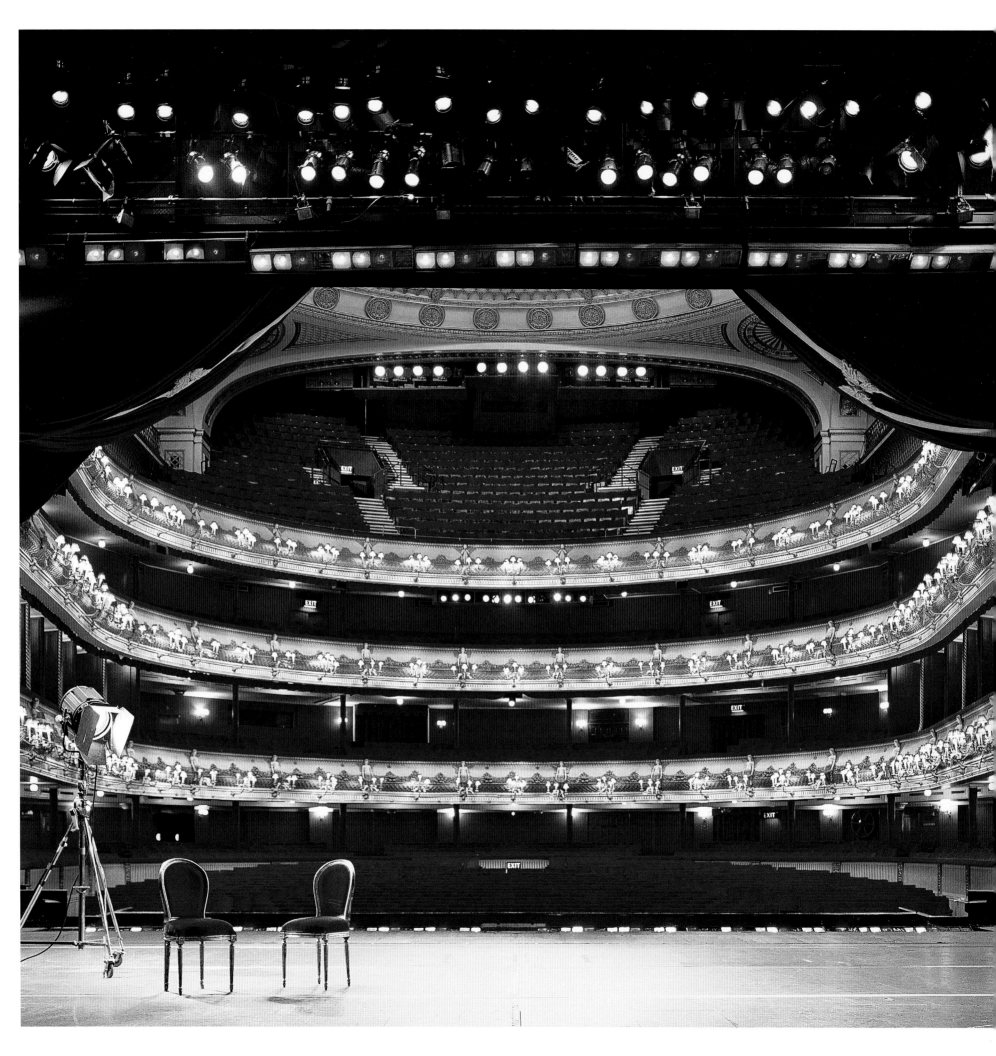

ROYAL OPERA HOUSE,
Covent Garden

LONDON GREAT BRITAIN

The Royal Opera House has brought a Latin flavor to the London neighborhood of Covent Garden, beginning with its façade reminiscent of La Scala's in Milan: One recognizes a similar loggia with a Corinthian peristyle, though it rests on a far more rustic-looking ground level. But it is mostly through its programming that the Royal Opera House has played the Italian card. In the nineteenth century, the theater was known as the Royal Italian Opera House and held performances only in the language of Dante. For the inauguration of the new opera house in 1858 (the theater formerly on the site burned down at the end of a masked ball in 1856), Meyerbeer's *Les Huguenots* was performed in an Italian translation. This practice slowly faded away, and the word "Italian" was removed from the theater's name in 1892, allowing Gustav Mahler an opportunity to direct Wagner's *Ring* here in the original version.

This evolution went hand in hand with the edifice's architectural development. While the theater Edward Barry designed in 1858 was efficient and classical (2,200 seats divided among an orchestra, three balconies, and stage-level boxes in an Italian floor plan), the architect Edwin O. Sachs made the orchestra safe in 1899 by installing several staircases to facilitate evacuation in case of emergency. Sachs also built a glass canopy under the exterior peristyle. The technical facilities were expanded in 1933 and the orchestra pit in 1956. The objective was clear: to turn Covent Garden into a first-rank opera house on the European scale.

This technically efficient theater is equally well known for the quality of its programming. The greatest singers have appeared there: Caruso was a regular guest from 1902 to 1914. Covent Garden is also a den of great orchestra conductors, the most famous of whom was Georg Solti, its musical director from 1961 to 1971.

The opera house underwent major renovation, including significant extensions, from 1997 to 1999. A new theater was built, the Linbury Studio Theatre, intended for small-scale theatrical productions and concerts, along with rehearsal rooms and administrative offices. But most importantly, the opera house took over the Floral Hall, the former premises of the Covent Garden flower market, with a magnificent bay window. It now serves as an atrium, with a bar and reception and conference rooms.

Today, the Royal Opera House has chosen to bank on digital technology by developing its presence on social networks and offering live broadcasts, with a single ambition: to diversify and renew its audience.

The theater built by Edward Barry was inaugurated in 1858.

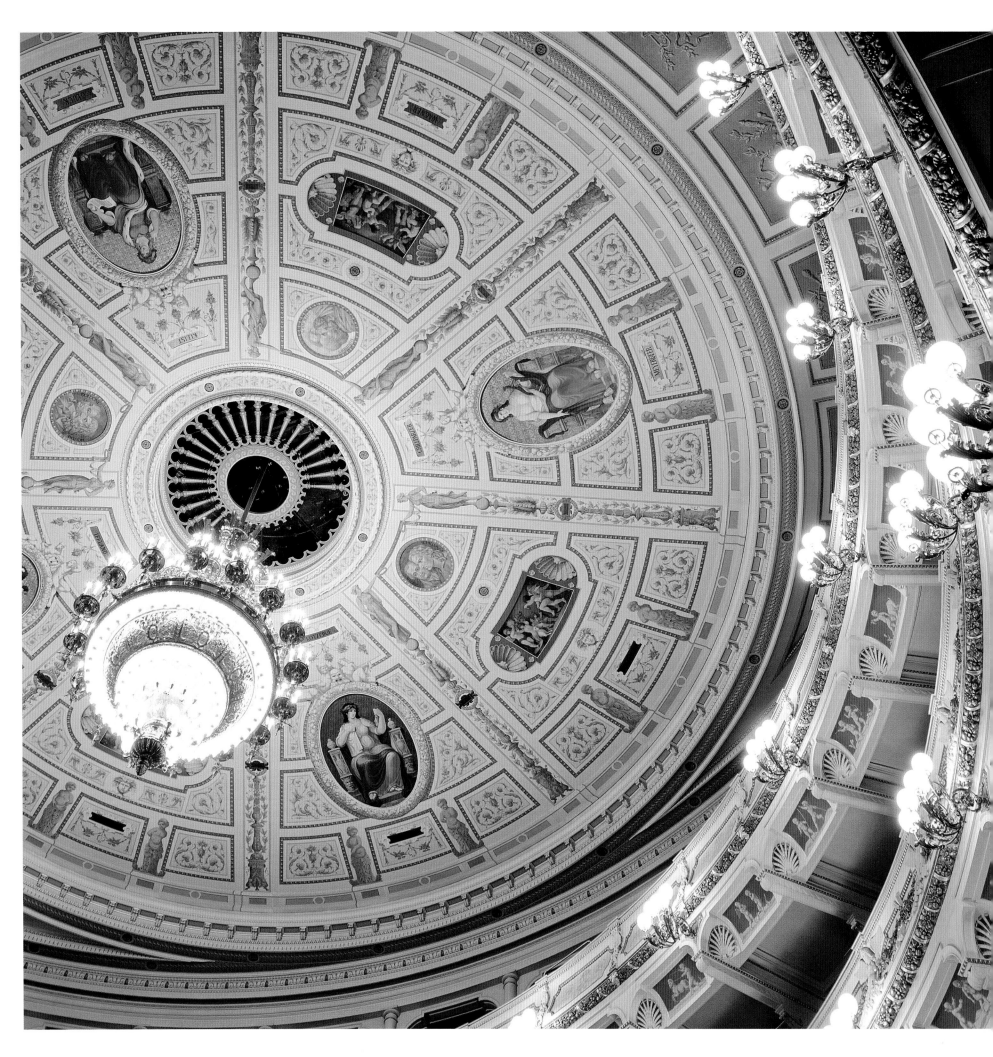

SEMPEROPER

DRESDEN

GERMANY

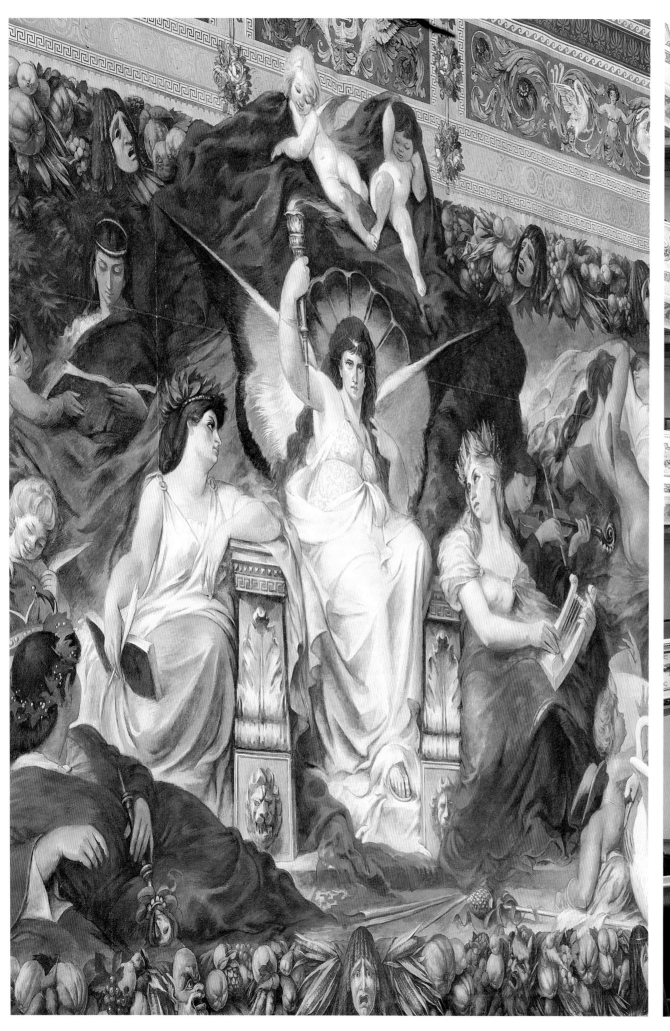
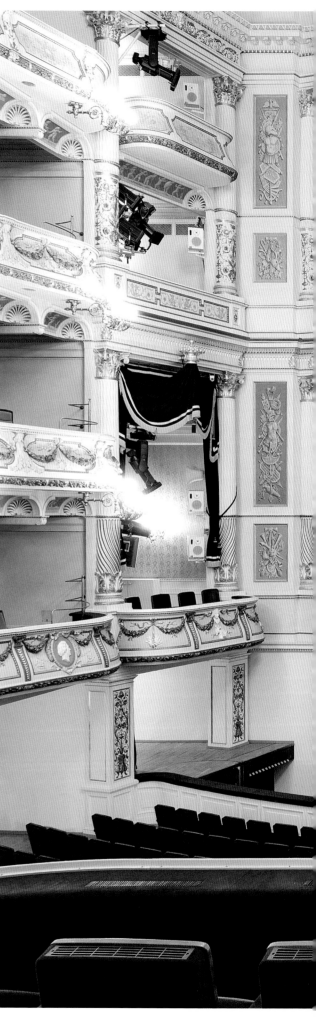

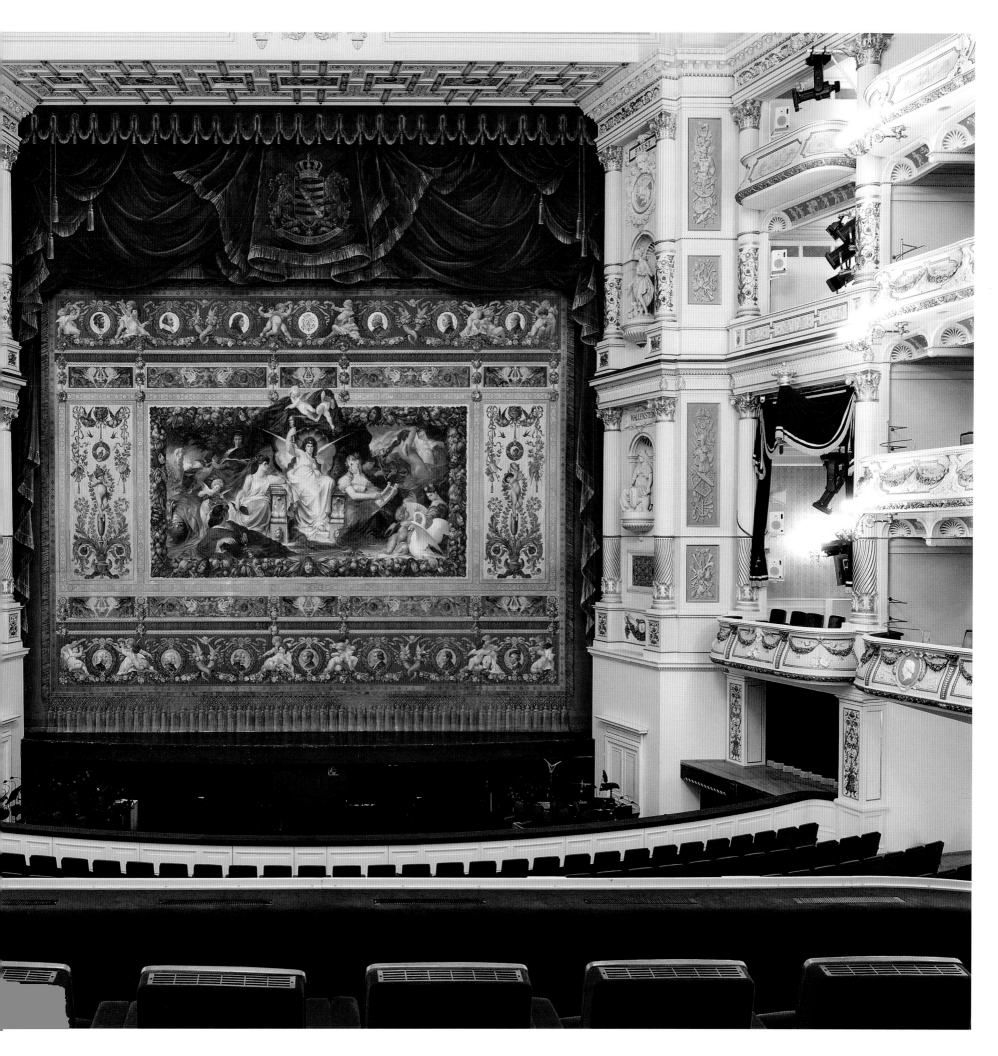

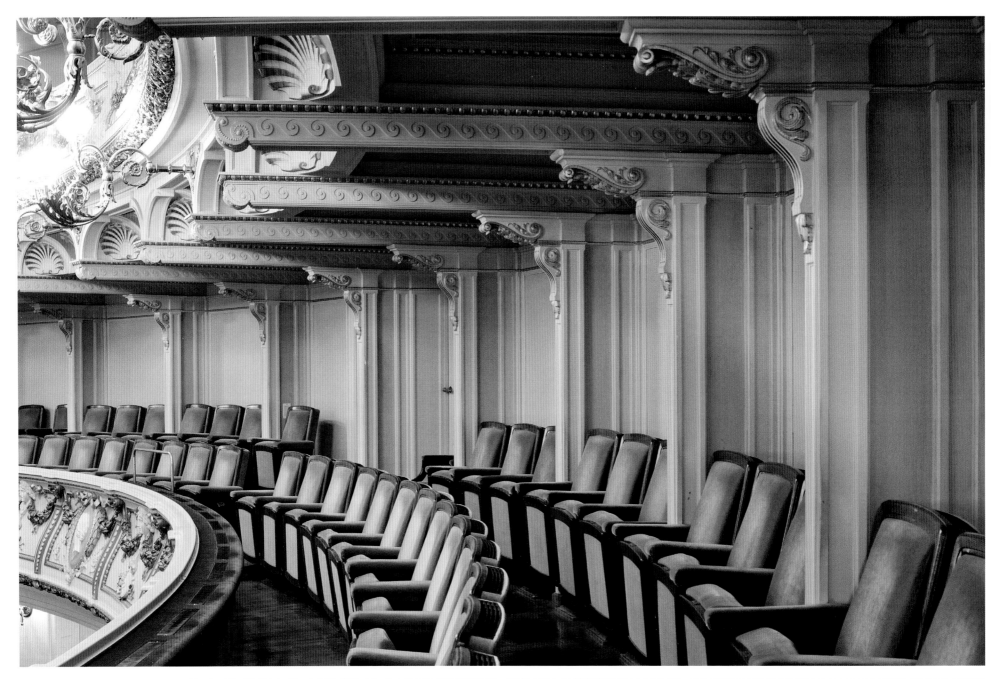

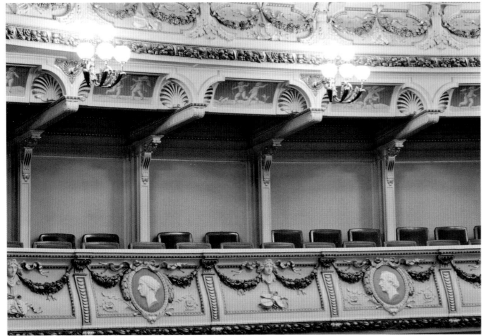

*T*n February 1945, the city of Dresden was almost totally destroyed by Allied bombing. The opera house built by Gottfried Semper was not spared. Only its exterior walls survived. In the following years, a crucial question was raised: Should the edifice be exactly replicated, or should a modern building be designed? In 1975, the theater's original plans were rediscovered in Vienna. A decision was made to proceed with a meticulous reconstruction. Forty years after its destruction, the Semperoper reopened its doors with Weber's *Der Freischütz*, a symbol of German identity, marking the climax of a turbulent history that never tarnished this legendary stage's reputation for excellence.

Located between the Zwinger's royal pavilions and the banks of the Elbe, the Semperoper was inaugurated on April 13, 1841. The first opera performed there was also by Weber, *Euryanthe*. In 1843, the Dresden Opera hired Richard Wagner as its *Kapellmeister*, a position the composer held until his exile in Switzerland due to his revolutionary political activities. In 1869, the building was engulfed by fire; it was rebuilt a few years later, practically identically, also by Gottfried Semper, who was now working in collaboration with his son Manfred.

Immediately recognizable, the Semperoper is both grandiose and atypical. Its semicircular shape, which follows the theater's horseshoe design, is reminiscent of a circus. A succession of two-story arcades decorated with balustrades lends the building its elegance. Above it all, the neoclassical pediment shelters the stage house.

Semper did not simply make do with reproducing the traditional floor plan of a theater in the Italian style inside the 1,200-seat house. Notable innovations include his conception of the gallery, which is on the fourth balcony and in the shape of an amphitheater framed by neoclassical columns. This space, known as the *Hochparterre* (upper orchestra), is indicative of the social dimension of Semper's architecture and

his belief that opera should no longer be restricted to the wealthy. Semper had also worked with Wagner on an even more daring project for an opera house in Munich. But when the Dresden Opera was rebuilt from 1975 to 1985, technical issues led the gallery to be reduced to four rows; Semper's revolutionary move was erased. But one can still enjoy wandering through the elegant foyer, which follows the curve of the entire auditorium.

In 2002, the flooding of the Elbe had dramatic consequences: The opera house was flooded with up to twenty-six feet of water, causing severe damage in the stairwell. But after only a few months, audiences were able to return to this hall with ideal acoustics, which serves as a model for contemporary opera houses such as the one in Oslo (see page 46). In the pit, the Dresden Staatskapelle is proving to be one of the best orchestras in Germany. Conductor Christian Thielemann continues to celebrate the German repertoire, the historical foundation for this venue, which held the premieres of the most famous works of Richard Strauss, from *Salome* (in 1905) to *Der Rosenkavalier* (in 1911).

Destroyed during the Second World War, the Dresden Opera House was restored following the building's original plans with precision.

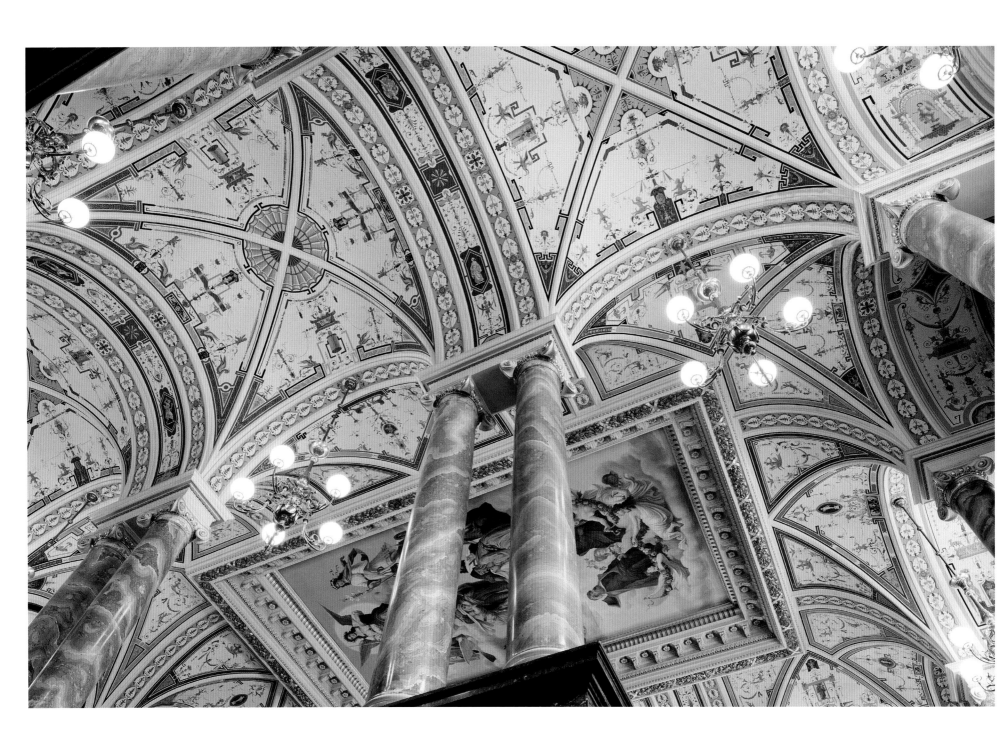

Richard Wagner served as Kapellmeister in this theater characterized by its elegant detailing.

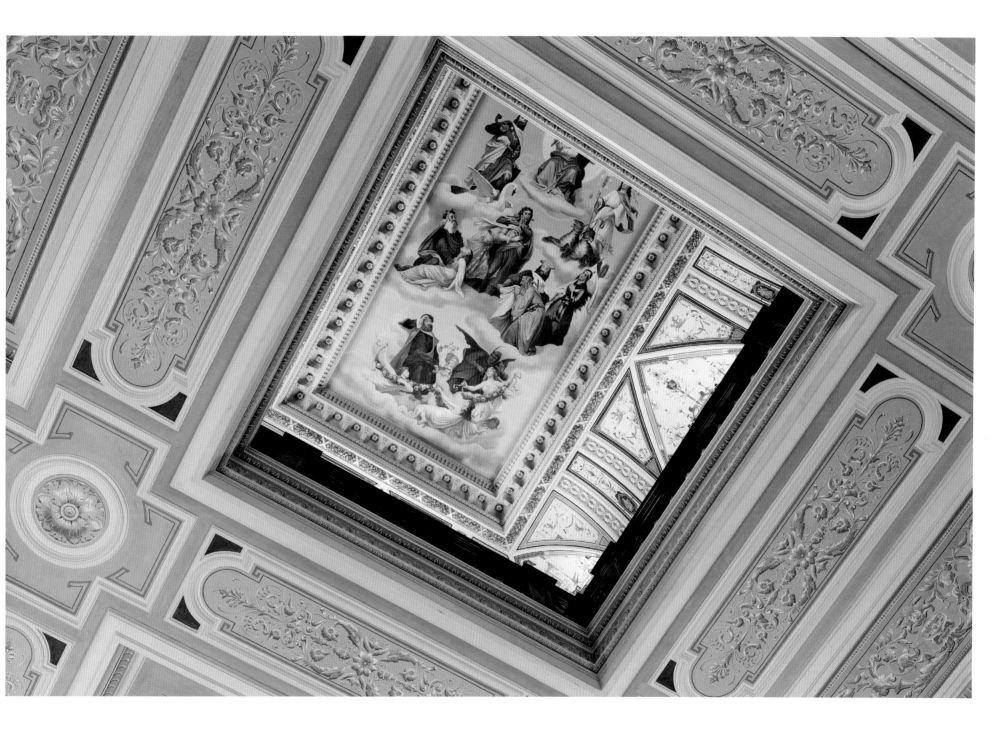

SLOTTS-TEATER

DROTTNINGHOLM

SWEDEN

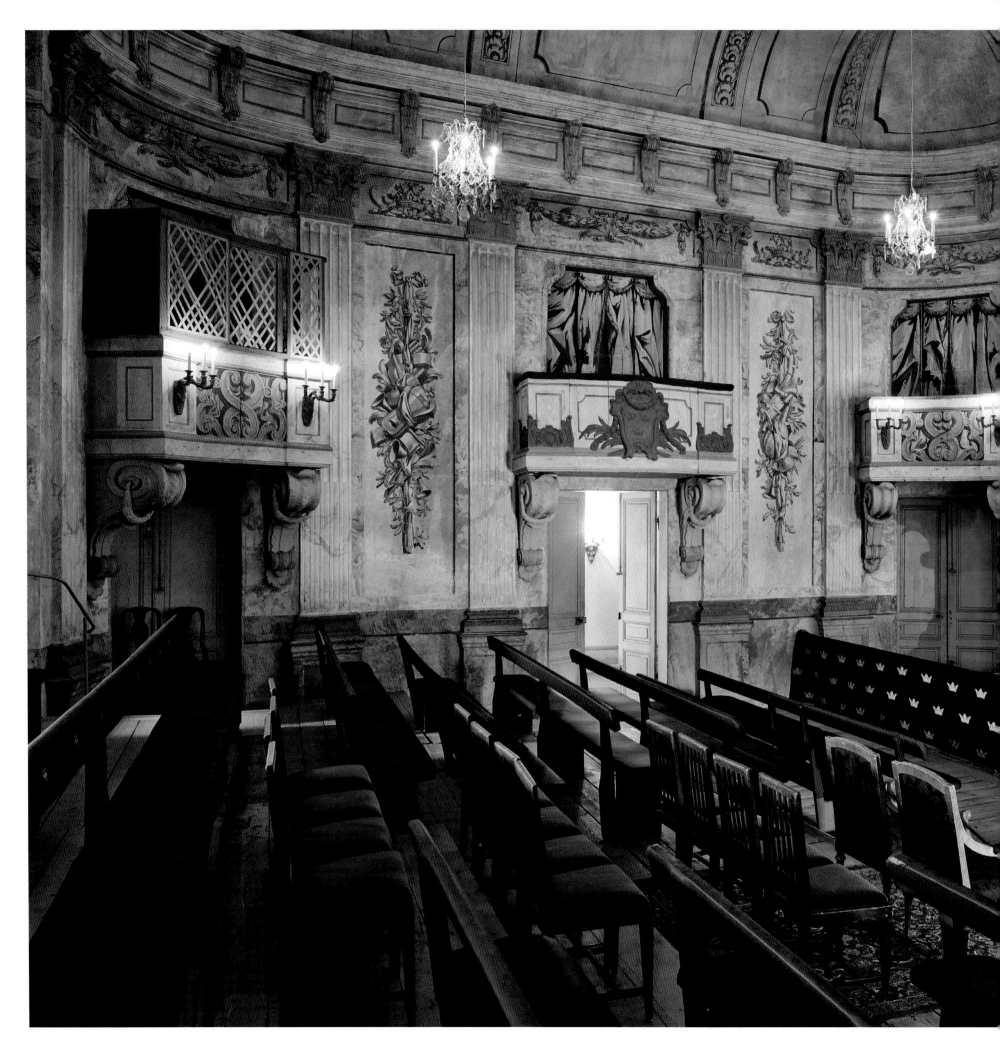

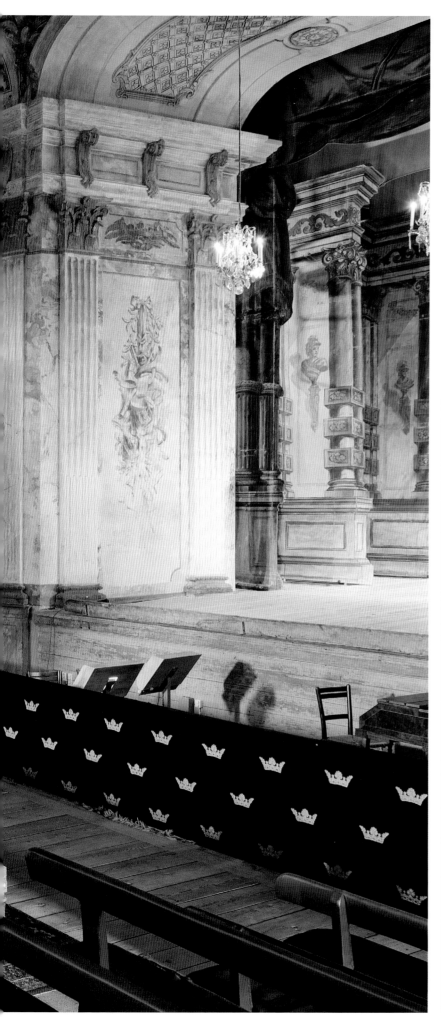
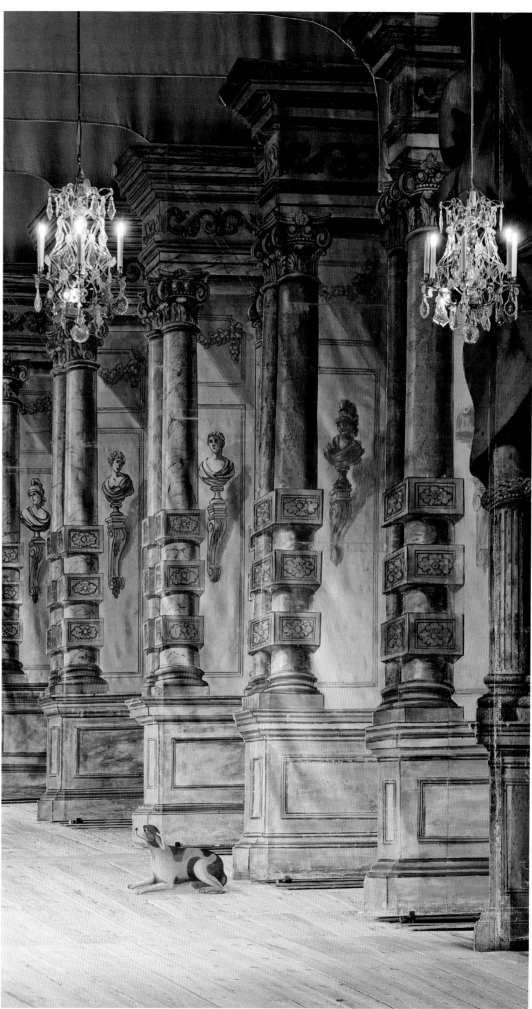

ntering the Slottsteater in Drottningholm, a few miles from Stockholm, is like stepping into a time machine. This opera house located on the grounds of Sweden's royal residence has remained in its original state since it was inaugurated in 1766. The theater, the machinery, and the stage sets have been conserved exactly as they were. Only the candles have been replaced by electric lightbulbs (which perfectly reproduce the soft light of the period). Thus the theater is an ideal setting for baroque and classical music, which is why Ingmar Bergman shot his opera-film *The Magic Flute* here.

Nonetheless, purists will be disappointed to learn that the Drottningholm theater one sees today was not the first theater built on the site. It was actually constructed in 1762, after the theater built there eight years earlier burned to the ground. The story goes that the day of the incident, the audience assumed that a performer's cries of "Fire!" were part of the show.

The presence of a theater within the royal residence is to be credited to Lovisa Ulrika, wife of Crown Prince Adolf Fredrik and sister of King Frederick the Great of Prussia, known for her talents as a flautist and composer. The construction of the second theater was entrusted to Swedish architect Carl Fredrik Adelcrantz. Adelcrantz thought big: His edifice proved to be twice as large as the original theater. The exterior façade is typically Nordic in its austerity. A central pediment is the only "decorative" element. The building is made of wood covered in cream-white roughcast. Its position at the entrance to the royal residence's gardens adds much to the general feeling of tranquility. Time seems to have stopped, far from the bustle of the capital.

Inside, the foyer is equally minimalist. It was designed in 1791 by the French painter Louis-Jean Desprez. When inside this well-preserved space it is easy to imagine the court of Gustav III, son of Adolf Fredrik and Lovisa Ulrika, when the theater

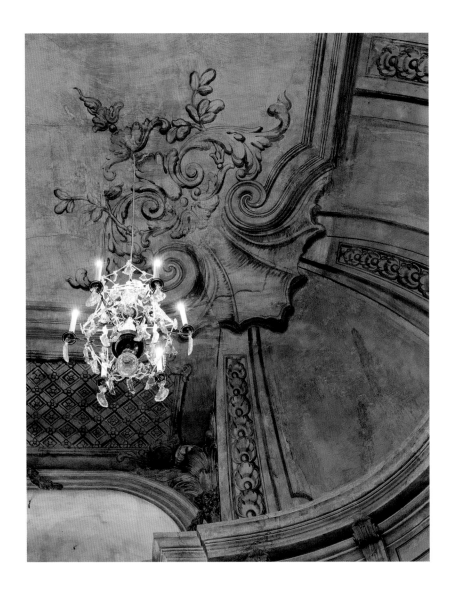

In Drottningholm, the orchestra and stage are of equal depth. The royal box is visible from the first rows of the orchestra.

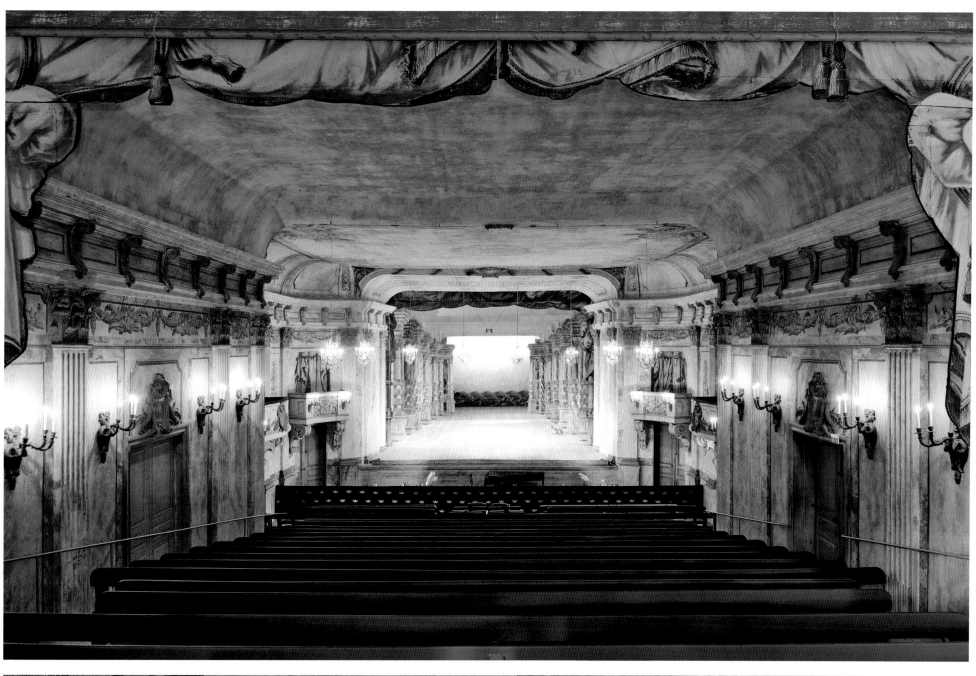

was probably at its height. In the nineteenth century, the Drottningholm theater was forgotten. This jewel of Swedish architecture was returned to the limelight only in 1920, when it was rediscovered by a student.

If Drottningholm is now considered one of the most beautiful opera houses in the world, it is largely because of its auditorium, an intimate, tastefully decorated room with stucco pilasters, which allows an ideal relationship between stage and audience. With the exception of a few scattered boxes, there are no balconies, but its amphitheater orchestra has 454 seats and spans the same depth as the stage, creating a perfectly symmetrical effect. The royal box, surprisingly located in the first rows of the orchestra, is immediately noticeable. Its Louis XV chairs are in pointed contrast with the spartan benches intended for the public. Originally, a divider could be set up between the royal boxes and the benches. At a depth of sixty-five feet, the stage is one of the deepest in Sweden. Depending on the production, spectators might see one of the thirty original sets: beautiful painted backdrops with subtle trompe l'oeil effects.

A visit to the theater's wings reveals period stage machinery conceived by Donato Stopani. Pulleys, ropes, cable drums, capstans: You'd think you were on a ship! Everything creaks and groans as the cloud cars, trap doors, and flying machines are set in motion. The theater also allows directors to stage historical reenactments with period sets, costumes, and blocking. Its acoustics are ideal for period instruments.

Since 1991, the entire royal residence of Sweden—which includes the theater, château, Chinese pavilion (also built by Adelcrantz), and gardens—has been on the UNESCO World Heritage List. One thing is for certain: The "Swedish Versailles" will still be charming our eyes and ears for years to come.

OPPOSITE *The wings have been preserved in their original state.*
PAGES 170–171 *Historical reenactments with period costumes are often staged in this theater that has remained in its original state since 1766.*

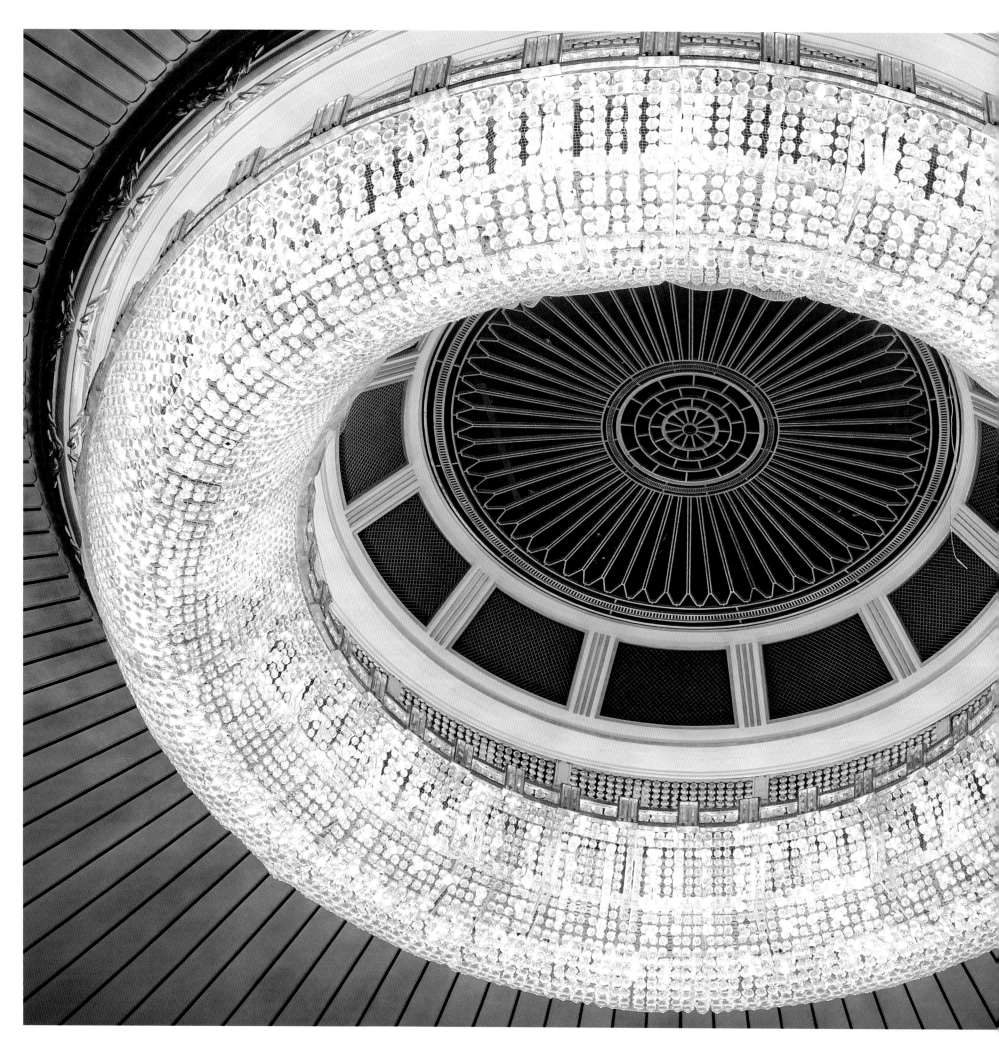

STAATSOPER

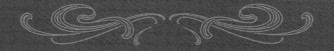

VIENNA

AUSTRIA

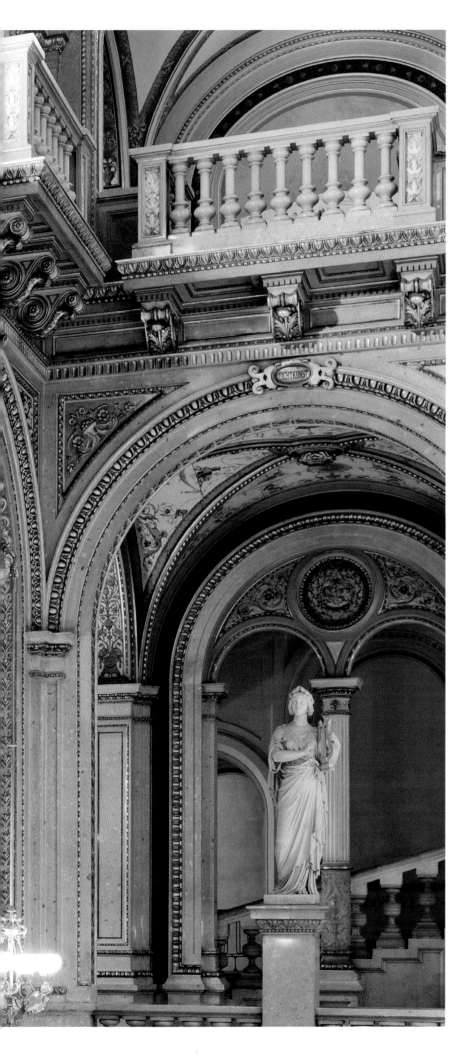

s Vienna still the capital of classical music? One statistic is particularly striking: Each night in the Austrian capital (population about 1.7 million), some 10,000 people set foot in concert halls. While lovers of symphonic music haunt the Musikverein, opera aficionados never miss a production at the Staatsoper. The opera house is on the Ring, a circular boulevard built in the 1850s over the city's former fortifications. Numerous Viennese cultural institutions, including theaters and museums, were constructed in the context of this vast urban renewal project launched by Emperor Franz Joseph of Austria. But the opera house certainly got the best spot at the intersection of the Ring and the bustling, unmissable Kärntner Strasse.

Despite this ideal location, the opera house's construction turned into a fiasco. The initial intention was certainly laudable: The two architects, August Sicard von Siccardsburg for the façade and Eduard van der Nüll for the interior, wanted to adopt the Italian neo-Renaissance style characteristic of all the buildings on the Ring. They drew much of their inspiration from Palladio's plans for a palace in Vicenza. Unfortunately, political contexts changed the design inspiration from one era to another, and from a city in Italy to the capital of the Austro-Hungarian Empire, which required several adaptations to the design.

The architectural result was attacked head-on by the emperor, who supposedly declared that "the opera is sinking underground." While the façade was tastefully arranged, with a loggia and arcades, the structure does indeed feel rather ponderous and static. These aesthetic issues were made more acute by the financial scandals that occurred at every stage of construction. Before the opera house could be officially inaugurated on May 25, 1869, with a performance of Mozart's *Don Giovanni*, Eduard van der Nüll had committed suicide and August Siccard von Siccardsburg had died of a devastating disease.

The Italian neo-Renaissance grand staircase of the Staatsoper was spared destruction by the Second World War bombings that devastated much of the theater.
PAGES 176–177 *The theater was rebuilt by Austrian architect Erich Boltenstern, who maintained the original Italian-style floorplan.*

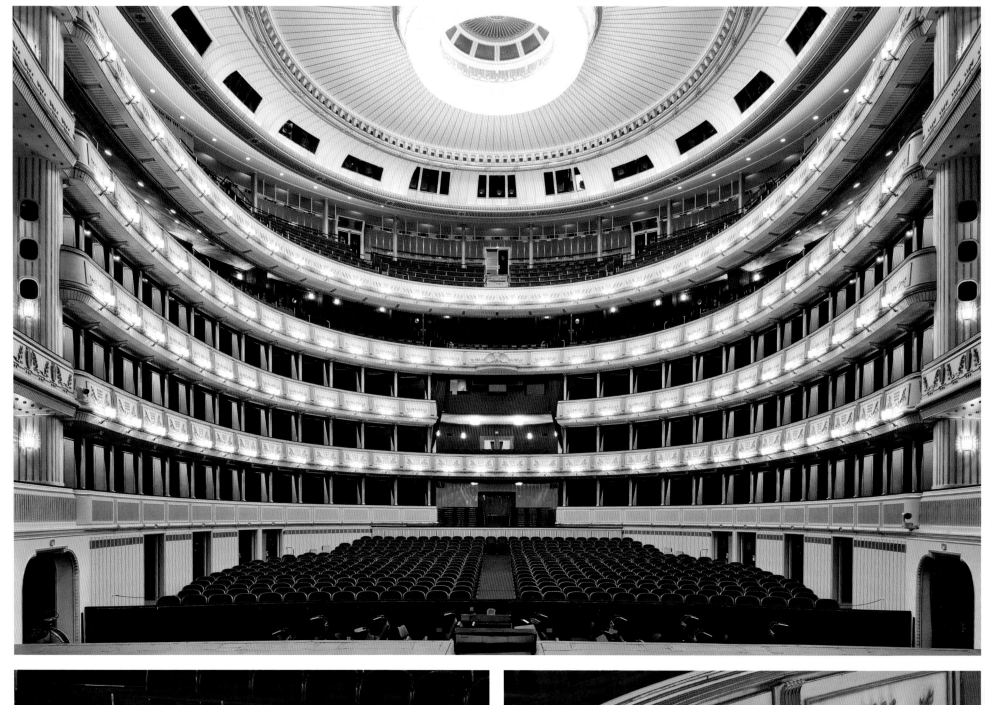

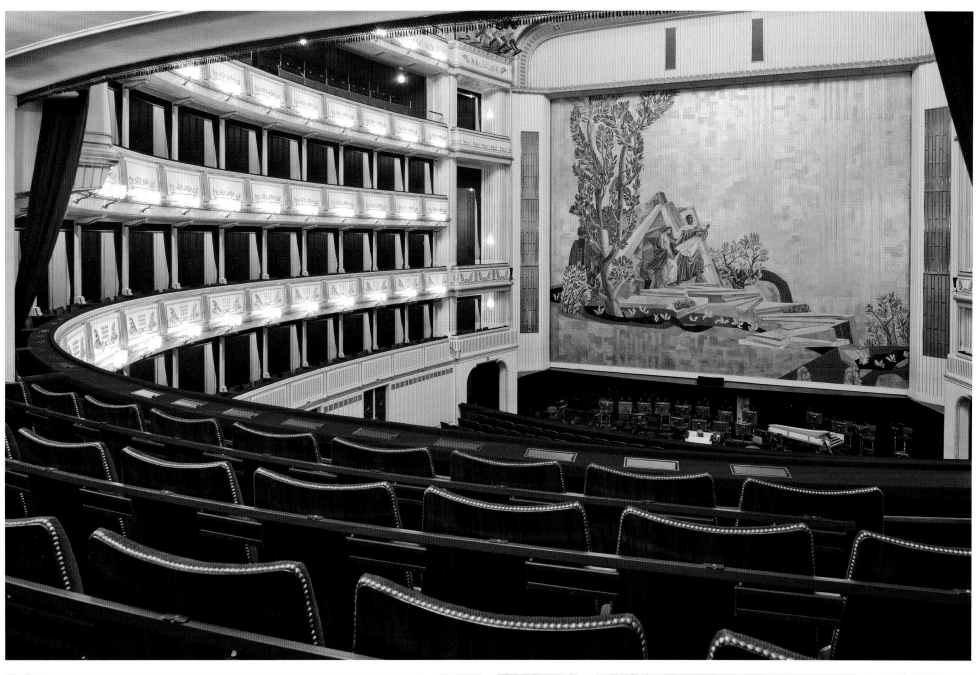

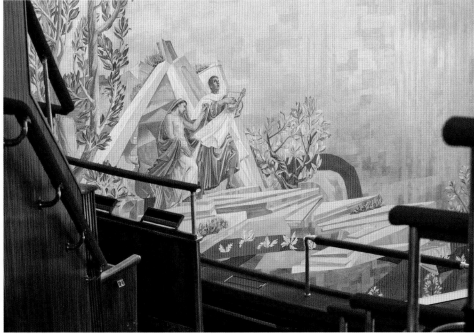

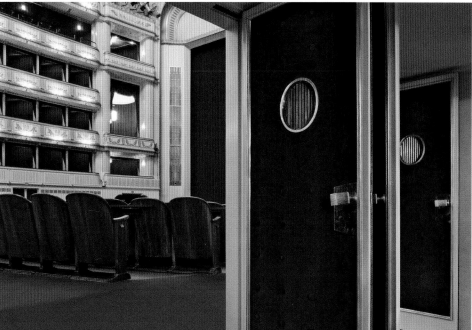

Yet the opera house quickly became a leading center of Viennese musical life. From 1897 to 1907, the establishment was directed by the composer Gustav Mahler, who surprisingly never wrote an opera. In 1918, as the First World War came to an end, the opera changed its name from the Hofoper (opera of the court) to the Staatsoper (national opera). The next war would have a far different effect: In 1945, the building was bombed by the Allies. Its façade was spared but the interior was severely damaged.

Austrian architect Erich Boltenstern led the reconstruction, and proved unable to decide between identically reproducing the original or taking a chance on a modernist design. As a result, it is hard to have anything but mixed feelings about the theater: The historical Italian-style floor plan with its succession of boxes is still there but lacking its original luxury and splendor. The mood is monumental (the theater holds about 2,200 seats) but austere. And it feels strange to pass from the grand staircase and foyer, which were spared by the bombing and thus kept in their original state, to other parts rebuilt in a utilitarian style.

For a little bit of daring, the opera commissions a different artist to decorate the stage curtain each year. In 2012, David Hockney lent himself to the exercise with his usual touch of humor. Another ritual takes place every winter, when the opera house turns into a dance floor for the evening to host the famous Vienna Opera Ball, which is regularly criticized by leftist organizations for embodying certain traditional values. As you can see, in Vienna the Staatsoper will always be at the center of controversy.

OPPOSITE AND PAGES 180–181 *The decorations throughout the public spaces lend a monumental air to this theater that seats more than 2,000 people.*

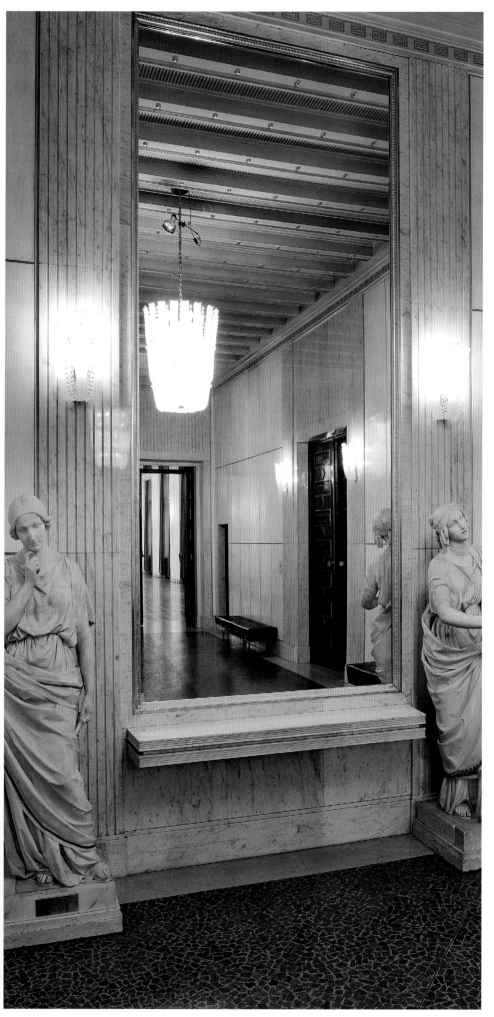

SYDNEY OPERA HOUSE

The death of Jørn Utzon went nearly unnoticed in 2008. Yet the Danish architect and winner of the 2003 Pritzker Architecture Prize had designed one of the most famous—if not *the* most famous—buildings of the second half of the twentieth century: the Sydney Opera House. It was also one of the most controversial.

Jørn Utzon was only thirty-eight when he entered the competition to design the structure in 1956—an unusual contest that included 233 candidates from some thirty countries. Projects were presented anonymously to a jury composed entirely of architects, including Eero Saarinen. After a suspenseful deliberation process, the verdict was announced: The building of the Sydney Opera House would be entrusted to the little-known Danish architect, who had previously focused primarily on individual homes. But Utzon managed to stand out from the crowd by presenting a unique design with revolutionary lines. Reactions came fast and furious. The press was divided, while the architect Frank Lloyd Wright harshly criticized the design.

To fulfill the requirements, which called for the construction of two auditoriums—a large one for opera and symphonic music and a smaller one for theater and chamber music—Jørn Utzon imagined two sets of white shells evoking sails, a design perfectly attuned to the future opera house's location on Bennelong Point in Sydney Harbour. This architectural gesture suggested a variety of influences ranging from Scandinavia and pre-Columbian culture (the podium platform is reminiscent of Mayan temples) to the COBRA movement (Utzon had asked the painter Asger Jorn, one of COBRA's leading artists, to realize objects for the opera house—a project which was sadly never carried out). Utzon was also not shy about his admiration for the Palais Garnier, of which he owned a large blueprint. But while the importance of these aesthetic influences cannot be denied, the overall structure is peerless.

An architectural novelty of this magnitude amounted to a daunting engineering challenge. For the construction of the building, Utzon was associated with the engineers of the London-based Arup firm. The first problem arose when it was discovered that the foundations had not been given a prior geologic evaluation. It soon turned out that the subsoil was unreliable and permeable, requiring consolidation with 700 concrete piers. But the most complex challenge lay ahead, with the construction of the famous concrete sails that would serve as a roof. How could concrete be used in such an innovative way while guaranteeing the quality of the acoustics and the sails' wind resistance? After hundreds of thousands of hours of discussion, the answer was found in the principle of spherical geometry: To some extent, the shells became vaults, which certain admirers of the original design regretted, considering that version more organic. As for the sails' appearance, after

initially envisioning tiling with black-and-white or blue-and-white stripes, Utzon opted for an immaculate white roof. Close to 4,250 tiles were made.

The construction project grew to the point that Utzon decided to immigrate to Australia with his family in 1963. He set to work on the opera house's glass curtain walls, which were inspired by the shape of bird wings. The framework for the windows was made of plywood, complementing the use of concrete. The auditoriums were kept separate from the roof, in order to isolate the halls from the sounds of the harbor. But the question of acoustics was not limited to this aspect, and would in fact cause Utzon severe problems. After working with Arup, he hired Lothar Cremer and Werner Gabler, the German acousticians responsible for the Berliner Philharmonie. The challenge was in the programming: The major hall was to serve both for opera and symphonic concerts, which are radically different from an acoustic perspective. The same was true of the minor hall, which was to be dedicated to theater and chamber music. Unlike the other architectural candidates, who had placed the two halls in alignment in order to have them share a stage-house, Jørn Utzon chose to place the two spaces side by side—a striking architectural choice, but a technically problematic one, requiring the construction of two stage-houses. For the halls' design, Utzon had wanted to draw inspiration from Asian shapes (with the smaller hall symbolizing a geisha's headdress) and use bright colors (red and gold for the major hall, blue and silver for the minor).

But these plans were not to be. The inexorable increase in construction costs was blamed: Initially estimated at seven million Australian dollars, the cost of building the opera house now threatened to reach more than fifty million. In 1965, the government of New South Wales changed hands. The conservatives who replaced the labor party had been up in arms since the call for offers during the design competition, which they believed had not been properly carried out. The authorities decided to suspend the monthly payment of Utzon's fees. To make matters worse, the engineers did not want to implement the architect's decisions, particularly in regards to the auditorium's ceiling. Tension, marked by a whiff of nationalism, reached new heights. In 1966, Utzon was left no choice but to resign. A demonstration drawing several thousand people demanded the architect's return, while the government appointed three Australian architects to replace him, supervised by New South Wales' chief architect. Utzon left Australia with his family, never to return.

Construction continued with dramatic changes made to the interior of the halls. The main auditorium was not given a stage-house and thus limited to symphonic music. Operas could only be performed in the minor hall, which did have a stage-house, but entirely inappropriate acoustics. Additionally, none of the glass curtain walls or interior finishing was by the Danish architect, leading to an unfortunate aesthetic patchwork. In 1973, the opera house was inaugurated at a final cost of 102 million Australian dollars, and Queen Elizabeth II did not even mention Utzon by name. The architect himself never spoke of the subject again.

But a great symbol remains on several levels: a symbol of a continent-nation, of the difficulties between contractors and contracting authorities, and of opera itself.

TEATRO FARNESE

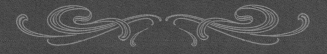

PARMA

ITALY

One of the most beautiful theaters of the Renaissance is hidden behind the monumental façade of the Palazzo della Pilotta in the center of Parma. The Farnese family, which reigned over the Duchy of Parma during the Renaissance, was always committed to supporting the arts, as evidenced by its exceptional collection of paintings and sculptures. In the early seventeenth century, Duke Ranuccio I Farnese commissioned the architect Giovanni Battista Aleotti to build a theater. Aleotti drew inspiration from the Teatro Olimpico (see page 192), inaugurated in 1585, and followed Palladio in drawing from the vocabulary of antiquity. But his theater is not a mere copy of the one in Vicenza—beginning with its dimensions, which at close to 4,000 seats (versus 1,000 in Vicenza) are far more impressive.

Aleotti partially replicated the shape of an ancient stadium—long and narrow—surrounded by U-shaped bleachers. The structure was enhanced with two levels of carefully decorated colonnades and a balustrade typical of Roman gardens. As in a stadium, the orchestra was not used for audience seating but was reserved for the arena, which in this case served as an extension to the stage. For the first work staged at the Teatro Farnese in 1628, Achillini's *Mercurio e Marte* with music by Monteverdi, the arena was flooded at the end of the performance, creating a spectacular naumachia effect. Elaborate stage machinery allowed quick set changes and enabled characters to make sudden appearances. The proscenium was a triumphal arch, giving the theater a solemn character softened by the sunlight entering the room through the oculus.

The theater's structure is made of wood covered in stucco faux marble, built separately from the palace's walls, as if the theater was supposed to be temporary. In fact, it hosted only nine performances before 1732. Then this architectural masterpiece was left empty. In 1846, Charles Dickens described it as a "ghostly stage." In 1913, the theater's interior was renovated on the occasion of the centennial of Giuseppe Verdi's birth. A short-lived rebirth—late in the Second World War, Allied bombings severely damaged the edifice, which had to be rebuilt once again.

Today the Teatro Farnese is an integral part of Parma's national galleries, which have been installed in the Palazzo della Pilotta and can thus easily be visited. One might have worried that the edifice would become a theater-museum, welcoming tourists but no artists. Yet in 2011, the organizers of the Verdi Festival brought the theater back to life by programming his *Falstaff*, an opera inspired by Shakespeare, who was a contemporary of the Teatro Farnese. The acoustics left music critics somewhat skeptical, with some wondering aloud if it wouldn't be preferable to use it to perform Renaissance or baroque music on period instruments. But everyone applauded the fact that this unique stage was back in use. Unfortunately, it isn't a done deal yet: A performance by the Mozart Orchestra conducted by Claudio Abbado and scheduled for June 2012 was canceled at the last moment because the theater no longer met the safety standards required to have an audience.

We can draw comfort from the fact that musical life in Parma shows no signs of slowing down. In this final resting place of violinist and composer Niccolò Paganini and birthplace of conductor Arturo Toscanini, music lovers enjoy a nineteenth-century theater in the Italian style (the Teatro Regio), and since 2001, a contemporary concert hall built by Renzo Piano in a former sugar factory. Ranging far beyond the family's own theater, the enlightened spirit of the Farnese continues to be felt in this city in Emilia-Romagna.

The architect Aleotti drew his inspiration from the floor plans of the long and narrow stadiums of antiquity.

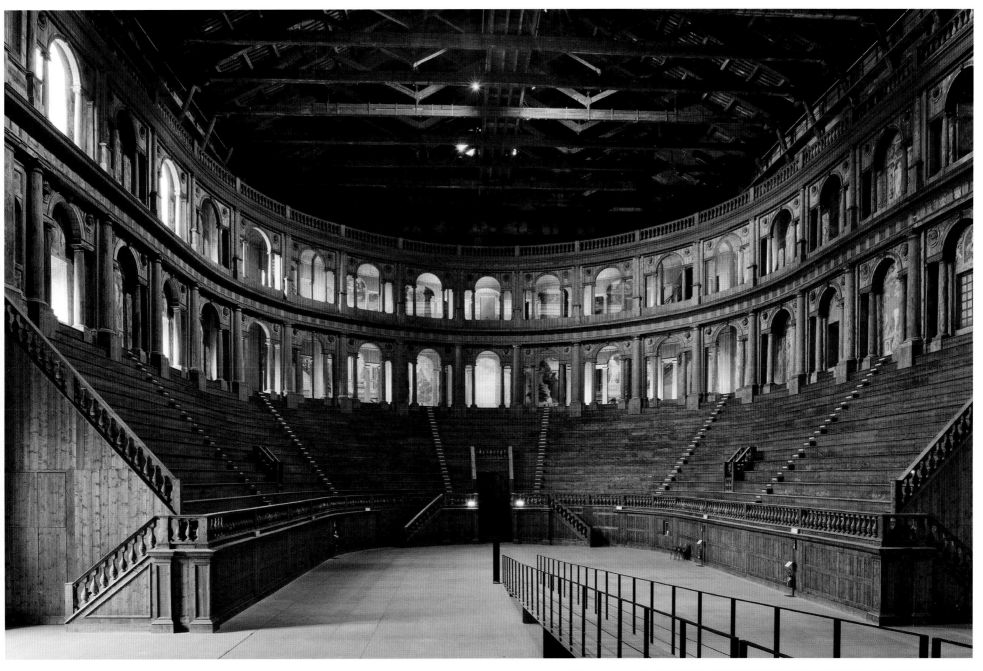

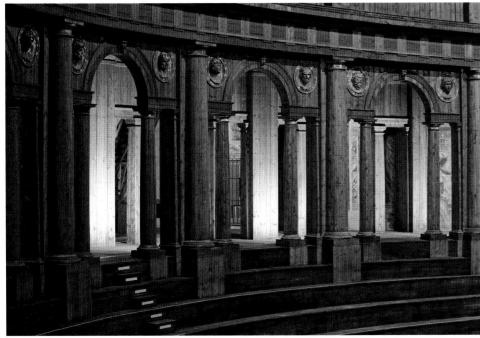

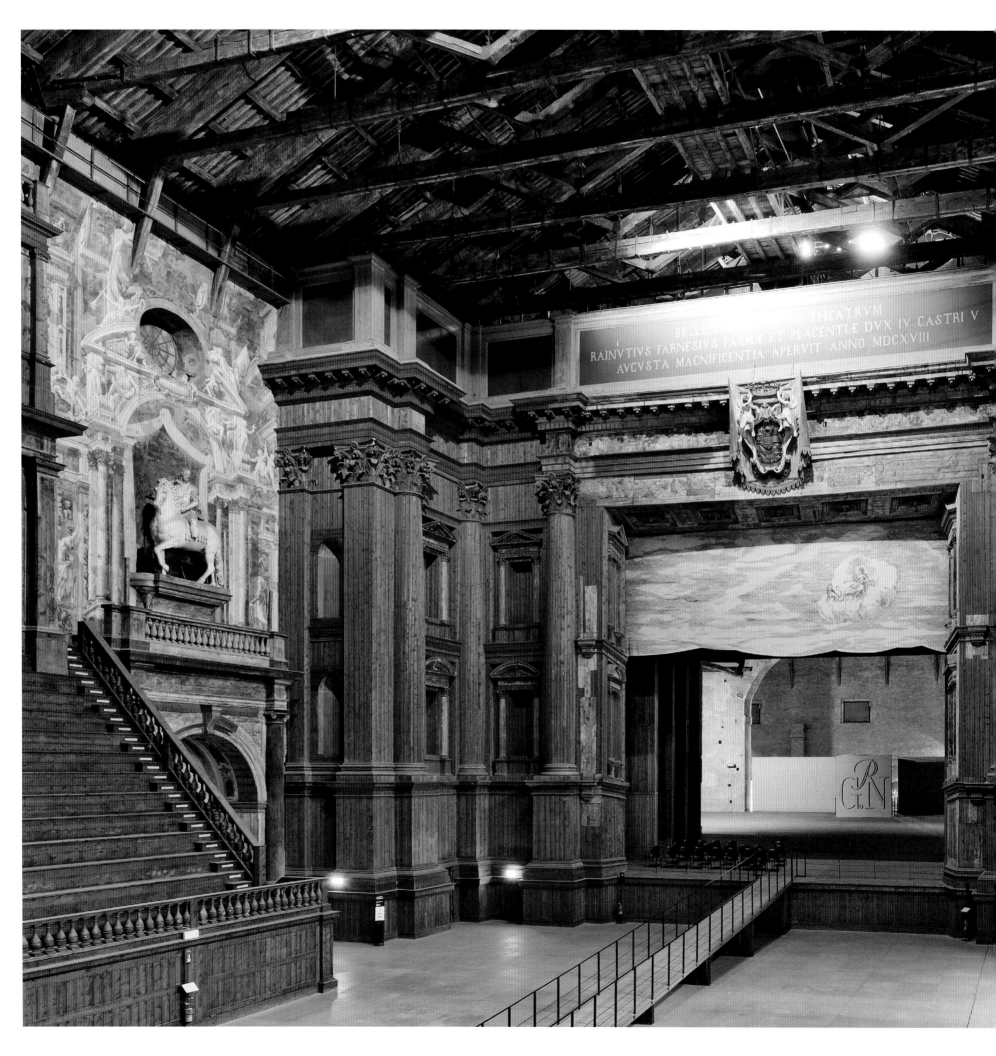

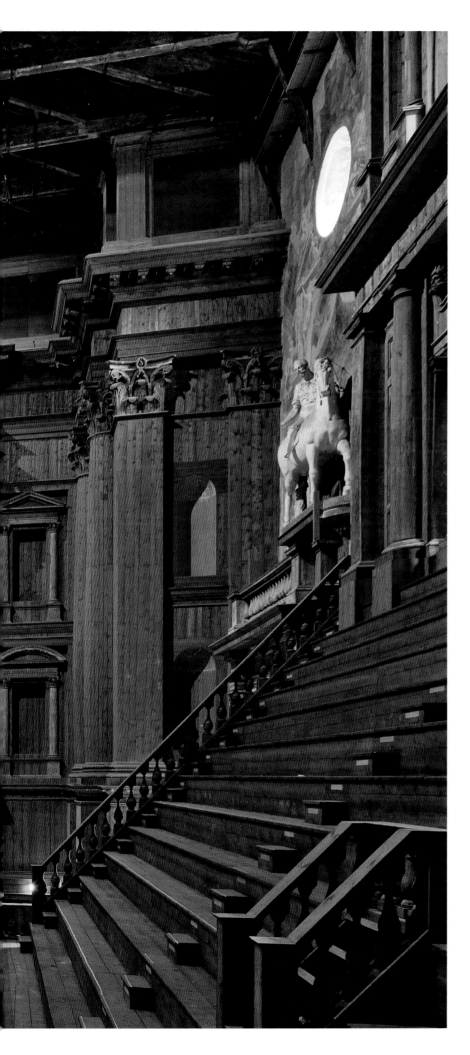

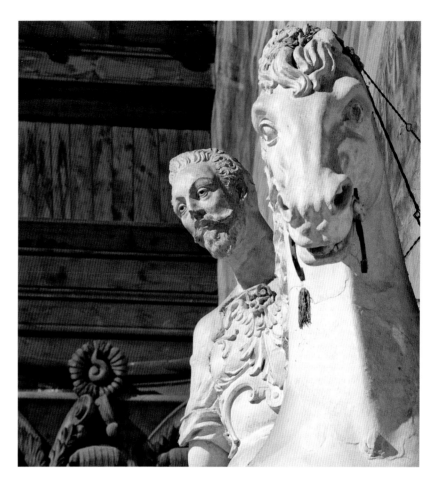

OPPOSITE *The proscenium is in the shape of a triumphal arch.*
PAGES 190–191 *The tiered seats have two levels of colonnades and a balustrade, in perfect Roman style.*

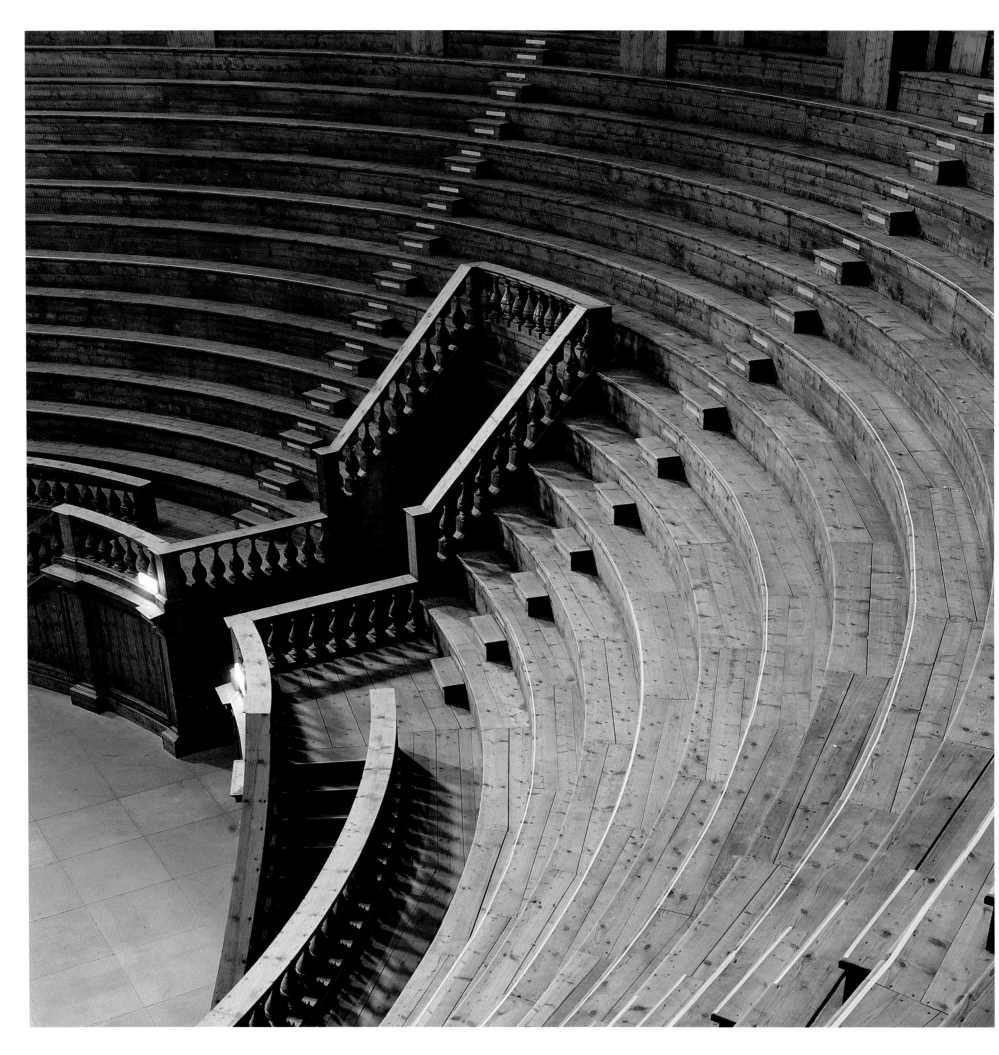

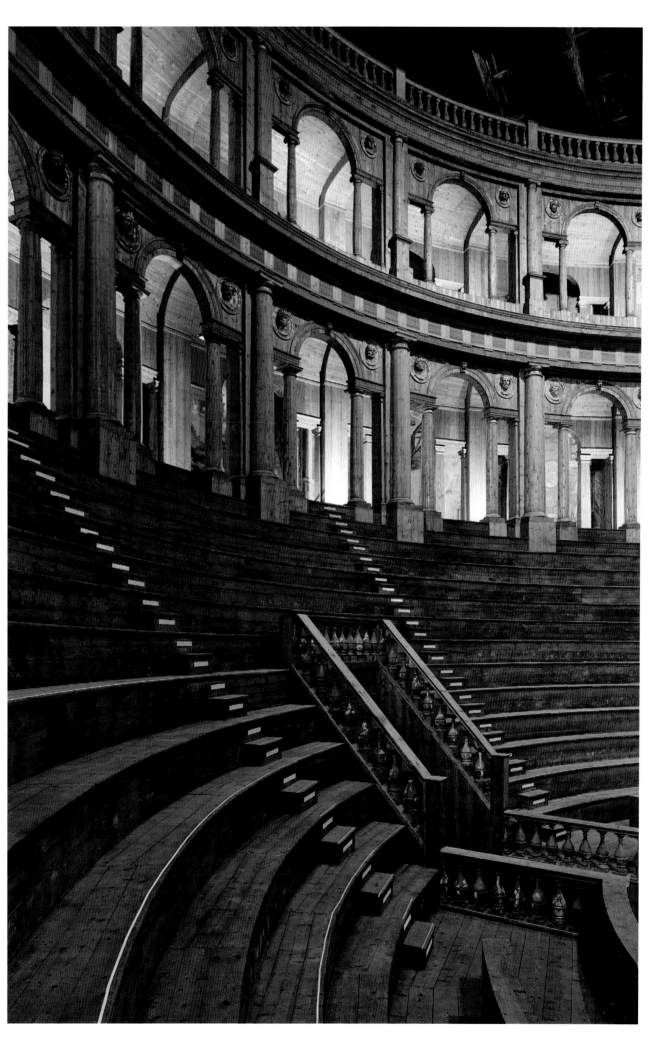

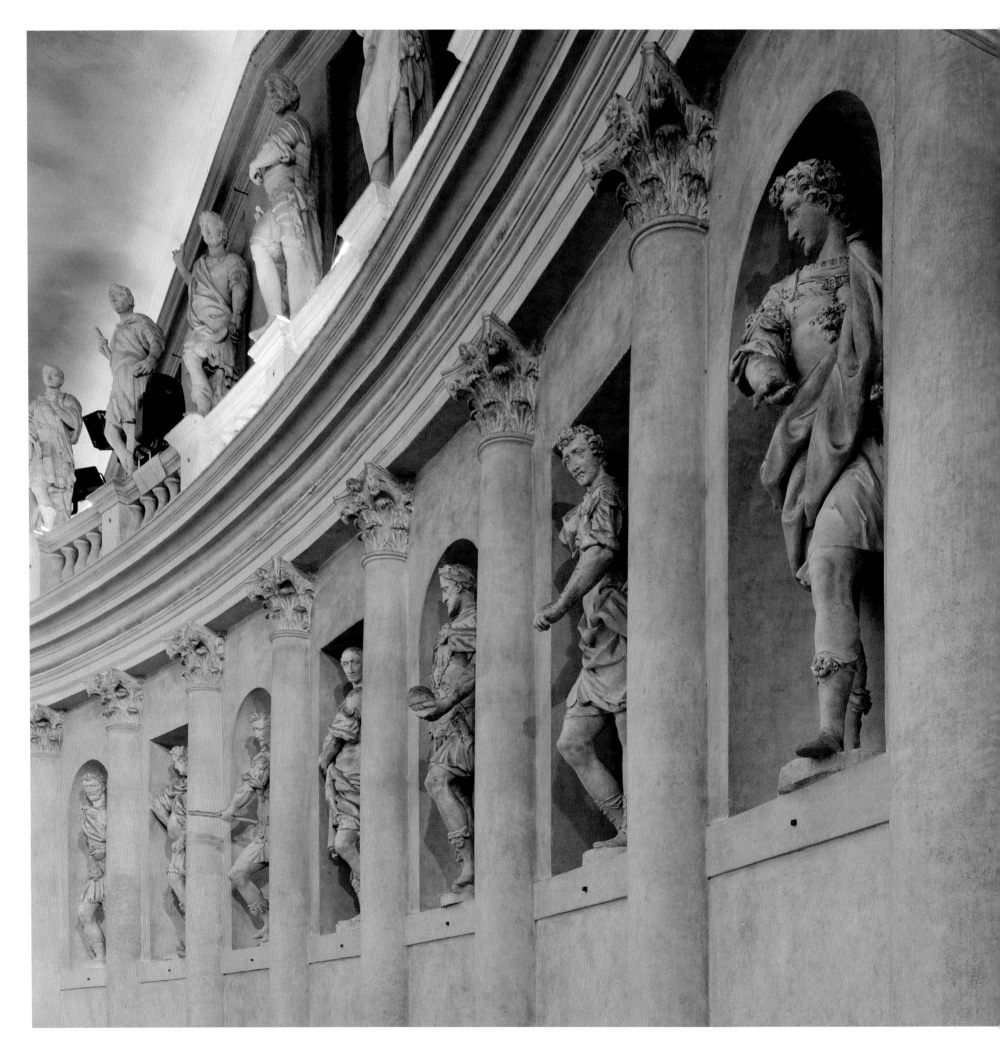

TEATRO OLIMPICO

VICENZA

ITALY

ndrea Palladio, the leading architect of the Italian Renaissance, died in Vicenza in 1580. This Venetian city is home to his final work, the Teatro Olimpico, which is considered one of the first covered theaters and a major edifice in the history of architecture. Yet from the outside the structure is not particularly attractive. The "project managers"—the members of the Olympic Academy—wanted the theater to be built inside a medieval fortress that had previously served as a prison. It was within these austere walls—with all the limitations they entailed—that Palladio created one of his masterpieces.

Spectators step back in time when they enter the auditorium. Its construction as an amphitheater and its stage wall (with sculptures representing Vicenza's academicians) leave no doubt that Palladio drew his inspiration from the theaters of antiquity, applying their lessons with virtuosity. He clearly read the Roman architect Vitruvius, whose treatise *De Architectura* describes Greek theaters as follows: "The ancient architects, having studied the nature of the voice and noted that it rises in the air by degrees, have regulated, based on this knowledge, the elevation that the degrees of a theater must have, in keeping with the rules of the canonic proportion of the mathematicians and the musical proportion; they proceeded so that everything pronounced on stage would clearly and easily reach the ears of all the spectators."

The acoustics in this wood theater must have been ideal, but the subsequent addition of concrete now prevents us from experiencing its original conditions. These were not the only changes: The building was subjected to many other modifications after Palladio died six months after construction began, leaving his work unfinished. The project was taken over by one of his disciples, the architect and set designer Vincenzo Scamozzi, who conceived of the theater as a gigantic set for Sophocles' *Oedipus Rex*, the play to be performed at the building's inauguration. Beyond the central stage archway,

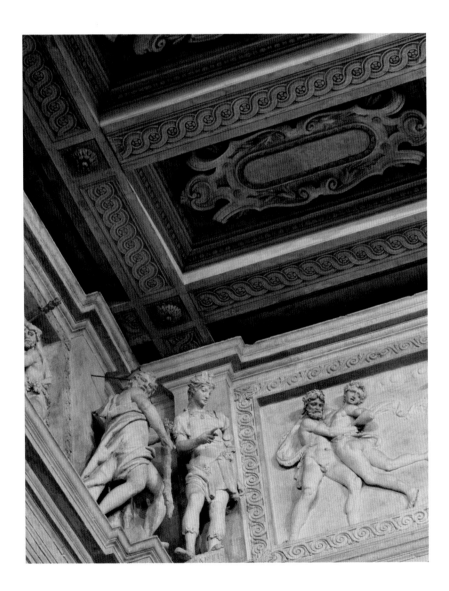

Palladio was inspired by the amphitheaters of antiquity, with a triumphal arch serving as a stage wall.

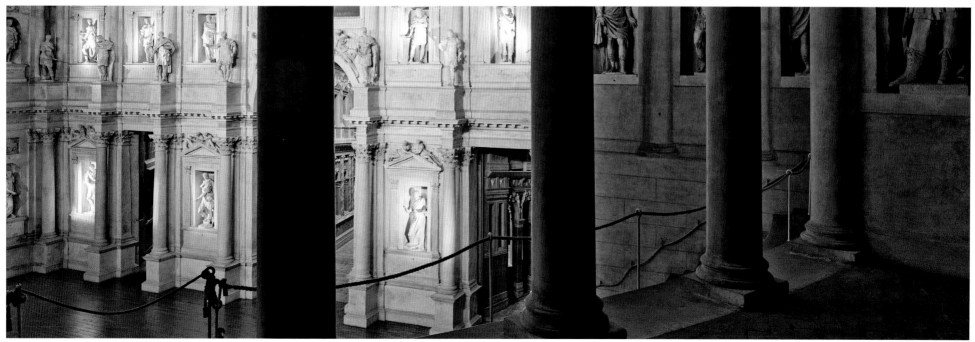

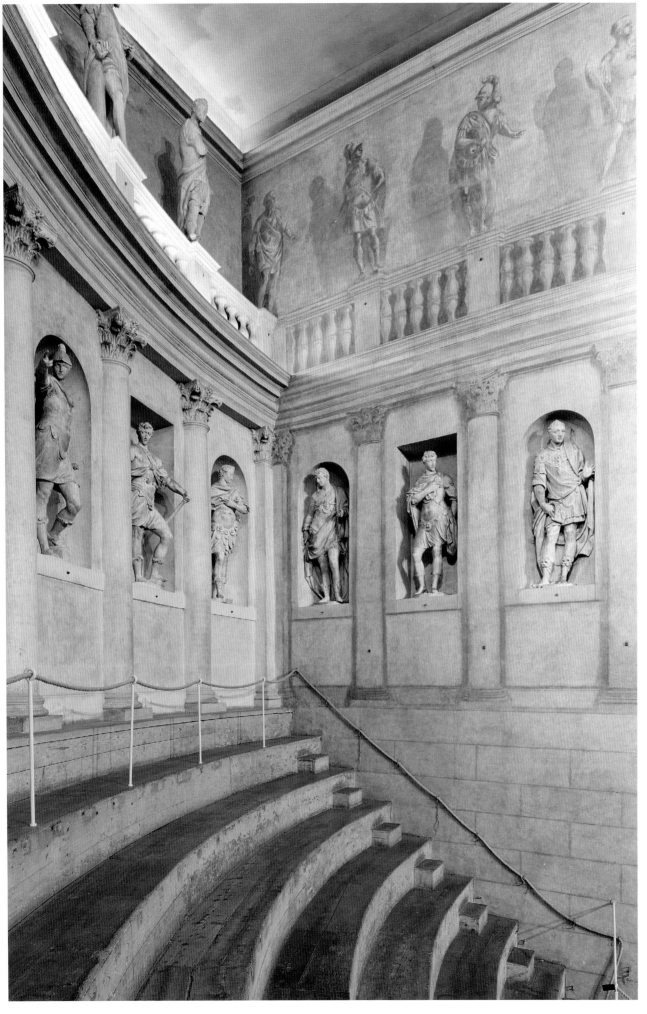

Scamozzi installed seven recesses creating striking perspective views. He was trying to stage the city of Thebes, the setting for Sophocles' drama; the Teatro Olimpico is thus an extremely rare example of a theater built to stage a specific play.

In the eighteenth century, Giacomo Cassetti built a balustrade over the amphitheater with a line of neoclassical statues, following the prevailing trend of the time. But the overall effect was not jarring, for the theater harmoniously combines the different periods of its construction.

Aside from the auditorium, one must absolutely see the Odeon, a foyer that also serves as a concert hall for chamber music. With its trompe l'oeil and paneled ceiling, the Odeon is a marvelous example of the illusions of the Italian Renaissance.

Though it was a pioneer in theater and opera house architecture, the Teatro Olimpico has not been used much over the centuries, especially because it is difficult for a director to create his or her own staging in such a loaded setting. Yet since 1992 the Stresa Festival has held operas and concerts here. We will not soon forget the exceptional 1998 filmed recital by Cecilia Bartoli, which propelled the diva onto the most prestigious stages in the world.

The Teatro Olimpico was modified by Vincenzo Scamozzi, a disciple of Palladio, then by Giacomo Cassetti Marinali, who installed a balustrade incorporating neoclassical statues.

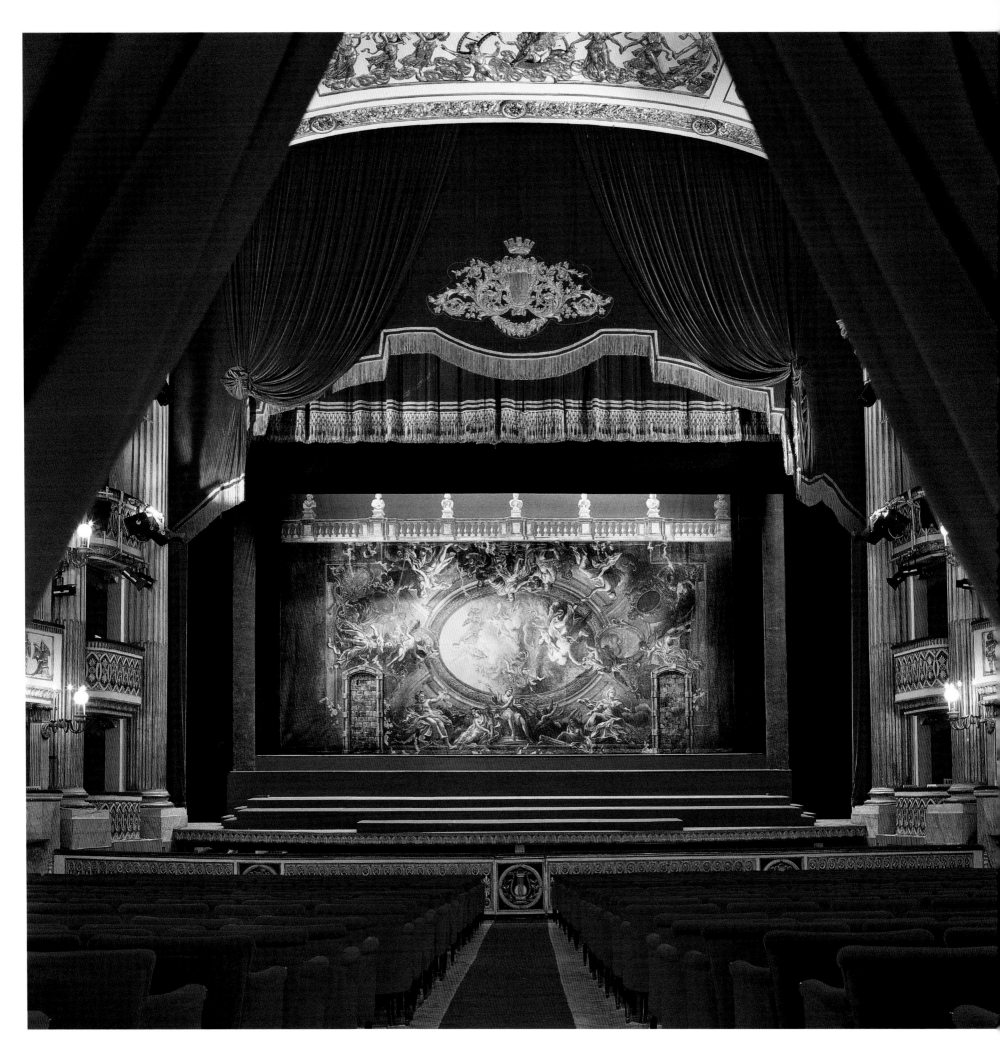

TEATRO DI SAN CARLO

NAPLES ITALY

With some 2,400 seats and six balcony levels, the Teatro di San Carlo demands superlatives. In 1734, Charles III, viceroy of Naples, commissioned the architects Giovanni Antonio Medrano and Angelo Carasale to design a grandiose theater. Inaugurated in 1737 with Domenico Sarro's *Achille in Sciro*, from a libretto by Metastasio, the auditorium boasts a horseshoe-shaped floor plan with no less than 180 boxes. At the time, Neapolitan musical life was at its height, dominated by Nicola Porpora, Niccolò Jommelli, and Johann Adolph Hasse. It was the era of the *opera seria* and castratos—Farinelli, the most famous castrato, was a native of the Kingdom of Naples.

Early in the nineteenth century, Joachim Murat, brother-in-law to Napoleon I, became King of Naples. In 1810, he commissioned the set designer of the Teatro di San Carlo, Antonio Niccolini, to design a new façade to assert his rule. His motivation was clearly political: The San Carlo could no longer be a court theater connected to the royal palace, rather it had to become an edifice open to the bourgeoisie. Niccolini thus gave the San Carlo its own façade, avoiding any resemblance to the neighboring castle. Its style was both austere, with arcades made of neo-antique stone, and supremely elegant, particularly in the series of fourteen columns bordering the loggia. Five bas-relief panels represent the principal mythological figures, from Orpheus to Apollo.

Niccolini's work should have stopped there, but in 1816 the theater was severely damaged by fire. The set designer was forced to reconstruct the interior, preserving the soaring lines of boxes that lend the San Carlo its grandeur. The stage, orchestra pit, and some boxes were expanded. Flights of stairs were also installed to improve audience flow in case of another fire. The theater was originally dark blue; it became red and gold in 1854, after Niccolini's death.

The San Carlo was heavily damaged during the Second World War. Its renovation was given priority and executed in 1946, for the San Carlo is a symbol, one of the monuments that best embodies Naples, sharing the city's irresistible exuberance and vitality.

Originally dark blue, the theater was redesigned in crimson and gold in 1854.

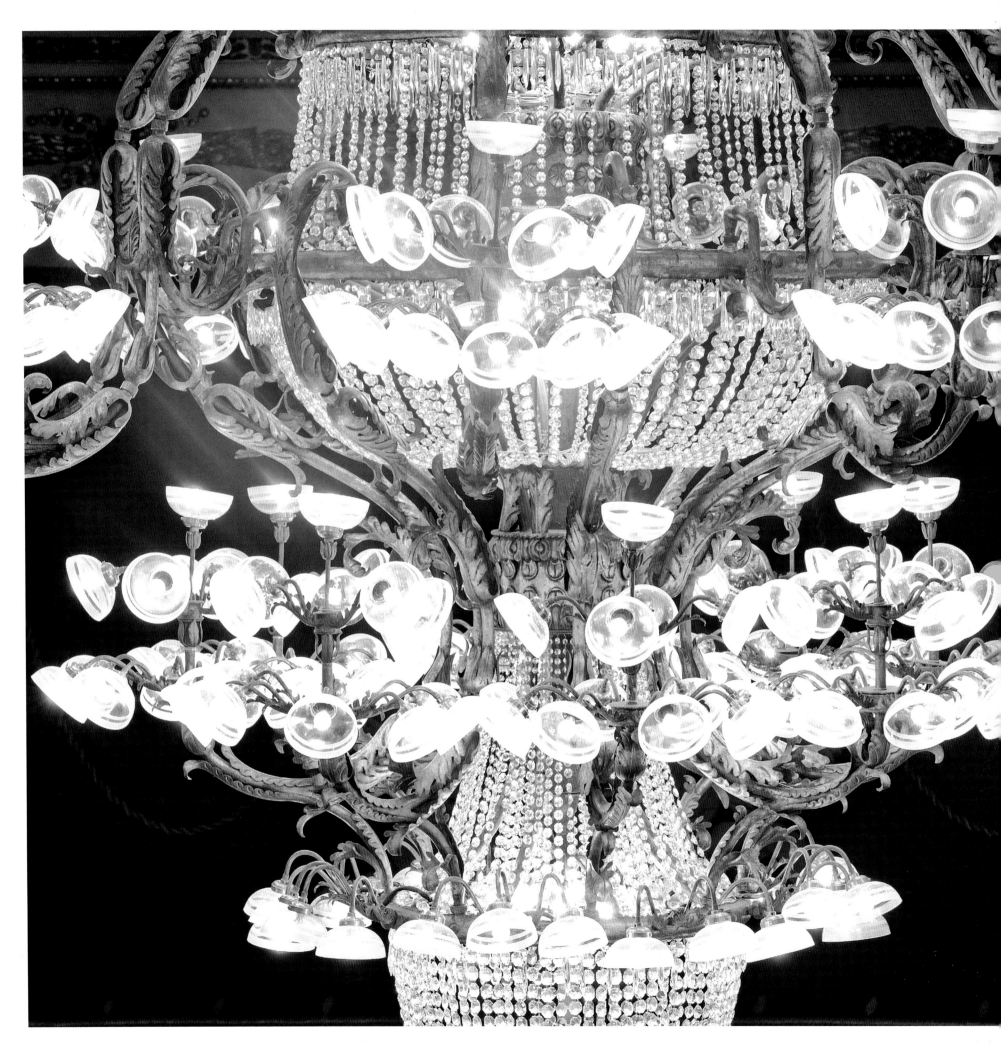

TEATRO ALLA SCALA

MILAN

ITALY

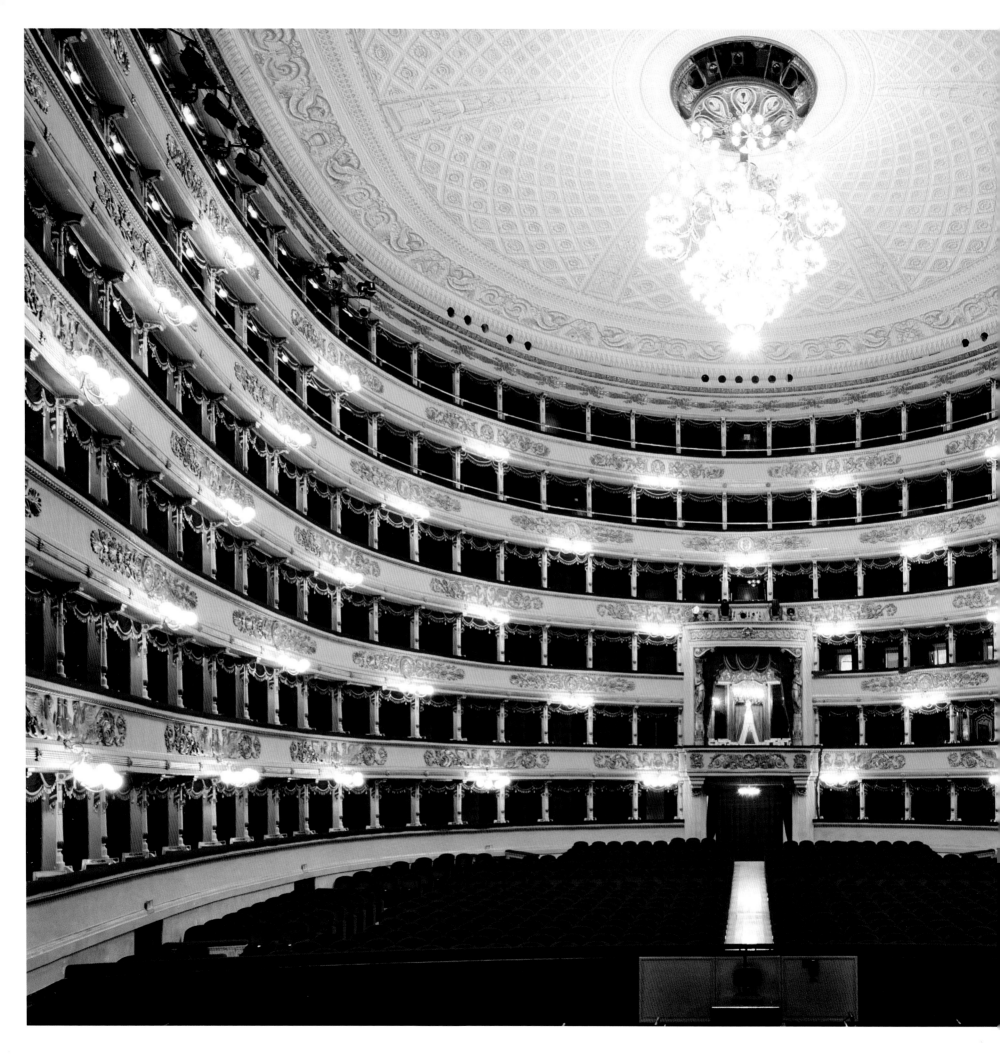

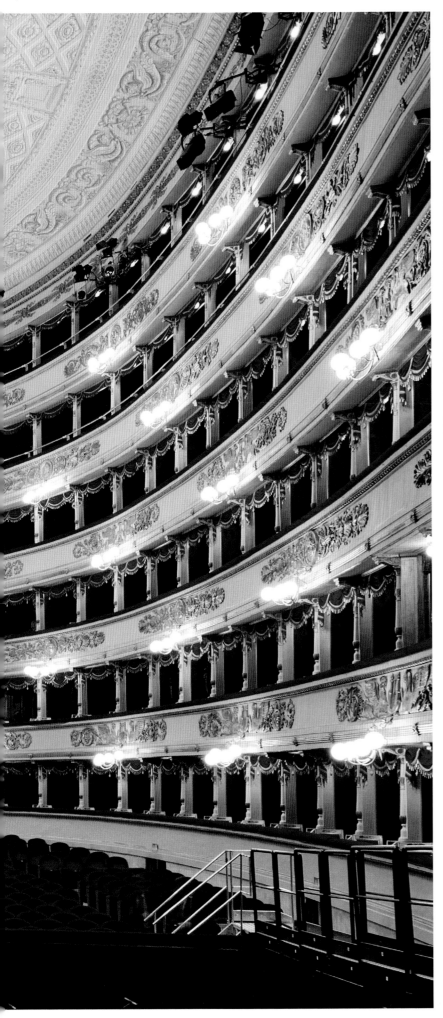
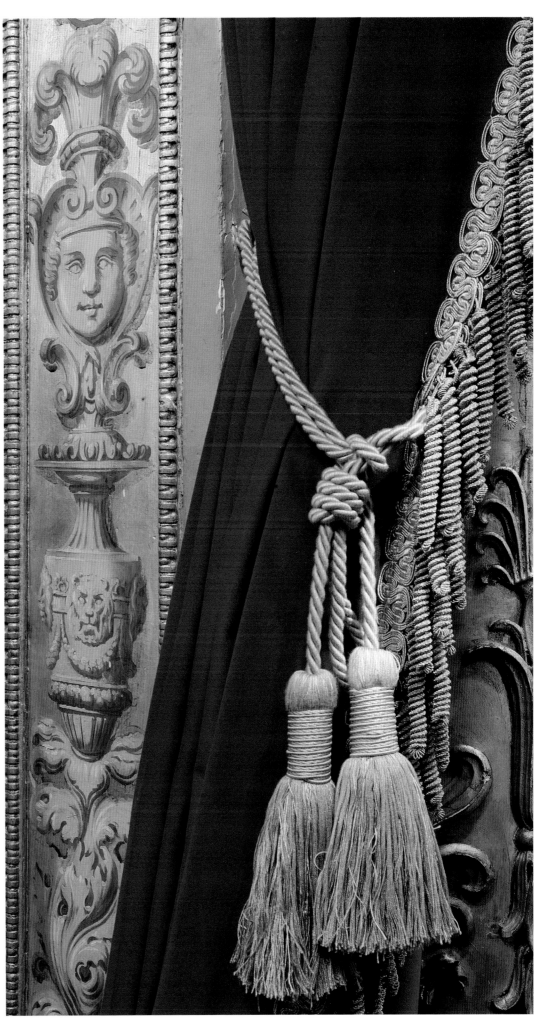

ecember 7 is not just any other day in Milan; every year on Saint Ambrose's day (in honor of the former bishop of Milan) the Teatro alla Scala officially opens its annual season. Anticipation is all the more intense given that other European operas start their programming several months earlier. The season-opening Milan performance draws numerous figures from politics (the president of the republic, the head of the government) and the financial world (the major Italian CEOs are always there), as well as the inevitable celebrities. A demonstration organized by unions and student movements generally takes place in front of the theater, closely supervised by the police.

This unrest surrounding La Scala is nothing new. Throughout its history, the theater has witnessed tremendous upheaval. Before La Scala was built, Milan had a court theater, the Teatro Regio Ducale, inaugurated in 1717. This stage welcomed countless composers, including a certain Mozart—for at the time Milan was under Austrian rule. Sadly, this intimate space was destroyed by fire in 1776. Empress Maria Theresa authorized the construction of a far vaster building, where the nobility and bourgeoisie would rub shoulders. This new theater was built on the site of the former church of Santa Maria della Scala. Erected in record time, it was inaugurated in 1778 with a work by Salieri, *Europa riconosciuta*. It is said that Gluck turned down this inaugural commission.

The architect Giuseppe Piermarini adopted a restrained—if not downright austere—Italianate neoclassical style. The geometrically shaped outer façade gives no clue to the theater's ostentatious interior. In red and gold, the auditorium is distinguished by its majestic proportions (it can hold 2,200 spectators). The balconies consist of closed boxes (separated by mirrored partitions), which are typical of Italian theaters and in contrast to the French open box.

The royal box in the first balcony would undergo many radical changes: With the end of Austrian rule in 1797, it was divided into six regular boxes, then turned back into a royal box when the Austrians returned to power in 1815. Though Italy is now a republic, the royal box remains as sumptuous as it was then.

The exterior areas are dizzying. Instead of a single grand staircase like the Palais Garnier or Staatsoper in Vienna, La Scala has a maze of staircases to bring spectators to their boxes (each has its own coat check). The foyers are imposing, but their decoration is also minimal.

The essential at La Scala is the music. And what music: The theater has hosted the premieres of such masterpieces of Italian opera as Verdi's *Nabucco* in 1842, Puccini's *Madama Butterfly* in 1904, and *Turandot* in 1926. The latter two productions were held under the leadership of the man who remains La Scala's most famous director, Arturo Toscanini. The strong-willed Italian conductor headed the Milanese institution from 1898 to 1929. Mementos of his time there can be seen at La Scala's museum inside the theater.

In 1943, the opera house was partially destroyed by Allied bombing. But Italy recognized the importance of this symbol: Reconstruction work on La Scala was considered a priority, and the theater was reopened in 1946. Today La Scala's unique atmosphere is largely due to its audience. This particularly lively crowd does not hesitate to raise its collective voice, whether to express its satisfaction or its disappointments. Cries of "*Bravi!*" are as quick to descend from the balconies as catcalls. In 2006, tenor Roberto Alagna walked off stage in the middle of a performance of Verdi's *Aida* after being booed by part of the audience. Even the recent financial crisis, whose consequences have been devastating for the Italian cultural field, has not yet impacted the Milanese spectators' fervent commitment.

A specifically Italian characteristic: The balconies consist of closed boxes, separated by mirror-covered partitions.

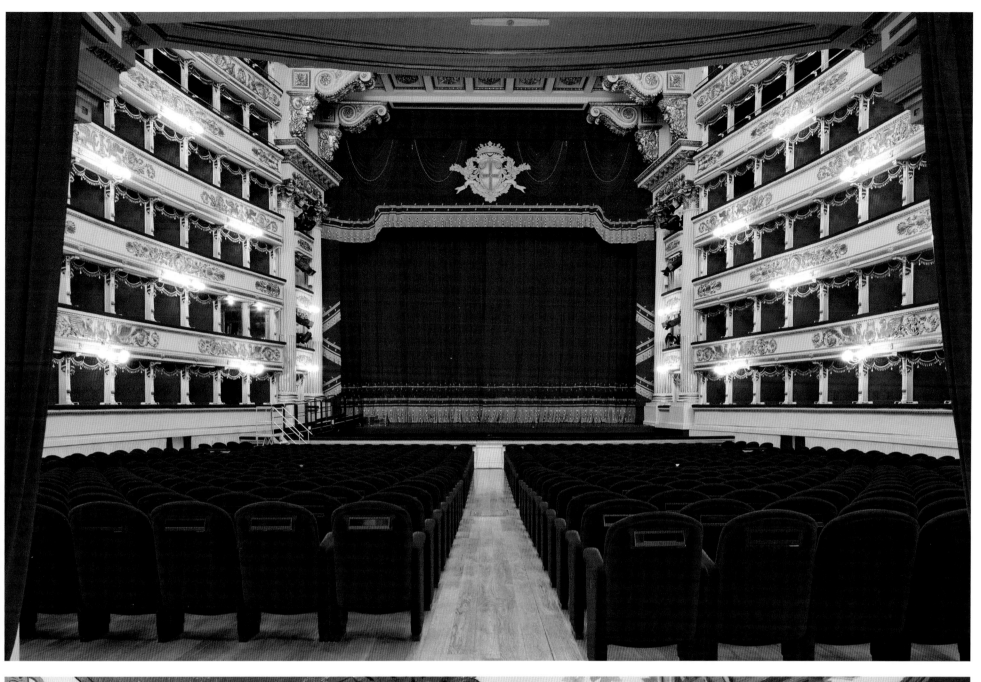

The theater's opulent interior is accented by red and gold decoration.
PAGES 208–209 The splendidly luxurious royal box is located on the first balcony.

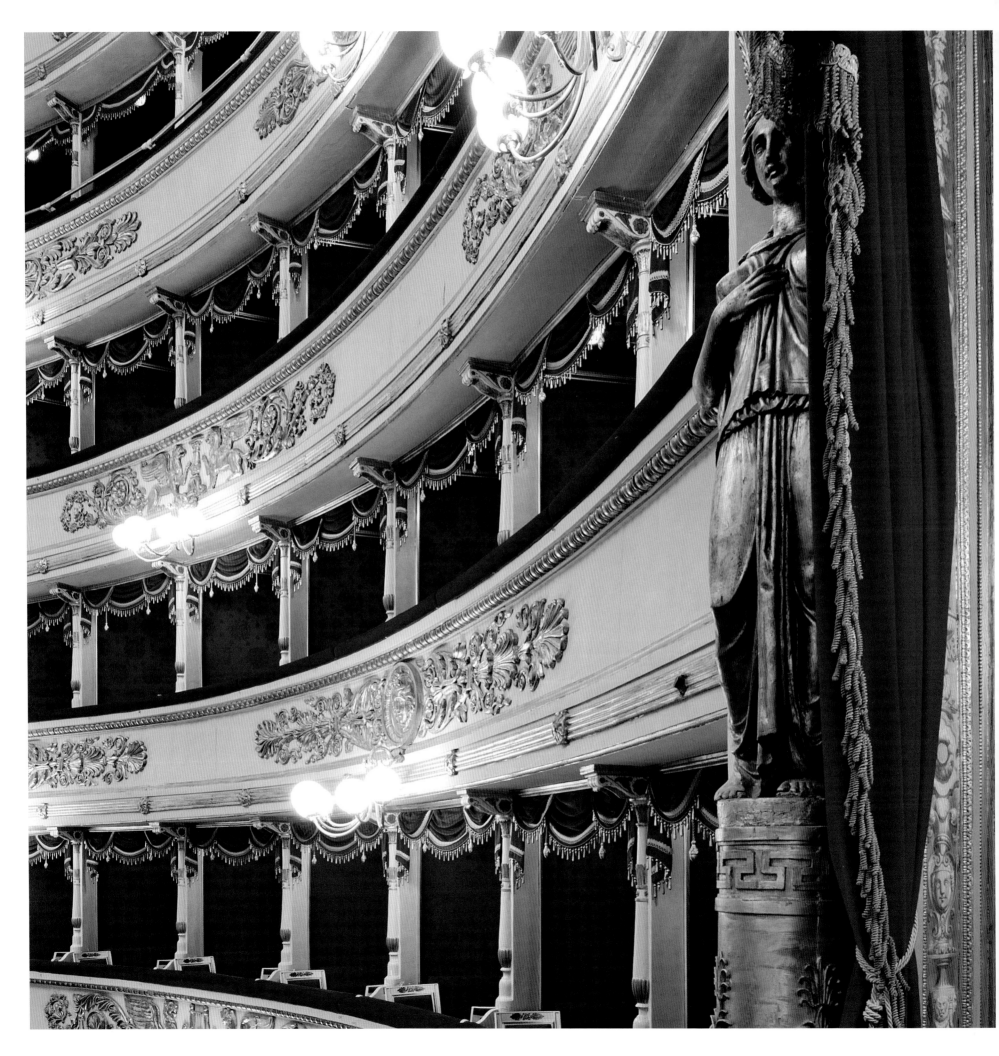

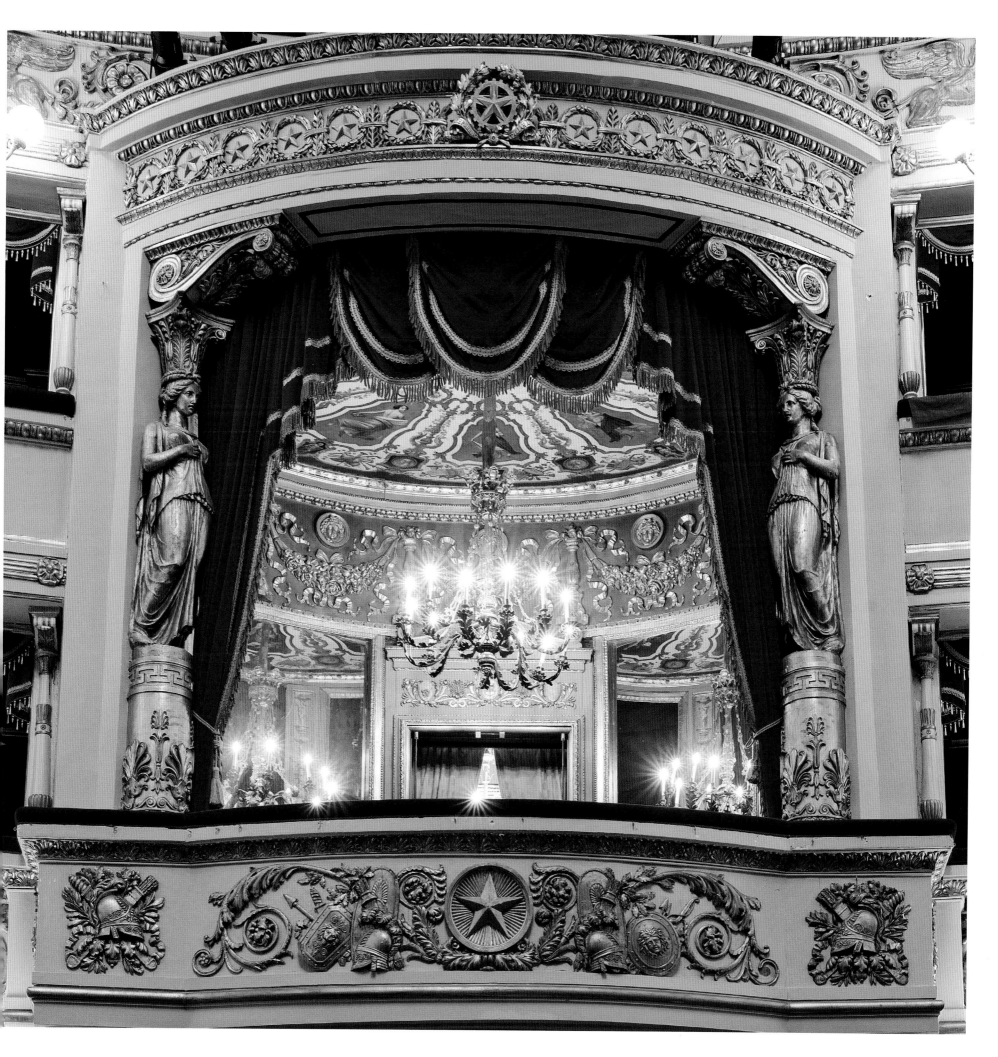

THÉÂTRE DU CHÂTEAU DE CHIMAY

CHIMAY

BELGIUM

The name Chimay is well known to beer drinkers, less so to music lovers. Yet aside from the abbey where the Trappist monks brew their precious beverage, this Belgian town in the province of Hainaut also has a neo-Renaissance château containing an exceptional court theater.

Standing on a rocky promontory overlooking the Vallée de l'Eau Blanche, the Château de Chimay has paid for its strategic emplacement with a long, tumultuous history (a dungeon is believed to have existed on the site in the twelfth century). Destruction due to various wars has required constant reconstruction in wildly different styles.

In 1805, Thérésa Cabarrus married François-Joseph de Riquet, Count of Caraman and Prince of Chimay, and decided she wanted to have her own theater within the actual château. The auditorium was built in the courtyard and surrounded by circular colonnades. Yet this edifice was short-lived; it was demolished as part of work undertaken by the son of François-Joseph de Riquet, Joseph de Riquet, known as the Grand Prince, who reconceived the château in a neo-gothic style. This expansion carried out in 1863 included the construction of a new theater via the architect Hector-Martin Lefuel, who had built the theater in the Château de Fontainebleau in 1857.

The auditorium in Chimay is very similar to the one in Fontainebleau: oval, with a small capacity (it seats about 200 people), an orchestra, and two balconies. A prince's box sits directly across from the stage. The first balcony is supported by a series of elegant small columns. Plaster moldings represent garlands, trophies, and musical instruments. The theater's proportions are harmonious overall and lend the room a delightful intimacy. Lefuel also collaborated with the painter and set designer Charles-Antoine Cambon, who designed the painted backdrops and stage curtain. The cupola's ornamental motifs are strikingly lavish.

In 1935, the château was severely damaged by fire and rebuilt in its current neo-Renaissance style. Luckily, the theater itself was not affected by the fire and has been preserved in its original state. It has required renovations, however, largely due to persistent insect infestations in its structure. The theater was thus forced to close temporarily in 1984.

In recent decades, a music festival has been held at the Théâtre de Chimay, which also served as a location for *Le maître de musique*, directed by Gérard Corbiau. In this 1988 film, singer José Van Dam plays a retired opera singer who gives his last recital at the château.

The Château de Chimay is now on the verge of being purchased by Demeures Historiques et Jardins de Belgique (Historical Homes and Gardens of Belgium). We can only hope that this acquisition, supported by the Belgian state and the region, will bring the arts—particularly opera—to the fore in this remarkable structure left intact by the passage of time.

Chimay, a miniature theater—its orchestra and two balconies hold only 200 seats.

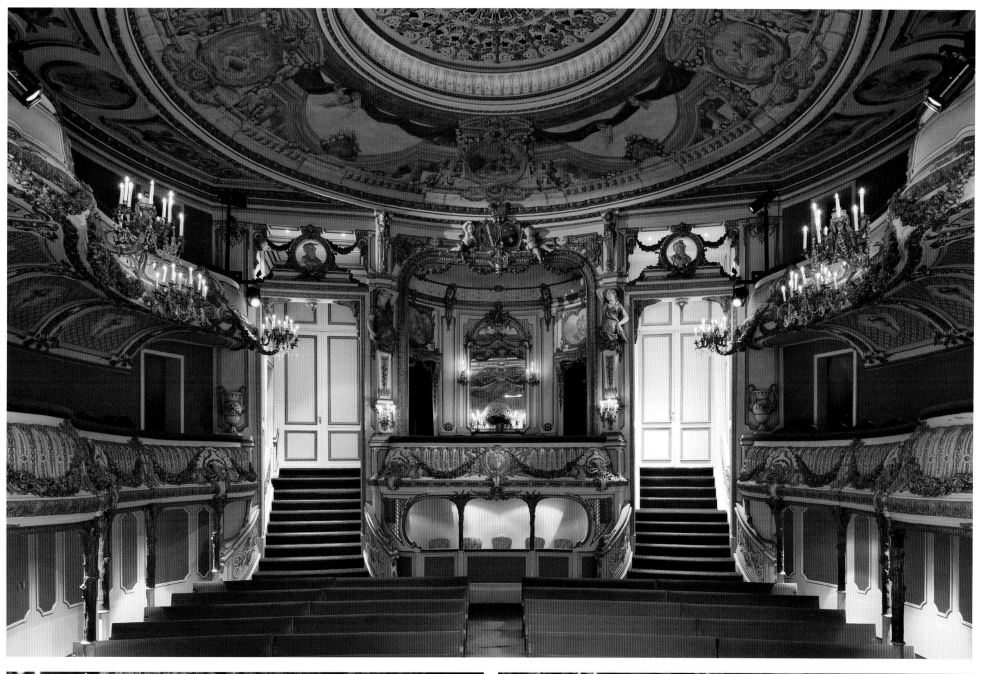

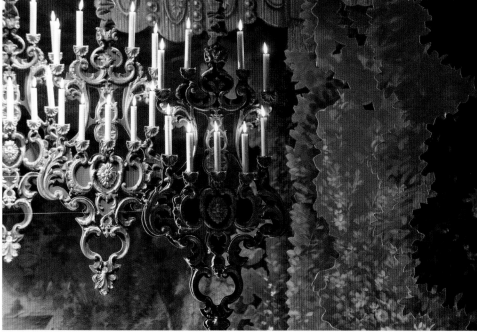

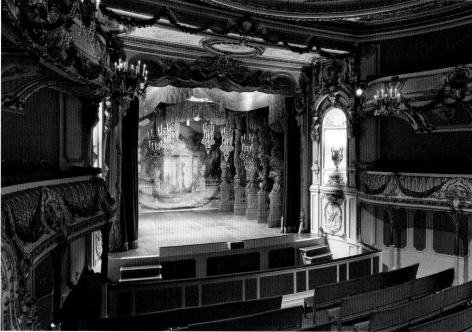

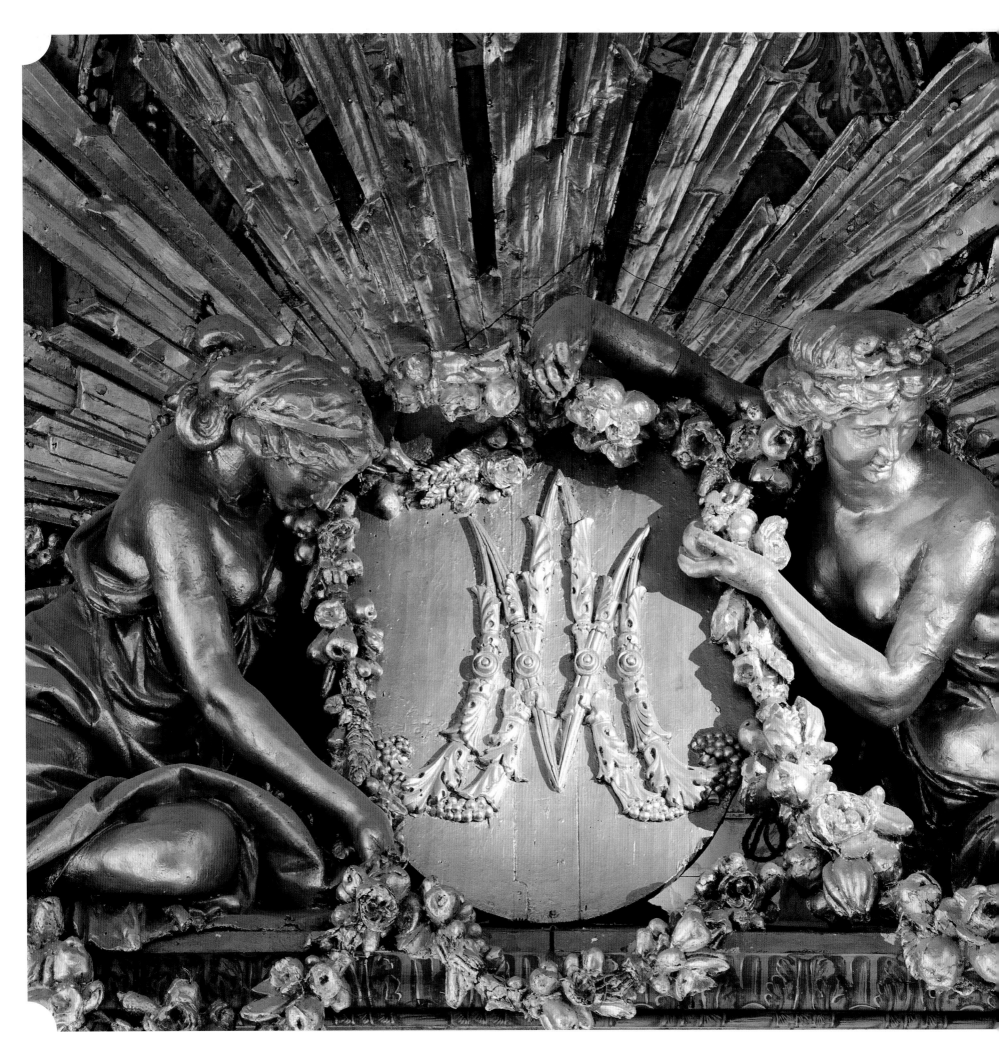

THÉÂTRE
DE LA
REINE

VERSAILLES

FRANCE

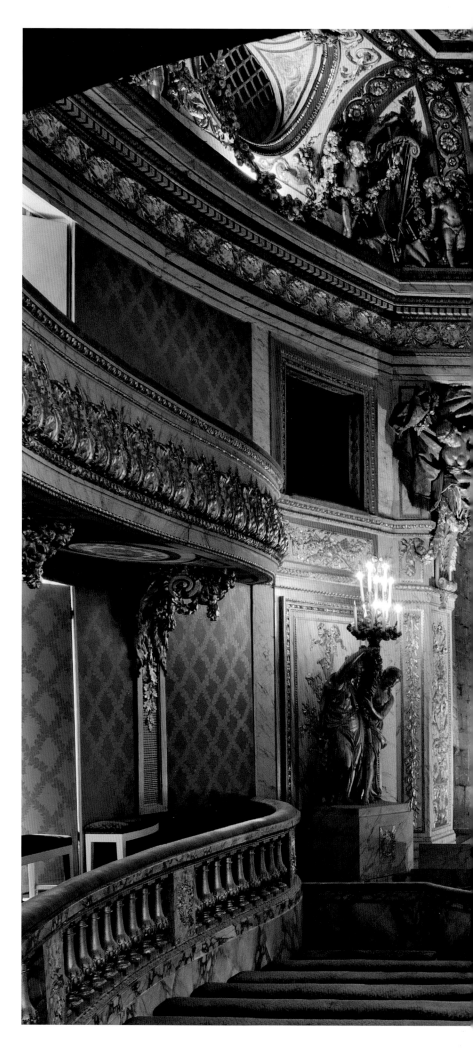

arie-Antoinette was a musician queen. At Versailles, she sang and played the harp, harpsichord, and pianoforte. Her musical tastes were eclectic, ranging from Salieri to Grétry through Piccinni and Gossec. But if there was one composer who truly benefited from the queen's support, it was her former professor in Vienna, Christoph Willibald Gluck, who was invited to the Paris Opera thanks to her. Surprisingly, the queen did not respond to one Wolfgang Amadeus Mozart's application to be the organist at the royal chapel in Versailles.

In 1774, Louis XVI gave his wife the Château du Petit Trianon and its grounds, a compound inside the gardens of the Château de Versailles. The queen moved into this neoclassical edifice built by the architect Jacques Ange Gabriel, also responsible for the Opéra Royal at Versailles (under Louis XV, constructed for his mistress Madame de Pompadour). Wanting to re-create the vibrant artistic life she had known in Vienna, Marie-Antoinette had a small theater built in her new property. The tiny Trianon theater, designed by the architect Richard Mique, was inaugurated in 1780.

From the outside, the edifice appears rather austere, with a single pediment and two Ionic columns as its only decorations. But the interior dazzles in blue, white, and gold. The wood faux marble, selected for financial reasons, is stunning. A miniature triumph of elegance, the oval auditorium can seat only some 100 spectators, divided among an orchestra, two stage-level boxes, and a balcony, along with the traditional fenced boxes like those at the Opéra Royal. The stage is larger than the area for the audience. The machinery by Pierre Boullet, which has been preserved in its original state, allowed for impressive set changes. The orchestra pit can hold some twenty musicians.

Inaugurated in 1780, the Théâtre de la Reine (Queen's Theater) was built by architect Richard Mique, who remained faithful to Marie-Antoinette to the end and was guillotined in 1794.

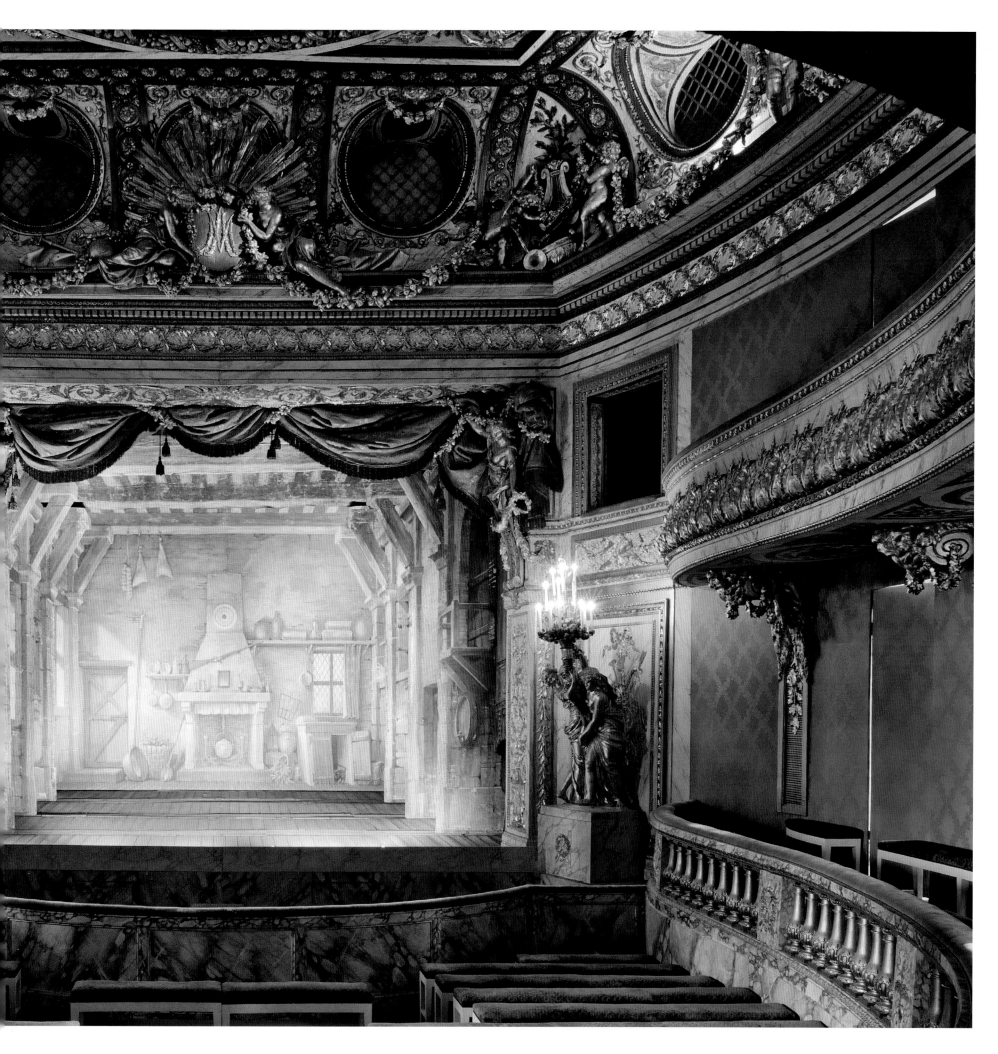

The queen herself would appear on stage, eagerly singing and disguising herself with elaborate costumes.

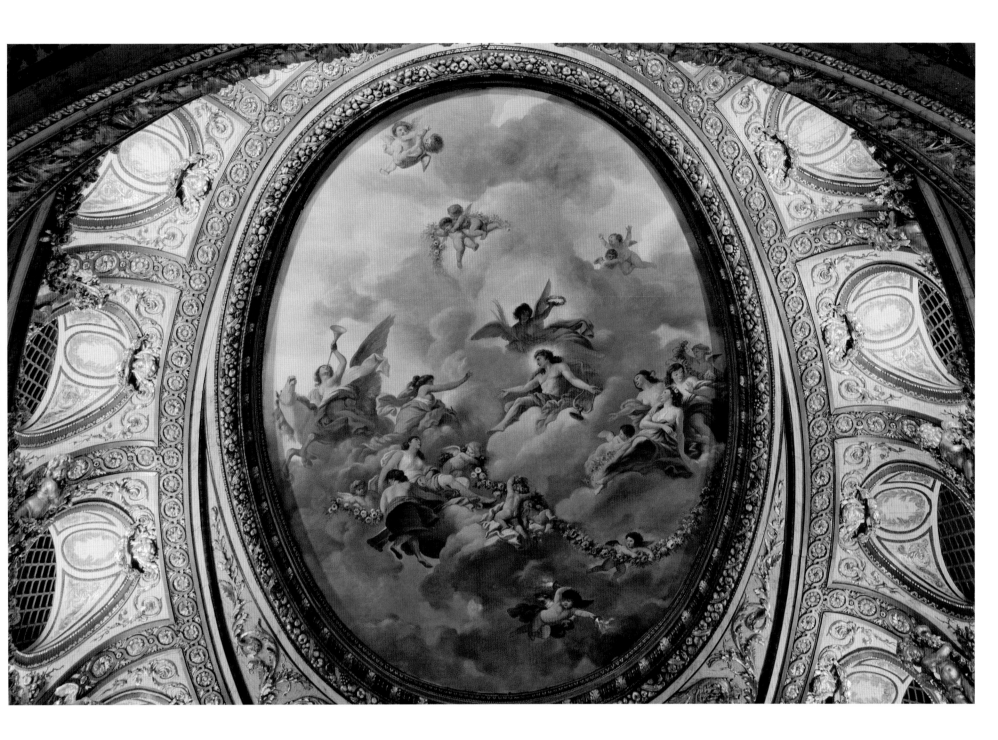

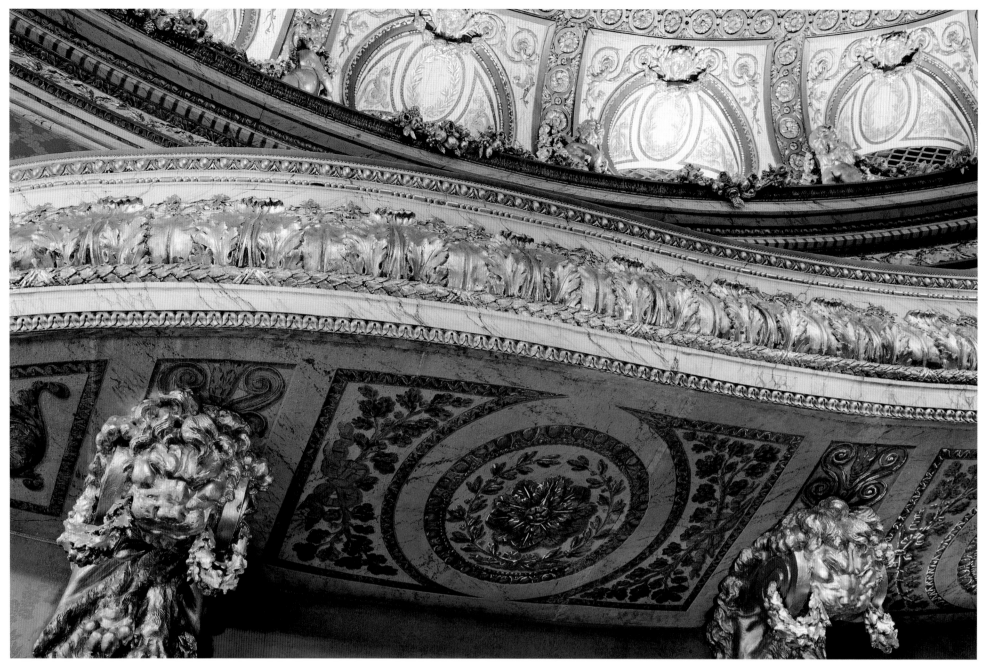

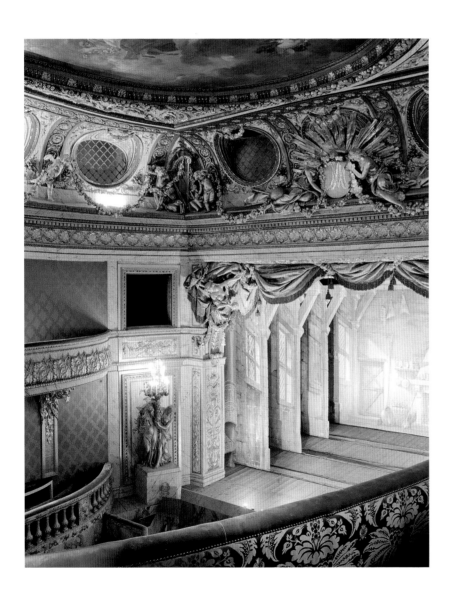

The queen herself participated in performances, sometimes dressing up as a shepherdess. Her maids were among the audience. By all accounts, Marie-Antoinette sang in tune and with spirit. These private performances alternated between operas and plays, such as Beaumarchais' *Le mariage de Figaro*.

Also at the Petit Trianon, Richard Mique built a rural hamlet and designed a garden in the English style. The estate could hardly have been more picturesque.

Marie-Antoinette's theater was miraculously spared by the revolution and was subsequently used at different times throughout the nineteenth century. It has been returned to its original state but is no longer suitable for public performances because of today's safety standards. One can get a glimpse of it, however, by looking at the auditorium from the vestibule. Some of the work created at the queen's theater lives on: Pierre-Alexandre Monsigny's opera *Le roi et le fermier* was originally presented here in 1780. Its sets were preserved and used for a 2012 revival at the Opéra Royal. As for the place where the queen expressed her artistic whimsy, it has been turned into a "sleeping beauty."

Accented by wood faux marble, the blue, white, and gold interior decorations are beautifully ornate.

THÉÂTRE ROYAL DE LA MONNAIE

BRUSSELS

BELGIUM

As a city constantly under construction, Brussels has a heterogeneous architecture, combining historical edifices, the functional aesthetic of the post-war years, and contemporary daring. As such, the Théâtre Royal de la Monnaie is representative of the Belgian capital. The latest upheaval was a major overhaul of the Place de la Monnaie, the square on which the opera house sits, to make it a pedestrian area. Work lasted from 2010 to 2012. But the Brussels opera house has experienced numerous transformations throughout its history, some more successful than others.

The original building dated from 1700. It was commissioned by ducal treasurer Gio Paolo Bombarda, who chose to have it built on the former *monnairie*, where coins were stamped with the mark established by the Brabant. A century later, the edifice was in a terrible state. By order of Napoleon a new theater by the Paris architect Louis Damesne was erected right behind the original one. The first theater was soon demolished, which allowed for a large plaza to be laid out in front of the new one. Damesne adopted a pure neoclassical style, with a pediment and colonnade.

La Monnaie was now ready for the world of music and the history books. In August 1830 Auber's opera *La Muette de Portici* was performed. Auber's story of the Neapolitans' rebellion against the Spanish occupant found particular resonance in Brussels, which was then under Dutch rule. As the aria *"Amour sacré de la patrie, rends-nous l'audace et la fierté"* ("Sacred love of the homeland, restore us to daring and pride") rang out, the audience's blood boiled: Theatergoers dashed into the street and set off the riots that would lead to Belgium's independence.

The theater was not destroyed by these political upheavals but was ravaged by an 1855 fire that spared only the peristyle and walls. Joseph Poelaert, architect for the city of Brussels (also responsible for the Colonne du Congrès and the Palais de Justice),

After a fire in 1855, the theater was designed in Louis XVI style.

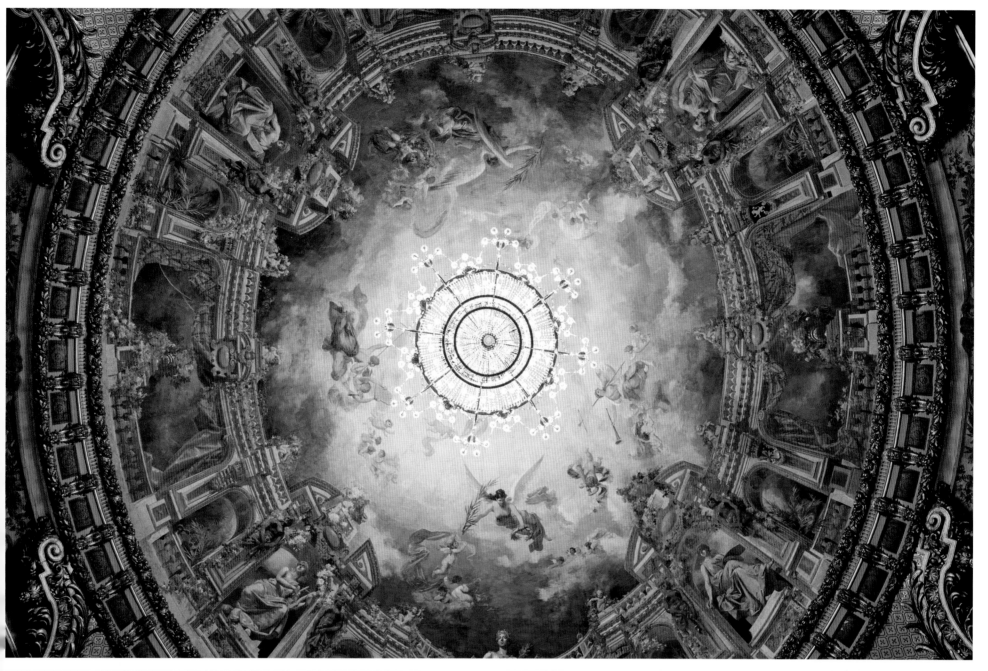

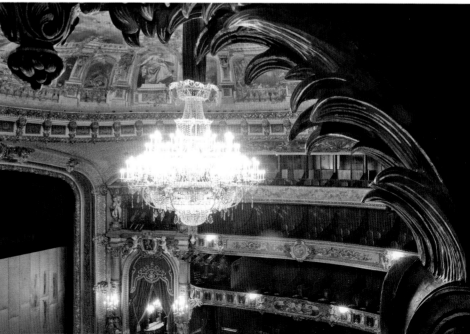

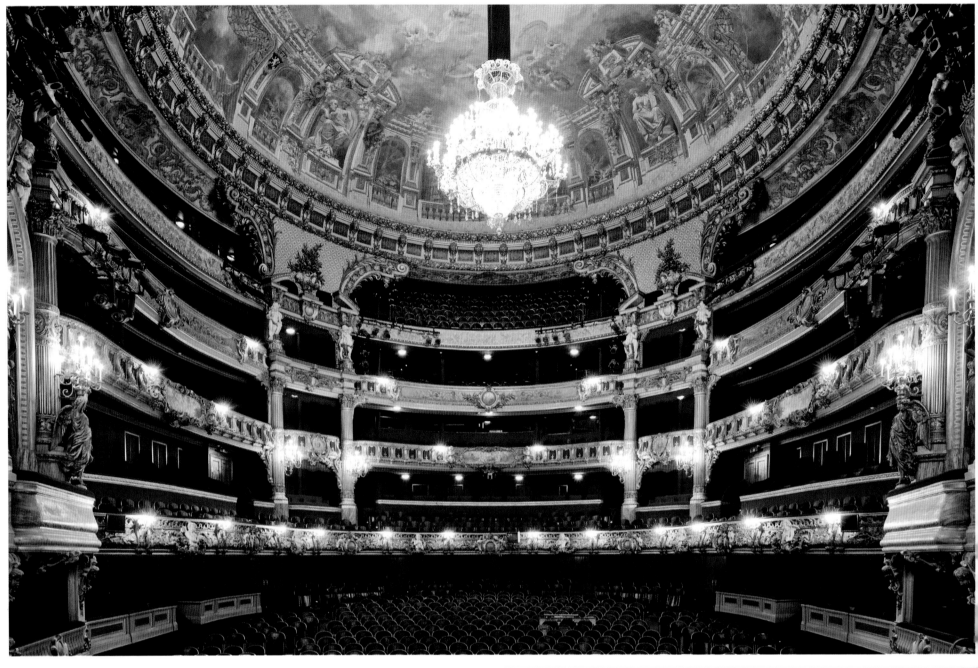

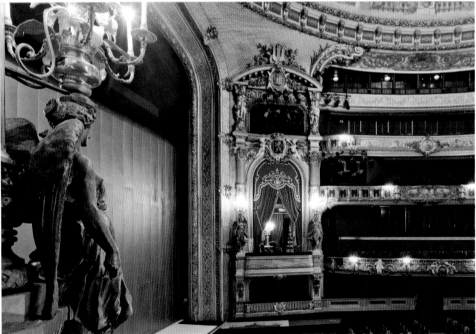

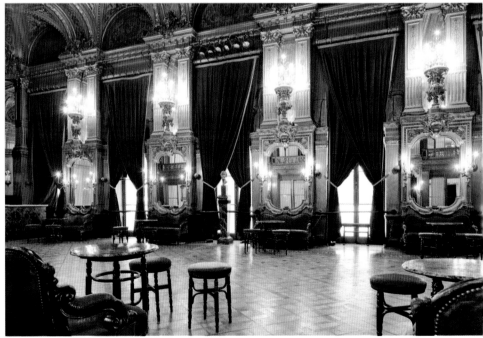

redesigned the entire building in Louis XVI style. The theater we know today is red and gold, with 1,100 seats in a horseshoe-shaped floor plan featuring open boxes in the French style. The cupola and crystal chandelier lend the room a sumptuous sheen.

Over the years, safety standards have become increasingly demanding. As a result, the theater had to undertake an ambitious renovation in 1985, particularly from a technical perspective. The raising of the building's height, which did not contribute anything from an architectural point of view, allowed for the addition of a large rehearsal room. Acoustics were improved and the orchestra pit expanded, so that works written for large orchestras beginning in the late nineteenth century could now be performed.

Gerard Mortier, the theater's director at the time, took the opportunity to add an artistic touch: The hall was decorated by two leading contemporary American artists, Sam Francis (who created the colorful ceiling) and Sol LeWitt (who designed the fan-shaped black-and-white marble tiling). Daniel Buren was also invited to decorate the Salon Royal.

For its reopening in November 1986, the theater chose Beethoven's Ninth Symphony, "Ode to Joy," an appropriate symbol in this European capital.

The theater's horseshoe-shaped floor plan and open balconies in the French style accommodate 1,100 spectators.
PAGES 228–229 *The Théâtre Royal de la Monnaie showcases contemporary art.*
LEFT *Daniel Buren decorated the Salon Royal with his trademark stripes.*
RIGHT *The entrance hall decorated by Sam Francis (the colorful ceiling) and Sol LeWitt (the black-and-white marble tiling).*

ZÁMACKÉ
BAROKNÍ
DIVADLO

ČESKÝ KRUMLOV

CZECH REPUBLIC

A few miles from the Austrian border, Český Krumlov Castle boasts one of the few surviving theaters of the baroque period preserved in its original state, from the stage machinery to the sets. It has never burned or been rebuilt.

The theatrical tradition at this court in Bohemia is said to go back to the fifteenth century. We know for certain that in 1675 Prince Johann Christian I had a stage built inside one of the castle's rooms. Since its capacity soon became too small, the same prince hired the Italian architects Giacomo Antonio de Maggi and Giovanni Maria Spinetti to build a real theater in one of the courtyards along the castle's west wing in 1680. In 1719, a major political change occurred: The Český Krumlov Castle came under the rule of the House of Schwarzenberg, known for its support of the arts.

Under the reign of Josef Adam of Schwarzenberg, the castle's rooms were repainted in the rococo style, and a chapel and manège were built. But most importantly, the count decided to overhaul the theater's interior completely. He called on the best specialists: The machinery was made by Lorenz Makh of Vienna, the auditorium's paintings and curtains were by Hans Wetschel and Leo Märkl, and the overall architecture was assigned to Andreas Altomonte. The new theater was inaugurated in 1766.

To reach the theater, you must cross a baroque bridge over the moat surrounding the castle. Once inside, you can feel the influence of the aesthetic of the architect and theater decorator Giuseppe Galli Bibiena, who also designed the Markgräfliches Opernhaus in Bayreuth (see page 106). The theater has an orchestra, a balcony, and a center box. Period conditions are respected to this day, from the wood benches to the candlelight. On stage, the original machinery's cables, pulleys, and winches are a fascinating sight. In the years that followed its inauguration, the theater staged operas by Salieri, Gluck, and Piccinni; the theater's archives include hundreds of volumes of period scores.

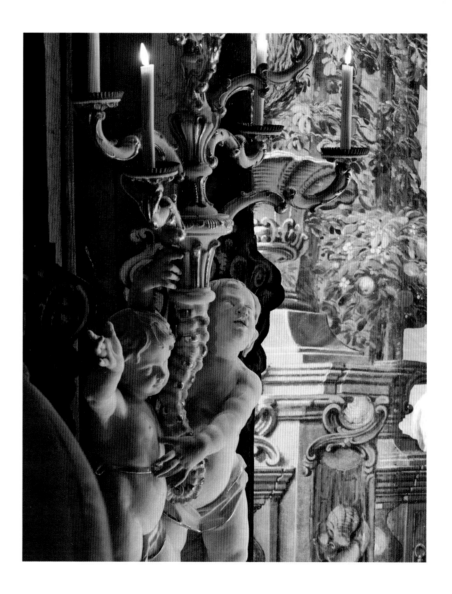

Candles are still used to light the theater.

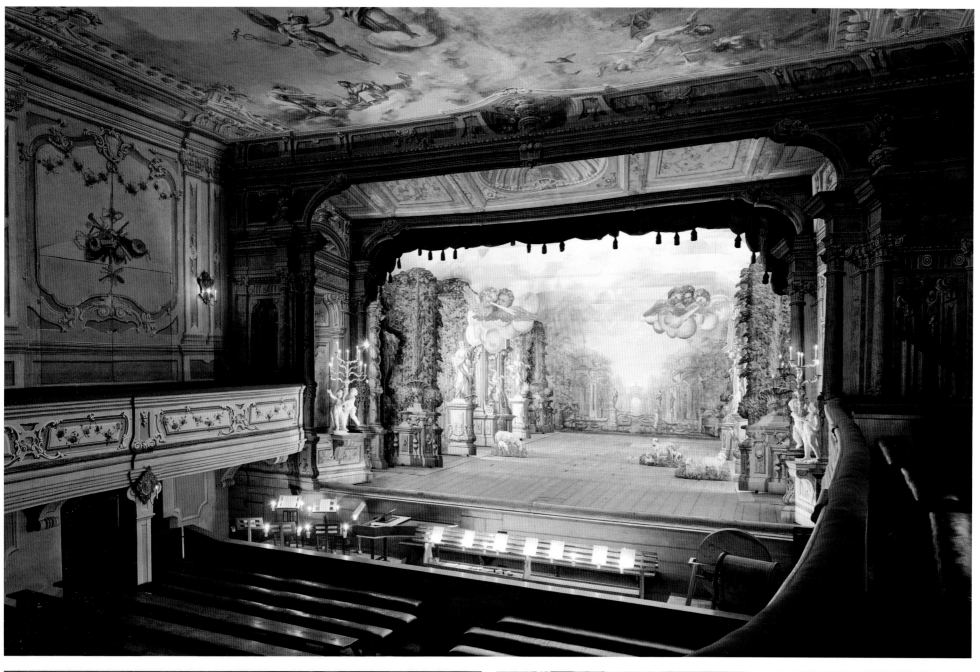

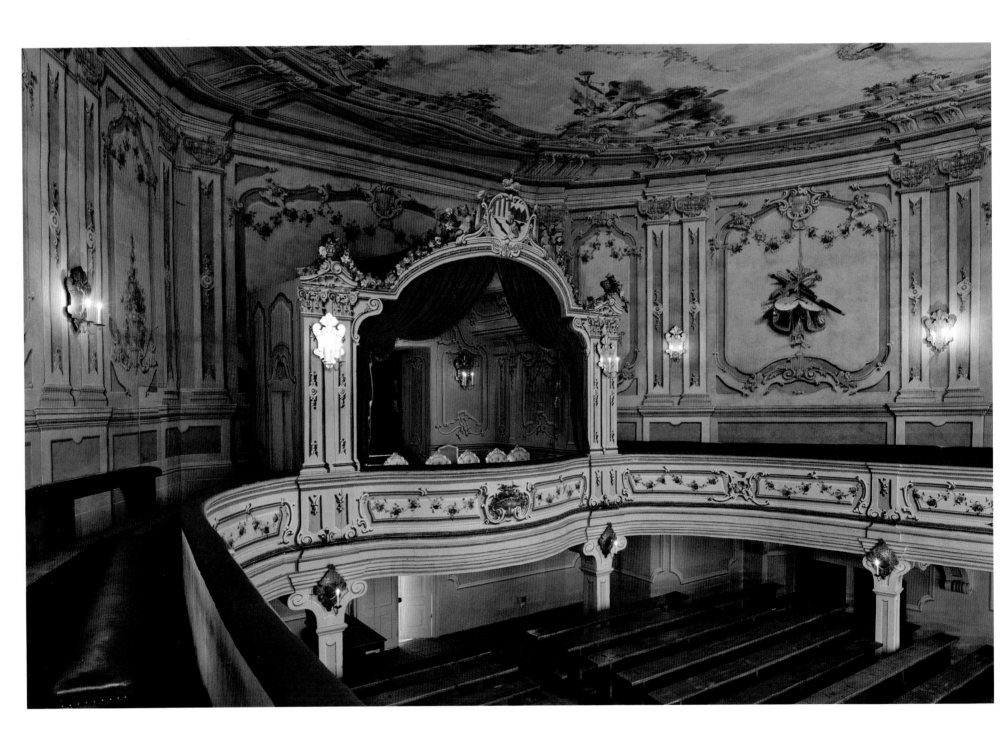

As in Drottningholm, the audience sits on period wood benches, which provide spartan comfort.

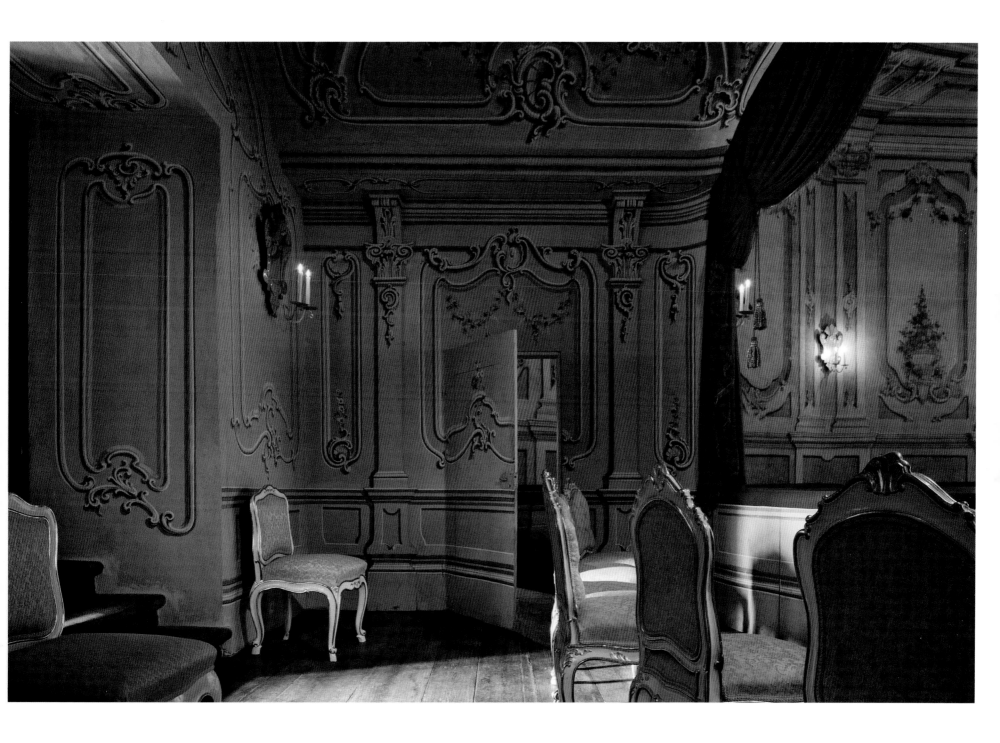

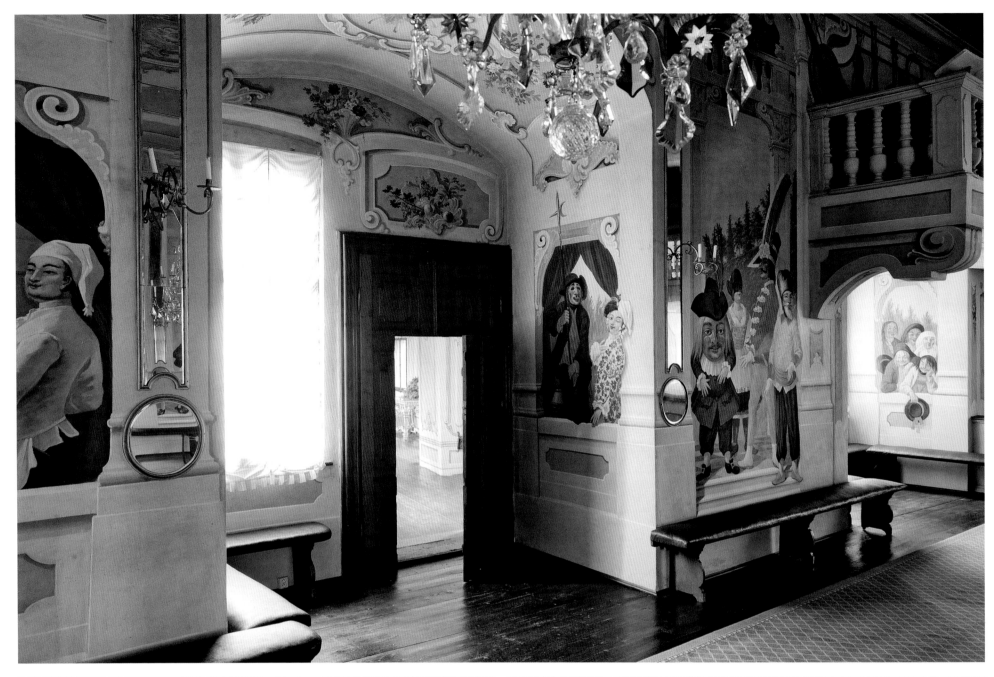

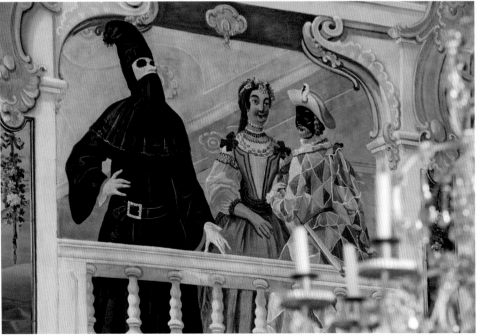

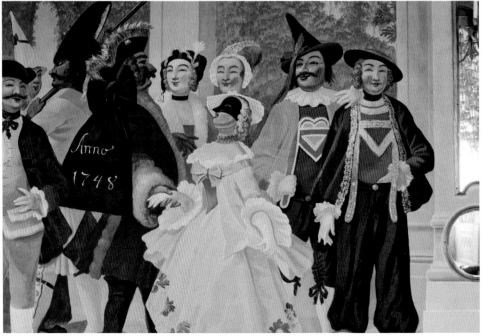

The castle's musical life is not limited to the theater: A wood concert pavilion was built in the garden to host wind ensembles. Bohemia's wind sections were among the best in Europe and were known to perform adaptations of Mozart operas.

After experiencing a golden age under Josef Adam of Schwarzenberg, the castle fell into disuse in the nineteenth century. It was taken over by the German authorities during the Second World War and nationalized according to communist dictates after the war. During this period, an open-air theater with a revolving stage was built in the garden (the stage mechanism was initially driven by manpower but has been electric since the 1960s). It is used for a theater and opera festival every summer. This second theater, built by the architect and set designer Joan Brehms, is embroiled in controversy: UNESCO, which lists the castle as a World Heritage Site, would like this typically 1960s edifice to be moved so as not to adulterate the castle's baroque garden. So far, the open-air theater's defenders have held their ground.

As for the original theater, it was briefly used for festivals from 1956 to 1964, and then closed to the public from 1966 to 1997. It is currently still being restored but is accessible to tourists; 300,000 people a year pay a visit to Zámacké Barokní Divadlo.

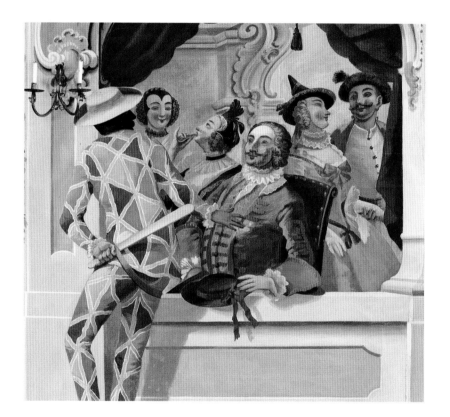

The delightfully naive paintings in the foyer bear witness to the artistic liveliness of the castle at the time of the Schwarzenbergs.

BIBLIOGRAPHY

Leo Beranek, *Concert Halls and Opera Houses: Music, Acoustics and Architecture*, New York, Springer, 2004.

Laurent Croizier and Luc Bourrousse, *Le Grand-Théâtre de Bordeaux, l'album des 20 ans, 1992–2012, de la réouverture à demain*, Bordeaux, Éditions de l'Opéra de Bordeaux, 2012.

Michael Forsyth, *Architecture et musique, l'architecte, le musicien et l'auditeur, du XVIIᵉ siècle à vos jours*, Brussels, Pierre Mardaga, 1985.

Françoise Fromonot, *Jørn Utzon et l'Opéra de Sydney*, Paris, Gallimard, 1998.

Michael Hammond, *Performing Architecture: Opera Houses, Theatres and Concert Halls for the Twenty-First Century*, London, Merrell, 2006.

Andras Kaldor, *Great Opera Houses (Masterpieces of Architecture)*, Woodbridge, Antique Collectors Club, 1996.

Henning Larsen, *De skal sige tak! Kulturhistorisk testamente om Operaen*, Copenhagen, People's Press, 2009.

Marcel Val, *Acoustique et music: rencontre entre l'architecture et le monde musical*, Paris, Dunod, 2002.

Jean Vermeil, *Opéras d'Europe*, Paris, Plume, 1989.

Richard Weston, *Alvar Aalto*, Paris, Phaidon, 2006.

ACKNOWLEDGMENTS

GUILLAUME DE LAUBIER

Photographing an opera house proved to be more complicated than I had imagined. These huge buildings are like machines perfectly designed to stage often expensive and elaborate spectacles, requiring a back-stage army of highly trained technicians and stagehands ready for the most unpredictable challenges—except for the intrusion of a photographer looking at anything other than the scheduled performance. The photographer must then take the stage, if only for an instant. It is best for him to have closely negotiated with the institution in question beforehand, sometimes several months in advance, to gain a short window of time during which he can slip between rehearsals and set changes, matinee and evening performances. But one was never sure—an unexpected delay could lead the theater to ban the photographer, which explains why some people seemed particularly welcoming to me. I would like to thank Maria Hilber in Essen, Annarita Ziveri of the Teatro Farnese in Parma, Katerina Novikova at the Bolshoi, María Ferrando Montalva in Valencia, Jenny Callow at the Coliseum in London, Marie-France Botte and Clio Rosenoer at the Théâtre de la Monnaie, the passionately erudite Jean-Paul Gousset in Versailles, Catherine Plichon at the Palais Garnier, Ida Karine Gullvik in Norway, Eva Lundgren in Sweden, Louise Pedersen in Denmark, and finally Hidemi Kurita in Tokyo for his constant availability and Sharon Lomasney at the Chicago Opera for her generous efficiency.

I would also like to thank Désirée Sadek, who steadfastly supported me throughout this project; Maria Aziz, who resolved tricky logistical problems; François Delétraz at *Figaro* magazine for the first photos on the subject; and, at Éditions de La Martinière, Laura Stioui, who planned the endeavor with flawless efficiency; Anne Serroy, for trusting me from the beginning; and Marianne Lassandro, who was able to untangle difficult situations abroad. Thank you, of course, to Antoine Pecqueur, whose enthusiasm for opera is contagious. Finally, my gratitude to my family, who paid close attention to this new challenge and set reassuring high standards as it was produced one perilous page at a time.

The publisher would like to thank all the opera houses that opened their doors to our photographer in order to make this volume possible.

PHOTO CREDITS

All photos by Guillaume de Laubier

pp. 11–17: Aalto-Musiktheater, Essen, Germany, © Alvar Aalto, ADAGP, Paris, 2013. pp. 47–53: Den Norske Opera & Ballett, Oslo, Norway, © Snøhetta. pp. 61–69: Det Kongelige Teater, Operaen Store Scene, Copenhagen, Denmark, © Henning Larsen Architects. pp. 109–115: Metropolitan Opera House, New York, United States, © Metropolitan Opera. pp. 117–23: New National Theatre Tokyo, Tokyo, Japan, © TAK Associated Architects INC./DR. pp. 145–51: Palau de les Arts Reina Sofía, Valencia, Spain, © Santiago Calatrava, ADAGP, Paris, 2013. pp. 182–83: Sydney Opera House, Sydney, Australia, © Sydney Opera House/DR. p. 183: Sydney Opera House © ImageZoo/Corbis.

FRENCH EDITION

Graphic Design and Layout: Éléonore Gerbier
Photogravure: Point 4

ABRAMS EDITION

Editor: Laura Dozier
Designer: Shawn Dahl, dahlimama inc
Production Manager: Erin Vandeveer

Library of Congress Control Number: 2013935974

ISBN: 978-1-4197-0961-6

Copyright © 2013 Éditions de La Martinière, La Martinière Groupe, Paris
English translation copyright © 2013 Abrams, New York

Published simultaneously in French under the title *Les plus beaux Opéras du monde*.

Printed and bound in France
10 9 8 7 6 5 4 3 2 1

Abrams books are available at special discounts when purchased in quantity for premiums and promotions as well as fundraising or educational use. Special editions can also be created to specification. For details, contact specialsales@abramsbooks.com or the address below.

THE ART OF BOOKS SINCE 1949
115 West 18th Street
New York, NY 10011
www.abramsbooks.com